IMAGES
of America

CARTERET COUNTY

IMAGES of America
CARTERET COUNTY

Lynn Salsi and Frances Eubanks

ARCADIA
PUBLISHING

Copyright © 1999 by Lynn Salsi and Frances Eubanks.
ISBN 978-1-5316-0175-1

Published by Arcadia Publishing
Charleston, South Carolina

For all general information contact Arcadia Publishing at:
Telephone 843-853-2070
Fax 843-853-0044
E-Mail sales@arcadiapublishing.com
For customer service and orders:
Toll-Free 1-888-313-2665

Visit us on the Internet at www.arcadiapublishing.com

Dedication

Written to honor Mrs. Nettie Willis Murrill and Mrs. Clara Salter Gaskins
And for Larry Eubanks
And for Bo, Brian, and Burke Salsi, Margaret Sims, and Jay and Maria Swygert

Contents

Acknowledgments		6
Introduction		7
1.	The Dawning of a New Century—1900	9
2.	Beaufort	21
3.	Morehead City and West	39
4.	Down East Communities	63
5.	Portsmouth Island and the Banks	77
6.	The Storms	95
7.	Scratching a Living	101
8.	Celebrations and Traditions	113
9.	The Dawning of a New Century—2000	121

ACKNOWLEDGMENTS

Everywhere we turned we received encouragement. We would like to thank the following organizations and individuals that made this project possible:

Our spouses, Burke Salsi and Larry Eubanks, for their interest, encouragement, and assistance;

Nettie Murrill, for photographs, stories, and especially for remembering countless dates;

Elwin Jackson, for piloting Frances over marshes and islands for special aerials;

Barbara Gaskin-Eugene, Jo G. Holloman, Deborah G. Penny, Barbara Springs, and Andrew Martin, for their optimism and encouragement;

Janice Smith, for her help and assistance in making the fishing photos possible;

Candace Hentschel, for being a great assistant on rides over the county;

Bo and Brian Salsi, for helping with research and sharing the joy of history;

Jean Hoxie Naples and Billy Jean Huling, for their endless good will;

The Carteret County Historical Society, Les Ewen (president), Jack Goodwin (library director), and Andrew Duppstadt (the society's executive director);

Core Sound Waterfowl Museum and especially for the personal help of Karen Amspacher (museum director);

The North Carolina Maritime Museum and for the personal help of Connie Mason (historian);

Jerry Schill (executive director) of the North Carolina Fisheries Association;

Barbara Garrity Blake, Ph.D., East Carolina University, Carteret Community College;

Billy Piner, for sharing his postcard collection and local stories;

Steve Massengill (archivist), North Carolina Department of Archives and History;

Joanne Putnam, for sharing her World War II scrapbook and Morehead City memories;

Sonny Williamson, for memories he has published and lies he's told;

The North Carolina Arts in Education Project.

We gleaned our chronology, specific dates, and copy identification from personal memories and from the following publications:

Carteret County News-Times;

The Mailboat, Karen Amspacher (publisher);

The Researcher, Carteret County Historical Society Publication;

Fort Macon Ramparts, Friends of Fort Macon Publication;

Carteret County History, Vol. I and II, the Carteret Historical Research Association (publisher);

Good Old Days, Sonny Williamson (publisher);

Doctor's Creek Journal, The Friends of Portsmouth Island (publisher), Chester Lynn (president);

The Old Port Town Beaufort, North Carolina, Jean Kell (author and publisher).

INTRODUCTION

Carteret County, North Carolina, is rich in the history of discovery, the plunder of pirates, and the struggle to survive.

The beginning of the county goes back to the first settlers in the New World. When sixteenth-century explorers found the coast of North Carolina to be rugged, shallow, and inhospitable, they established towns farther to the north in Virginia and farther south in Charleston. After the years passed, the colonial settlements grew and so did the demand for products. The colonists engaged in shipping and trading raw products to England, the West Indies, and beyond.

For decades trade routes were established via the Carolina Coast from the West Indies to the Northern colonies as far as Philadelphia and New York. As the traffic of ships increased, it became imperative to find safe harbors within a day's sail. When it was discovered that the Old Topsail Inlet (now Beaufort Inlet) led to a large, safe harbor and that the Ocracoke Inlet could be navigated to carry on trade with the settlements along the Pamlico River, first one and then another community sprang up. Seamen found fertile land, a temperate climate, forests, game, and plenty of fish.

With the discovery of the natural harbor at Fish Towne, shipping became so great that in 1713 the town of Beaufort was laid out. By 1722 it was incorporated and was declared a seaport by the English Lord Proprietors.

In 1753 the growth of Carteret County continued with the establishment of Portsmouth Village, which was bordered by the Atlantic Ocean, the Pamlico Sound, and the Ocracoke Inlet. The inlet provided a safe waterway to transport goods through the coastal rivers and sounds to serve small waterway communities.

For the most part Carteret County was settled by a hardy seafaring lot. The earliest times were years of struggle requiring a subsistence lifestyle. Throughout 200 years the people of the coastal communities endured the sea's dangers of wind and storms. They experienced the constant discomfort of heat, salt, bugs, and disease.

The county's progress came to a grinding halt many times, as it was impacted by the Revolutionary War, the War of 1812, the Civil War, World War I, and World War II.

Today citizens of the county participate in a modern society, yet they still live with the irony that much of the past is an integral part of the present. Our book was designed to honor the history and celebrate the future. We therefore chose to picture an overview of the county's development in the hundred years between 1900 and 2000. We were deliberate in our choices of images in order to present the culture, traditions, and the present in one small volume. We have focused on descendant families and their memories as a way of tying the last hundred years of history together. We also recognized the importance of outside entrepreneurs such as the Moreheads, the Arendells, and the Webbs. The involvement, investment, and vision of these families was integral to the development of a modern county.

The 1990s has brought original descendants, investors, and visitors together into a phase of tremendous economic growth that has given Carteret County a resort image and has made the "Crystal Coast" the place to be.

We think the original settlers would be pleased that we value their history. Thereby, we hope that your reflections on this book will also make you think your history is important.

—Lynn Salsi and Frances Eubanks
August 1999

One
The Dawning of a New Century—1900

The dawning of the twentieth century was a step forward for the citizens of Carteret County. The Civil War brought every part of daily life to a halt, as the residents endured Federal occupation. As soon as the troops exited, folks struggled to rebuild their farms and their houses, refurbish their boats, and return to a normal life. Watermen no longer encumbered by blockades could get back to the business of fishing. Once the railroad returned, fish could be shipped by rail, the port could receive ships, and tourists could plan jaunts to the coast. A newfound sense of prosperity prevailed.

By the dawn of 1900, Carteret County was known as a summer resort and as a winter hunting ground. By the time the railroad reached Beaufort in 1907, the county was no longer considered a rural arm of North Carolina. Rather, it was a desirable destination. Roads to connect rural communities were envisioned and the growth of Morehead City and Beaufort was assured.

A new Fresnel lens was installed in the Cape Lookout Lighthouse and it was once again the sentinel of free trade. In the first part of the century, hurricanes swept over the barrier islands wrecking entire communities and causing most of the remaining residents to seek refuge in "the Promised Land" (Morehead City), Beaufort, or Harkers Island.

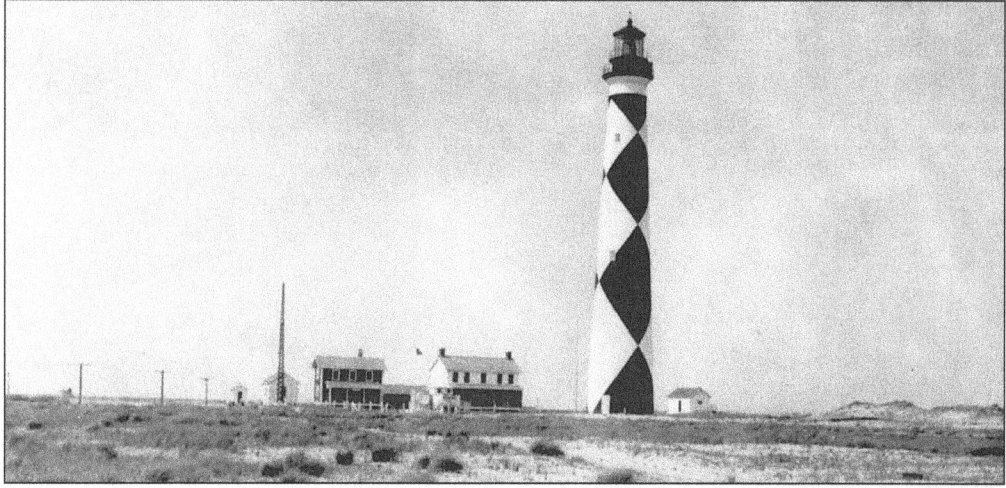

Cape Lookout Lighthouse, completed in 1858, was the sentinel to the new century. During the Civil War, Confederate soldiers rendered it inoperative. The 150-foot brick tower was painted in a diamond pattern in 1873. From left to right, the additional buildings shown are the outhouse, radio equipment building, keeper's quarters, the coal shed, the second keeper's quarters, the light tower, and the carpenter shop. (Courtesy Carteret County Historical Society.)

Devine Guthrie was a community leader and preacher on Shackleford Banks at the turn of the century. A born waterman, he was a whaler in season and in demand as a master boatbuilder. He witnessed tremendous growth in his time, as his life spanned the Civil War, numerous hurricanes, and the turn of the century. (Courtesy Core Sound Waterfowl Museum, Harkers Island.)

Captain Stacy Guthrie was born on Shackleford Banks in 1882. While on the Banks, he was a fisherman and member of a whaling crew. At the age of 16, he left the Banks and helped move his home by boat in sections. It was reconstructed on Harkers Island. He was known as one of Harkers Island's first master boatbuilders. (Courtesy Core Sound Waterfowl Museum, Harkers Island.)

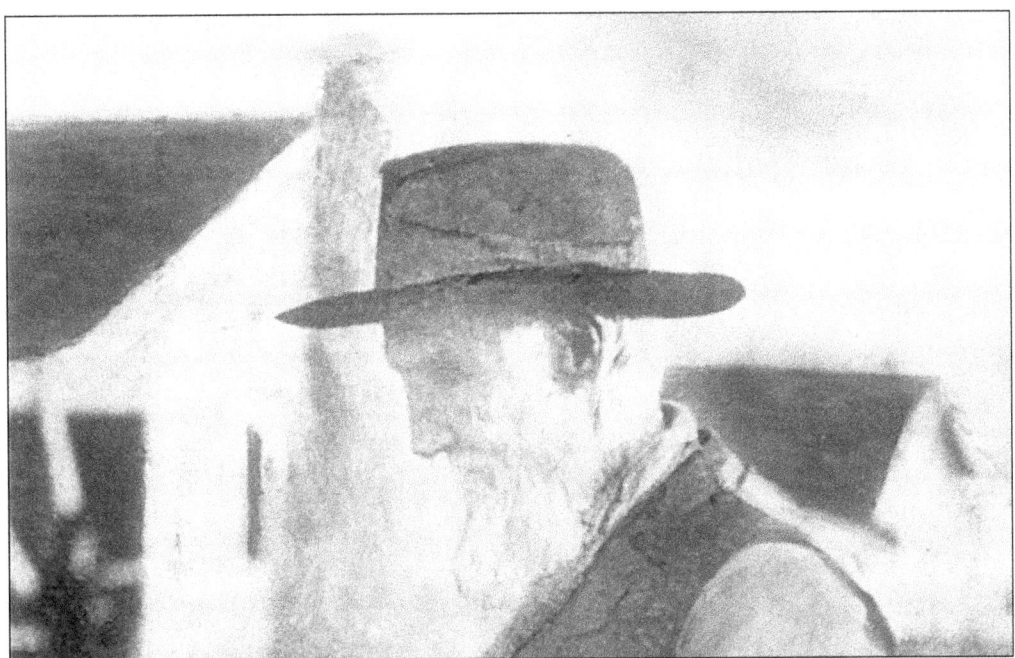

Josephus Willis was a determined sea captain and a well-known whaler on Shackleford Banks. He was best known as captain of the red oar whaling crew in which his six sons served as his crew. They successfully landed the Mayflower whale, whose skeleton is on display in the North Carolina Natural History Museum. (Courtesy Nettie Murrill, private collection.)

Emeline Piggott was a shy young woman living on her father's farm on the Calico Creek when the Civil War began. Emeline and her family helped provide food for the troops camped on the creek. When Morehead City fell to the Union, Emeline nursed the wounded. Through her efforts as a spy, she helped further the cause of the Confederacy. She was celebrated in Morehead City until her death in 1932. (Courtesy Carteret County Historical Society.)

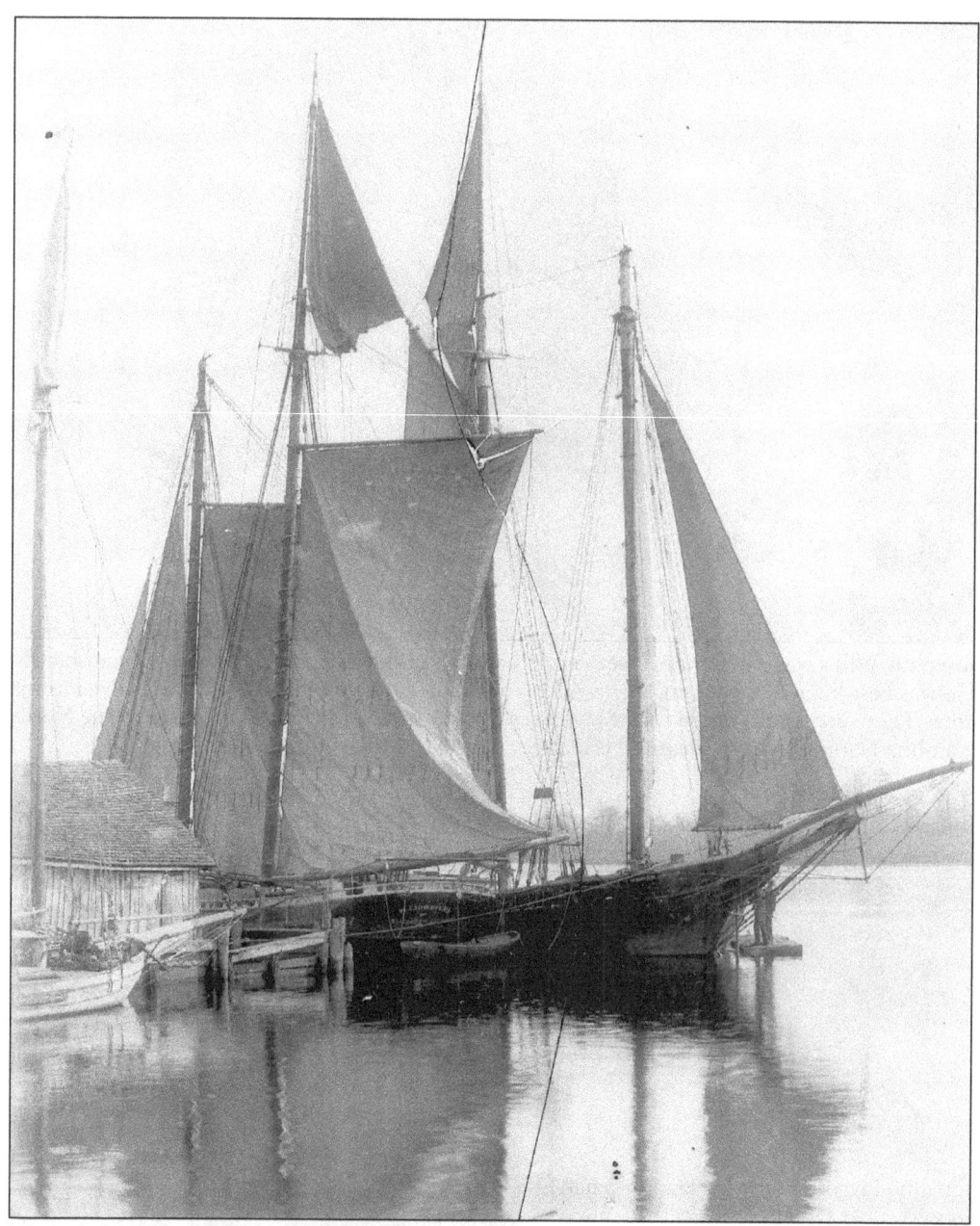
The schooner at dock with sails unfurled is possibly waiting to be loaded. Built in Williston, this one was owned by a waterman from Marshallberg and was the type used in commercial oystering at the turn of the century. About 1915, it was converted to gasoline. (Courtesy North Carolina Maritime Museum.)

Clem and Louise Gaskill are shown moving from Diamond City near the Cape Lookout Lighthouse in 1912. Captain Fred Gillikin is on the back of the horse-drawn wagon, along with their worldly possessions. (Courtesy Core Sound Waterfowl Museum.)

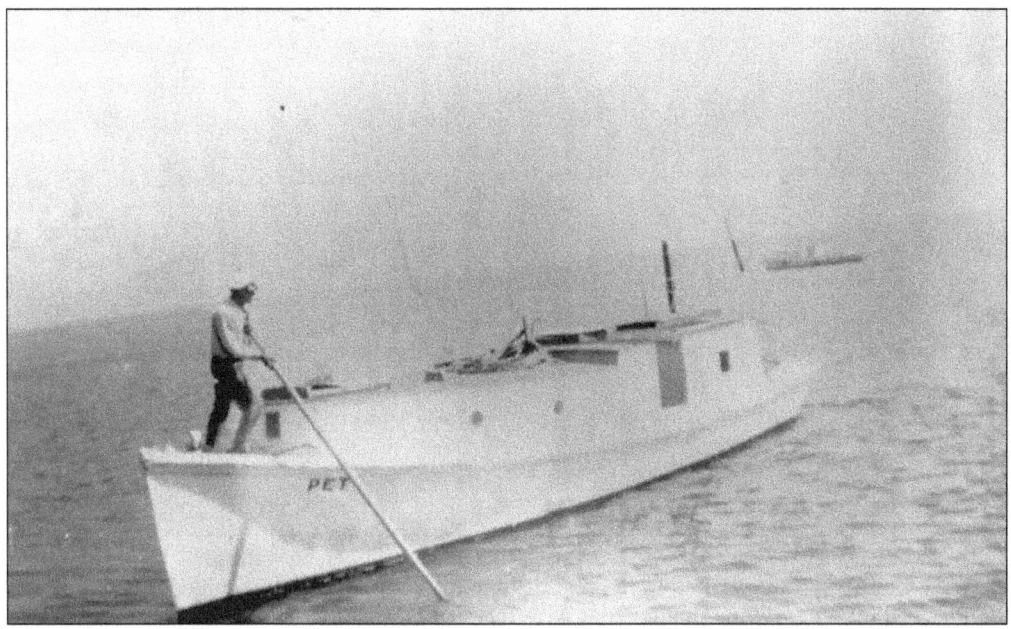
Kelly Willis and the mailboat "Pet" are shown coming into the post office dock at Harkers Island. There was no bridge to the island; supplies and mail were carried from one community to the other by mailboat. (Courtesy Core Sound Waterfowl Museum.)

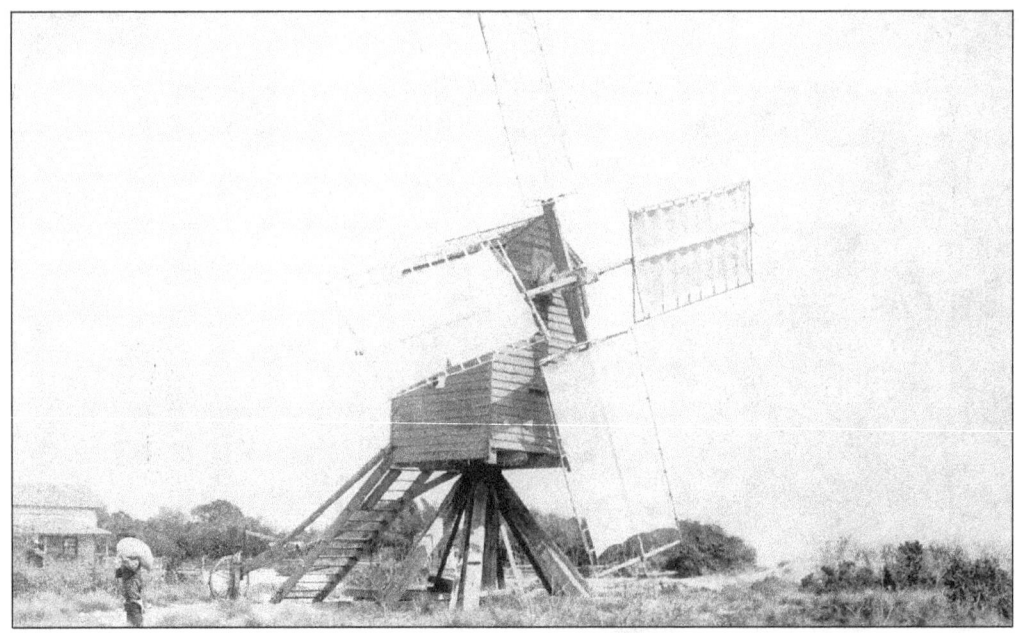

Located on the west end of Harkers Island, the gristmill at Knuckles Point was one of over a dozen in Carteret County powered by the wind for grinding corn and wheat and pumping water. The wind drove the wooden gears, which moved the stones to crush the grain. (Courtesy Core Sound Waterfowl Museum, the Joel Hancock Collection.)

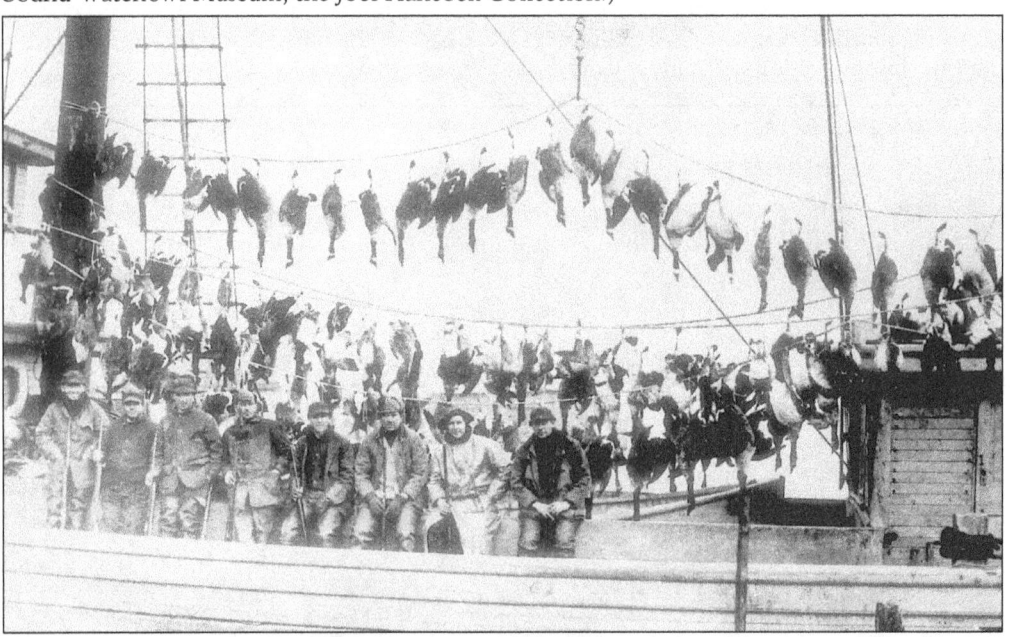

This picture from the early 1900s illustrates the great number of waterfowl to be found in Carteret County. Hunters came from great distances to engage hunting guides. These hunters are pictured on an early menhaden boat with over 100 ducks from a day's shoot. From left to right they are Paul Mengel, Dave Richardson, Ralph Daniels, Dave Morris, Henry Henderson, George Brooks, John Haywood Jones, and Bill Blades, c. 1925. In addition to the meat from the fowl, the feathers would be used for bedding. (Courtesy Core Sound Waterfowl Museum.)

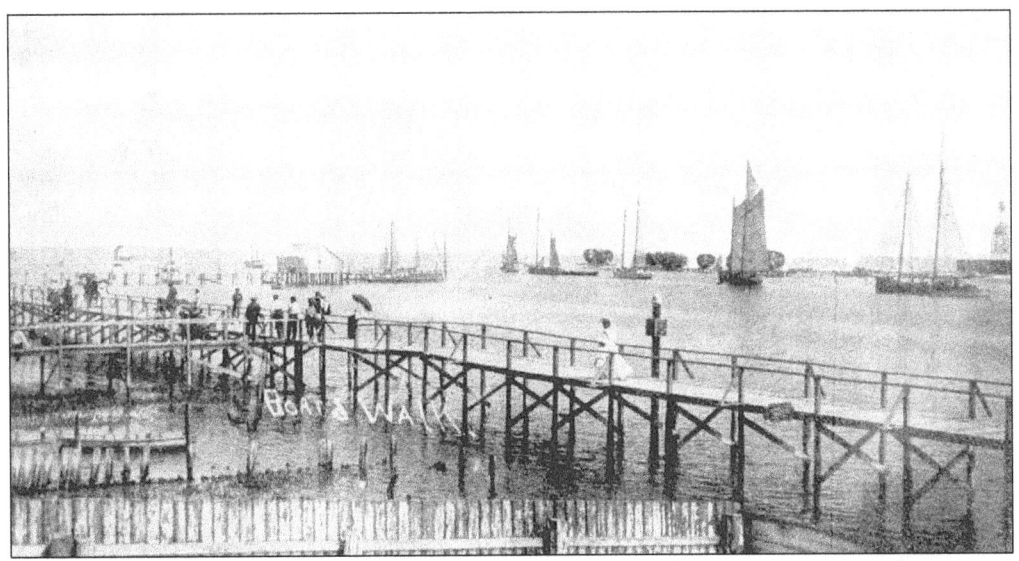

Around 1900, the old Beaufort boardwalk ran parallel to the waterfront with fingers that extended into Taylor's Creek. It was "the place" for a Sunday afternoon stroll along the "beach." Shortly before the turn of the century, Beaufort gained the reputation as a popular resort area for the elite. The boardwalk was enjoyed by visitors and townspeople. (Courtesy North Carolina Maritime Museum.)

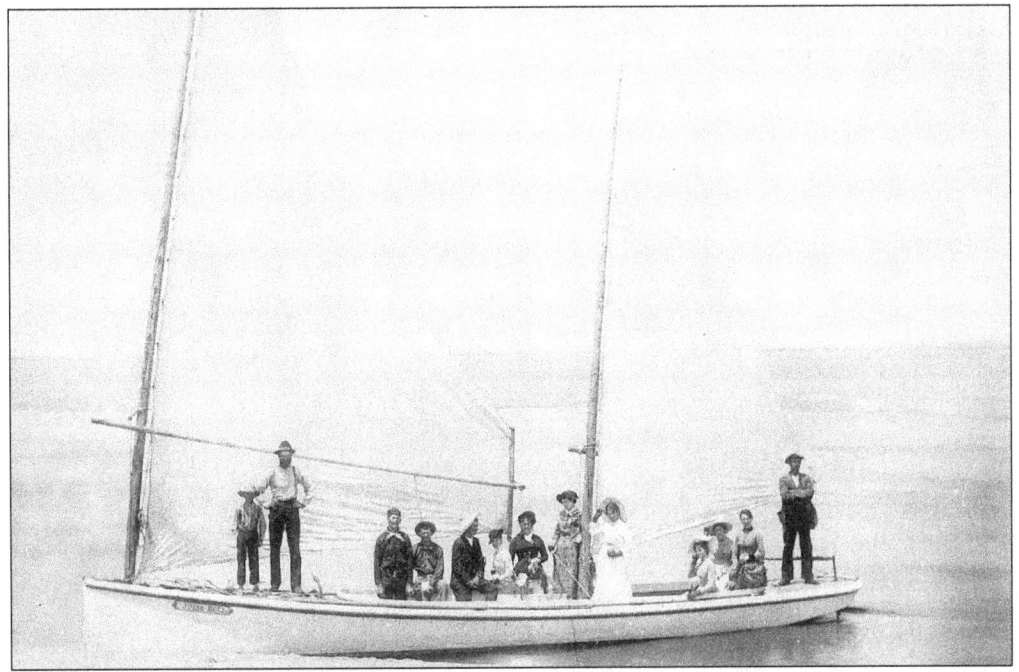

Around 1900 the sharpie *Julia Bell* was owned by a relative of Mr. Dan Bell. They were a well-known sailing family. Sharpies were used for work during the week and were often hired out for pleasure sailing on Sunday afternoons so that captains could make extra money. The photograph is in the style that made Wooten-Moulton from New Bern famous. This was one of the three *Julia Bell*'s built between 1876 and 1912. (Courtesy North Carolina Maritime Museum.)

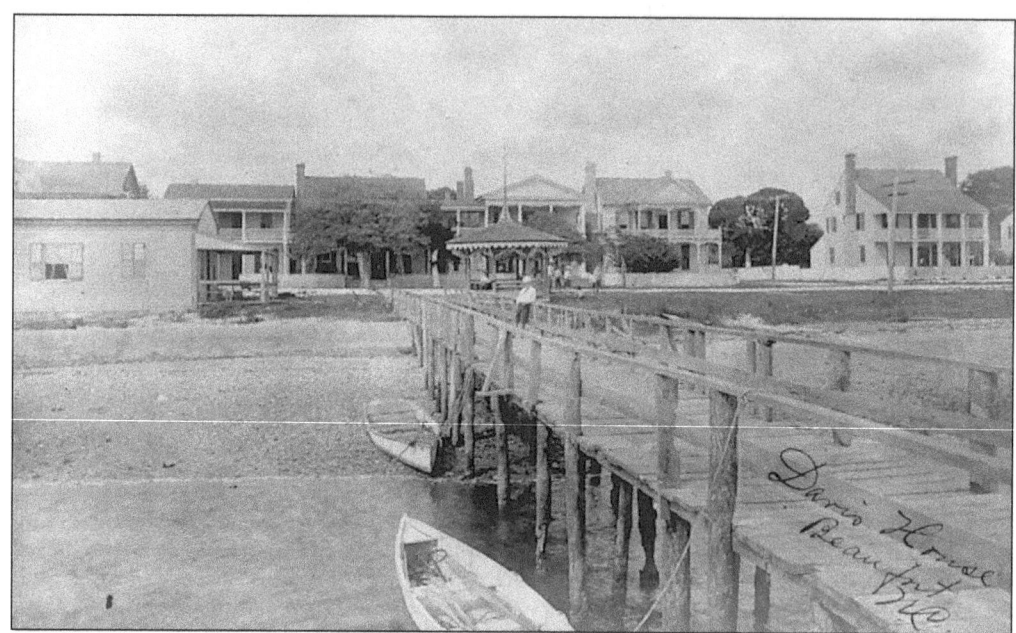

Beaufort greeted the new century as the place where the elite met for holiday. There would be bathing in Taylor's Creek and long strolls on the pier. The pier is shown at low tide with the elegant homes once owned by prosperous sea captains, ship owners, and merchants in the background. (Courtesy Carteret County Historical Museum.)

Net spreads along the shores of Harkers Island are seen in the foreground. Making and repairing fishing nets required great skill and patience. Care of the nets was paramount and very time consuming. (Courtesy Core Sound Waterfowl Museum.)

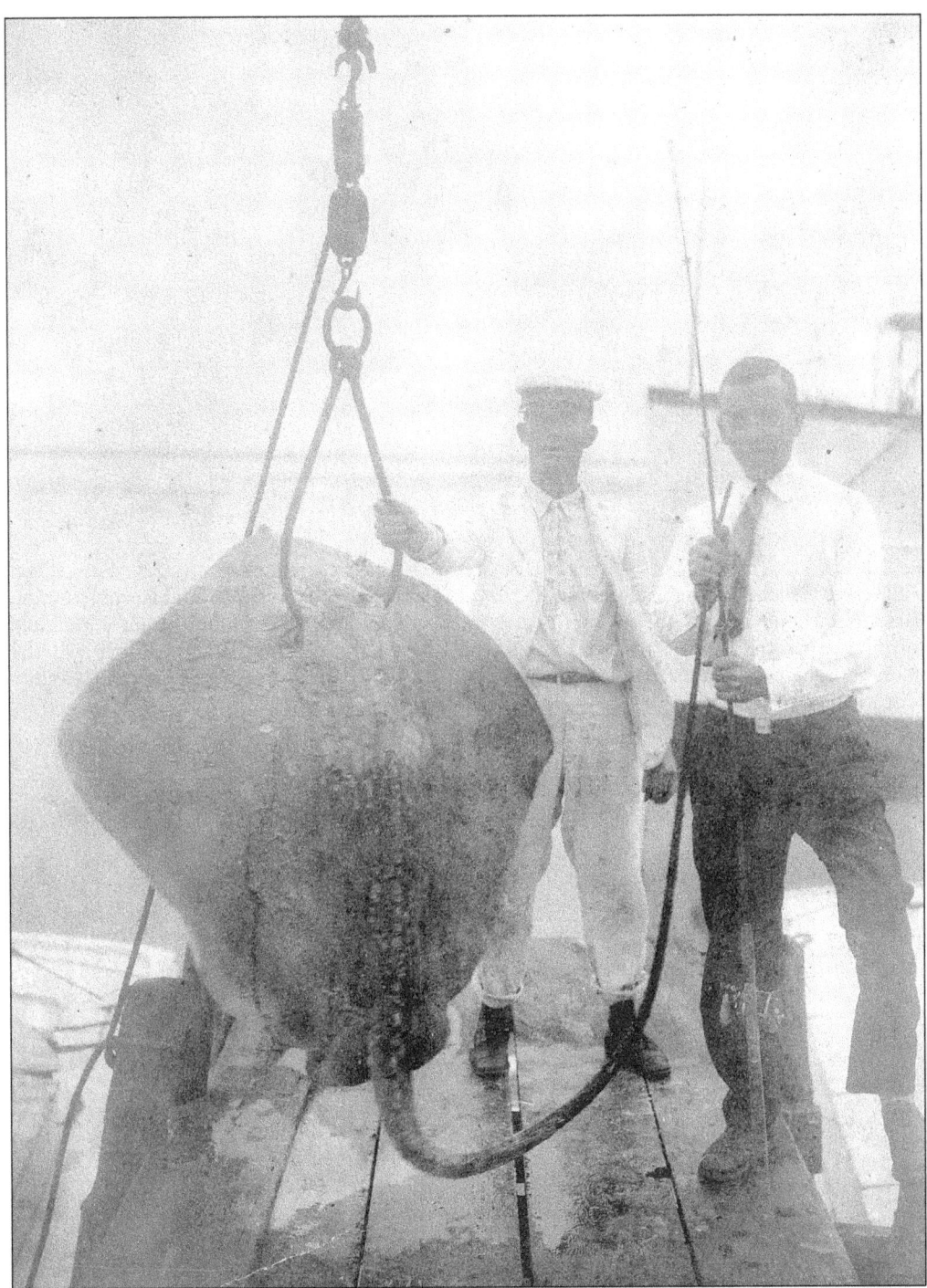

John Motley Morehead II is shown with Captain Gib Willis and their "catch-of-the-day," a giant ray. Captain Gib was Mr. Morehead's captain most of his adult life and was known for his outstanding sailing skills. In the winter months he was a hunting guide for the Morehead family and their guests. (Courtesy Nettie Murrill, private collection.)

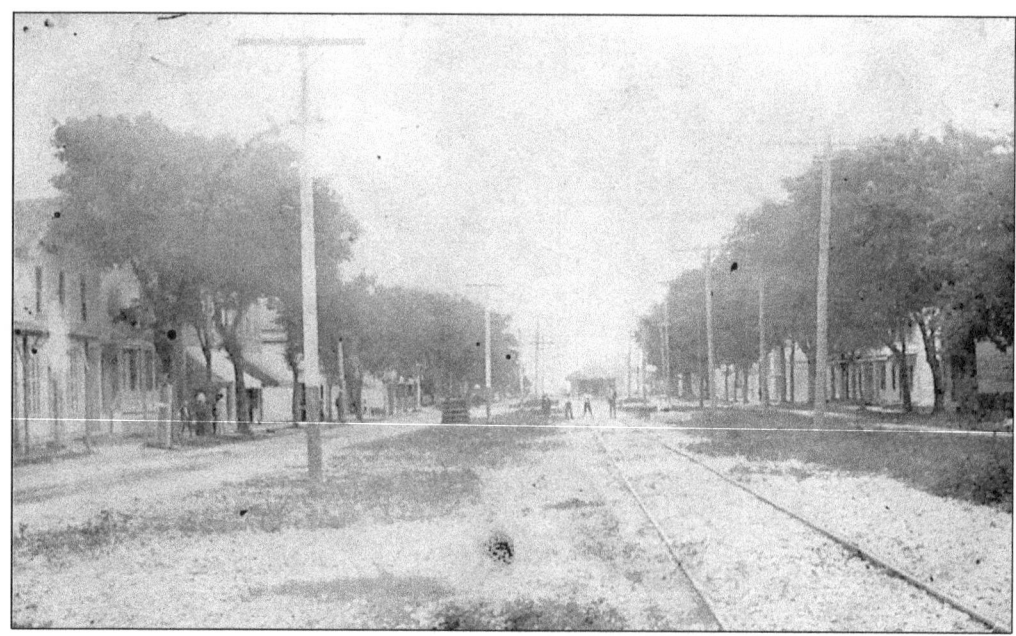

Rail service reached Morehead City in 1858, yet it was after the Civil War and Reconstruction that the citizens realized the prosperity the railroad could bring. Arendell Street is pictured running to the left of the train track. At the turn of the century, Bridges Street was the main thoroughfare until Arendell was paved in the late 1920s. (Courtesy Carteret County Historical Society.)

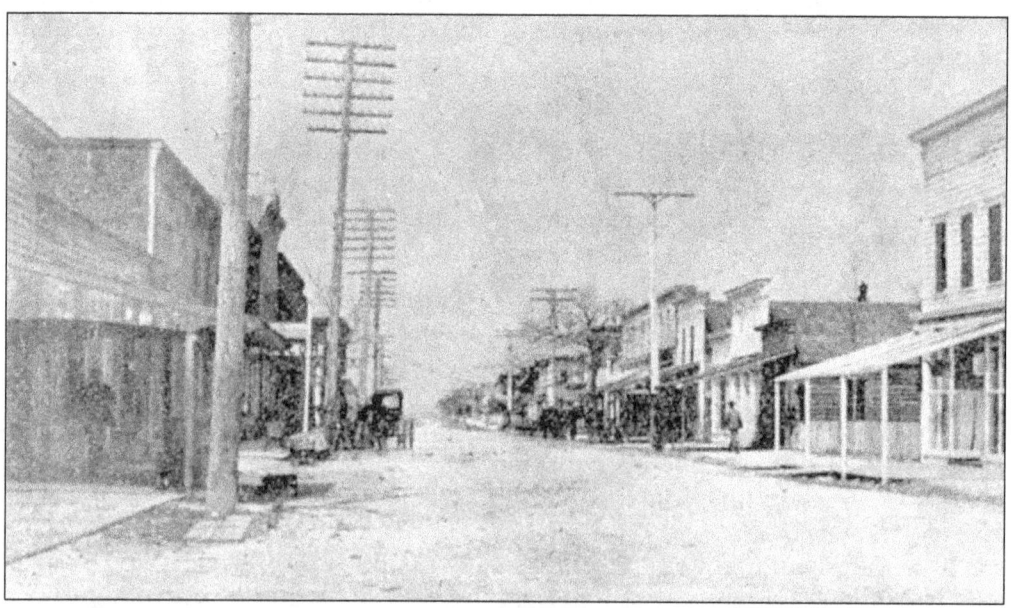

In 1906 Beaufort had been settled for almost 200 years. The town was well populated and the streets were lined with shops and homes. Shipping brought prosperity and a certain elegance. When this photo was made, the houses were already 100 years old. (Courtesy Carteret County Historical Society.)

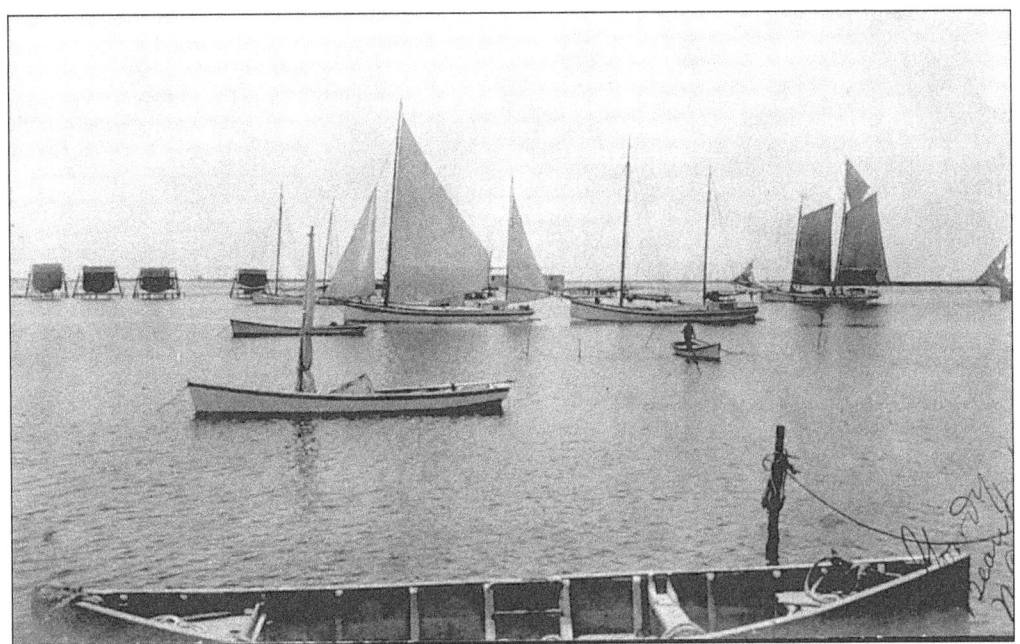

This is a view of a tranquil Beaufort harbor on Taylor's Creek around 1910. Sharpie schooners and spritsails are at anchor awaiting the work of a new day. Fishing nets have been rolled on reels for drying and can be seen in the left background. (Courtesy Carteret County Historical Society.)

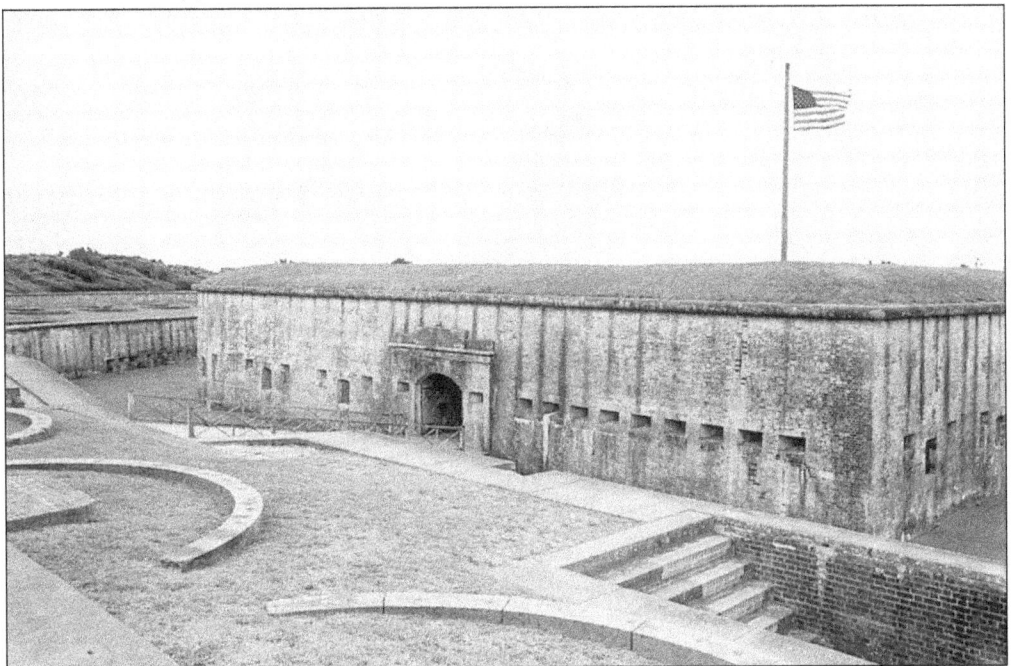

Fort Macon was built in 1834 to defend the Beaufort Inlet from attack from Spanish pirates and is considered a monument to masonry craftsman. It saw little action until the Civil War. After 1865, no one could have imagined that the fort would shortly be in use again during both World Wars. (Photo by Frances Eubanks.)

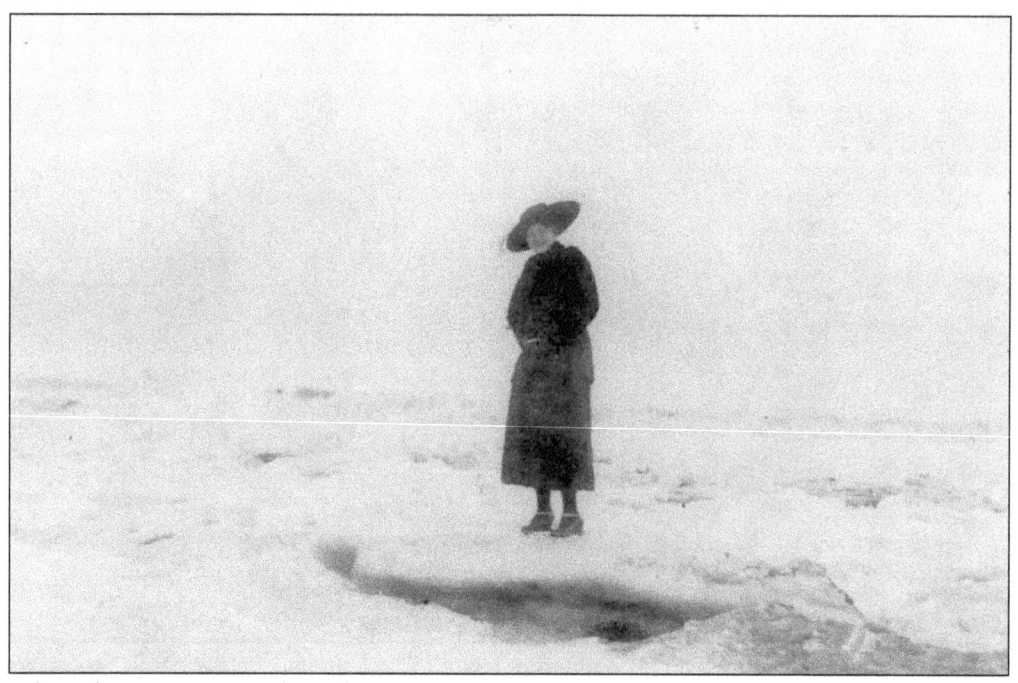

When the temperature plunged in December of 1917, no one could imagine that it would stay below freezing for 17 days in a row. The sound froze solid and many residents reported walking across it to find supplies. Frances Sibert was photographed on January 6, 1918, standing on the frozen surf of the Atlantic Ocean. (Courtesy North Carolina Department of Archives and History.)

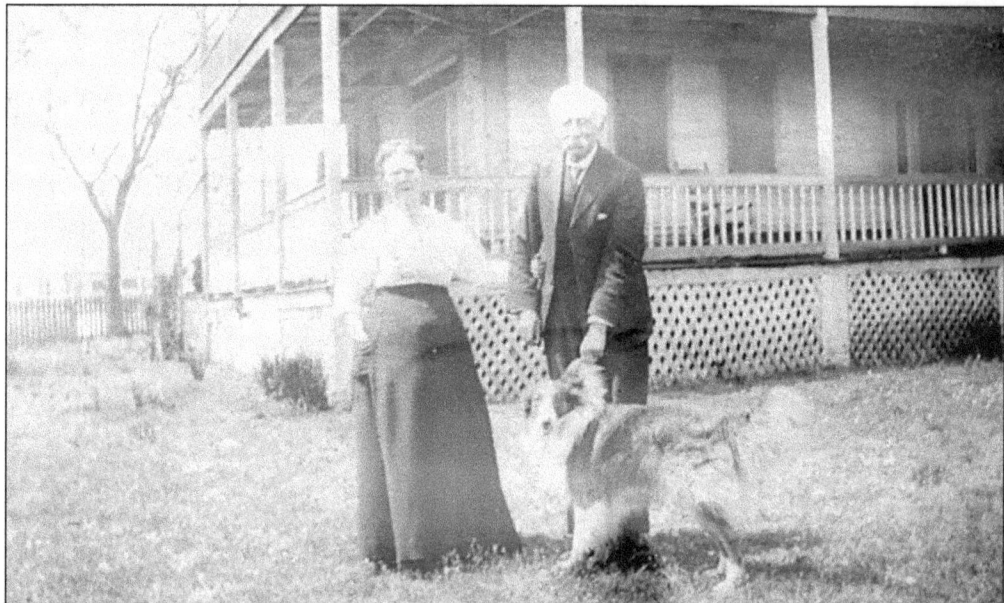

Arendell family land was acquired as part of the original parcel that became Morehead City. Pictured c. 1900 are descendants Mr. and Mrs. William Arendell in front of their house on Bridges Street. He served on the board of commissioners and in the state legislature. (Courtesy Carteret County Historical Society.)

Two

BEAUFORT

Beaufort is the third oldest city in North Carolina and the county seat for Carteret County. Its earliest history is dominated by the sea—ships, trade, seafaring, adventure, and prosperity. It was incorporated in 1722 and its name was changed from Fish Towne to Beaufort in honor of the Earl of Beaufort, one of the Lords Proprietors. Early on, Beaufort was a substantial port engaged in trade for the colony. Exports to England included tobacco, grains, salted meat and fish, lumber, tar, pitch, rosin, and turpentine.

Beaufort had a hey day up until the Civil War, when its access to the sea was blockaded. After the war and Reconstruction, Beaufort experienced revitalization when menhaden were discovered in vast quantities and large fleets of menhaden vessels, fish houses, and fish-packing companies were established.

The fishing industry is a vital part of Beaufort's present, yet it combines with businesses catering to sports fishermen and the preservation of its vast history that draws vacationers and history buffs to explore its streets.

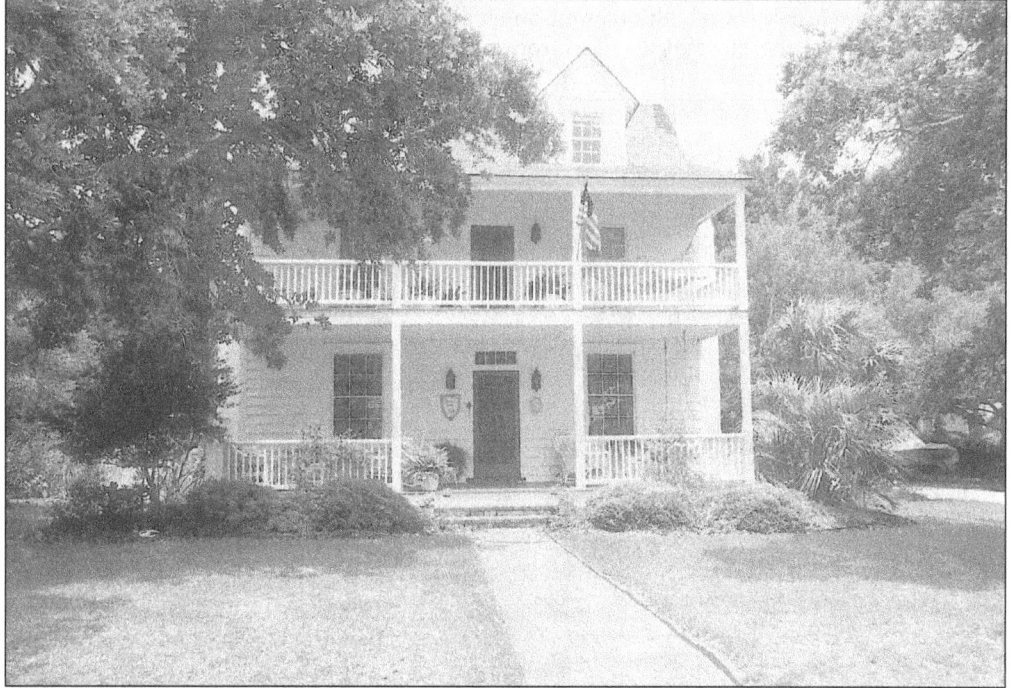

The Hammock House is the oldest house in Beaufort and is said to have been constructed approximately between 1700 and 1709. Built on a hill known as a "hummock," it is thought to have served as a guide to sailors entering the harbor as it is shown on early maps. (Photo by Frances Eubanks.)

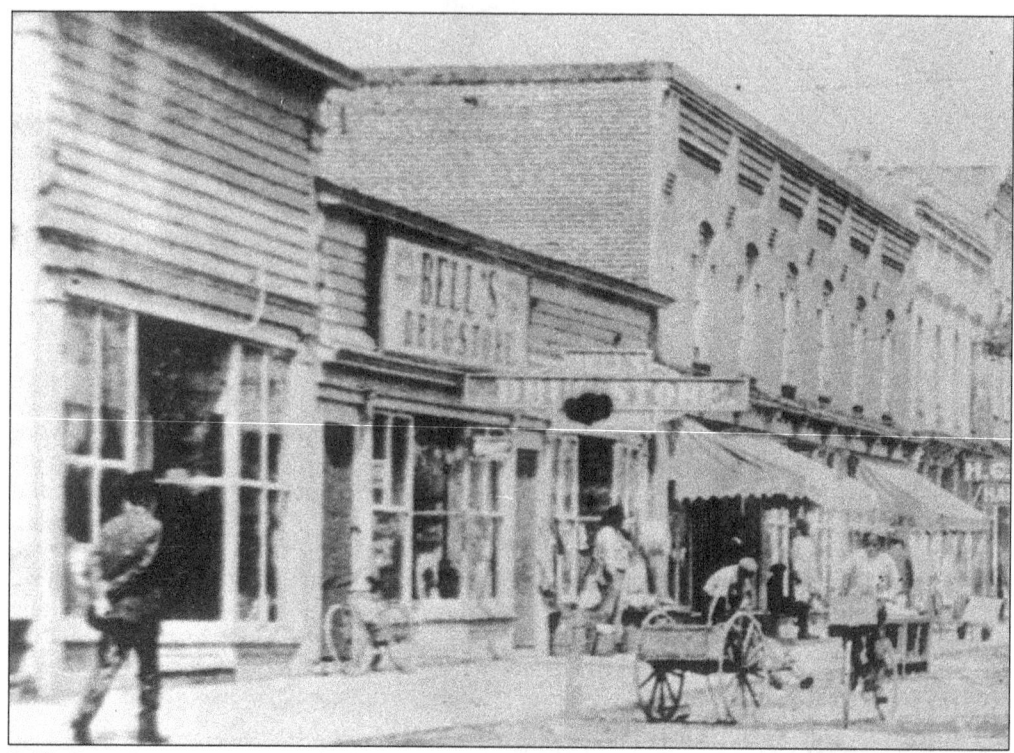

Bell's Drug Store in 1921 was built on Front Street and served the turn-of-the-century residents of Beaufort. Notice the bicycle parked in front of the store for deliveries. (Courtesy Carteret County Historical Society.)

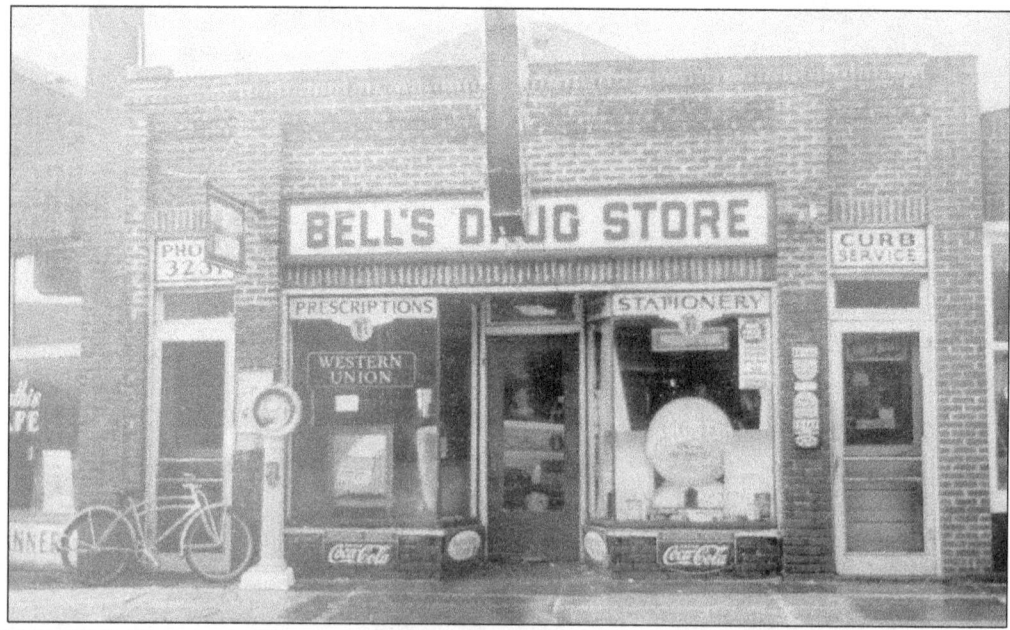

By 1939 Bell's Drug Store was serving another generation, yet had adapted a "new" look with a brick facade. Again, note the bicycle parked in front of the store for deliveries. (Courtesy Carteret County Historical Society.)

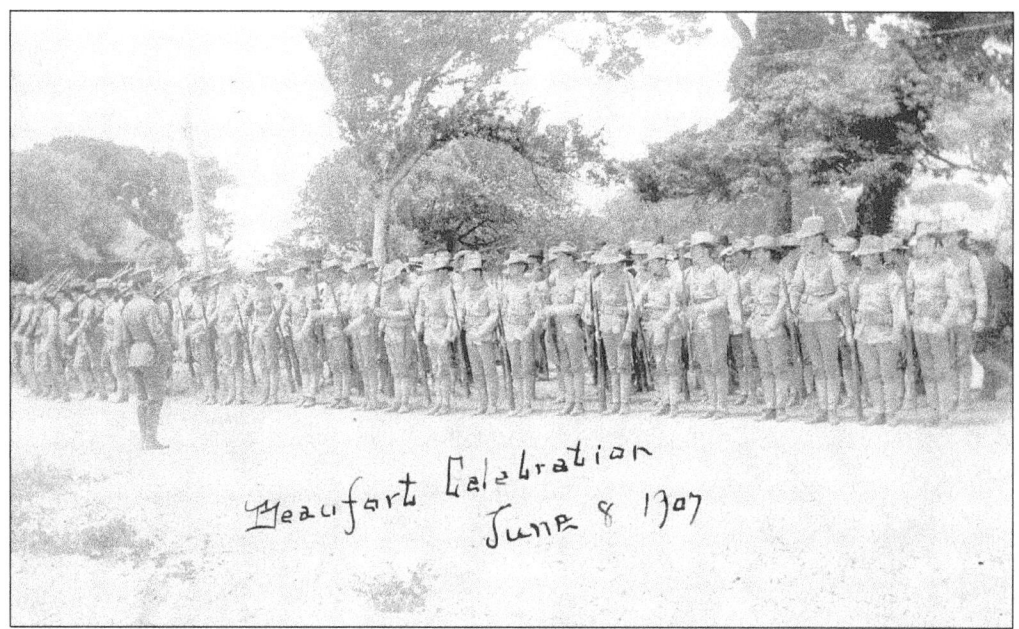

Parades and celebrations were popular in Beaufort. The troops lined up for inspection are part of the celebration of the opening of the railroad bridge that connected Morehead City and Beaufort on June 8, 1907. (Photo by Bayard Wootten, courtesy Billy Piner, private collection.)

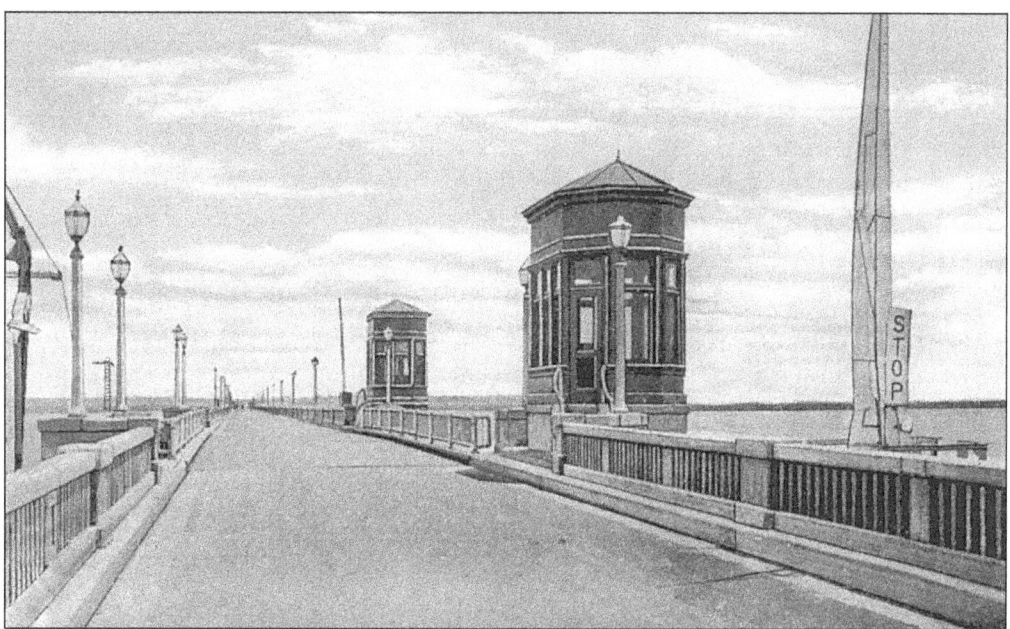

Above is a photo of the Beaufort Bridge looking west. This is the first Morehead City–Beaufort Bridge, which was opened in 1927. It was built as a causeway drawbridge before Radio Island came into existence. Prior to this time the only connection the two towns had was by water or by railroad. The 2-mile railroad bridge had been built in 1906. (Courtesy Carteret County Historical Society.)

In 1930 the Beaufort waterfront was undergoing a transformation. The old piers had been demolished and the beautiful homes of Front Street opened onto a sandy beach which attracted tourists long before the barrier island beaches were practical to visit. (Courtesy Billy Piner, private collection.)

The construction of the 2-mile railroad bridge connecting Morehead City and Beaufort came right down the middle of Ann Street, the main street of Beaufort. In 1938 the street was the most beautiful in town with its lovely old houses. (Courtesy Carteret County Historical Society.)

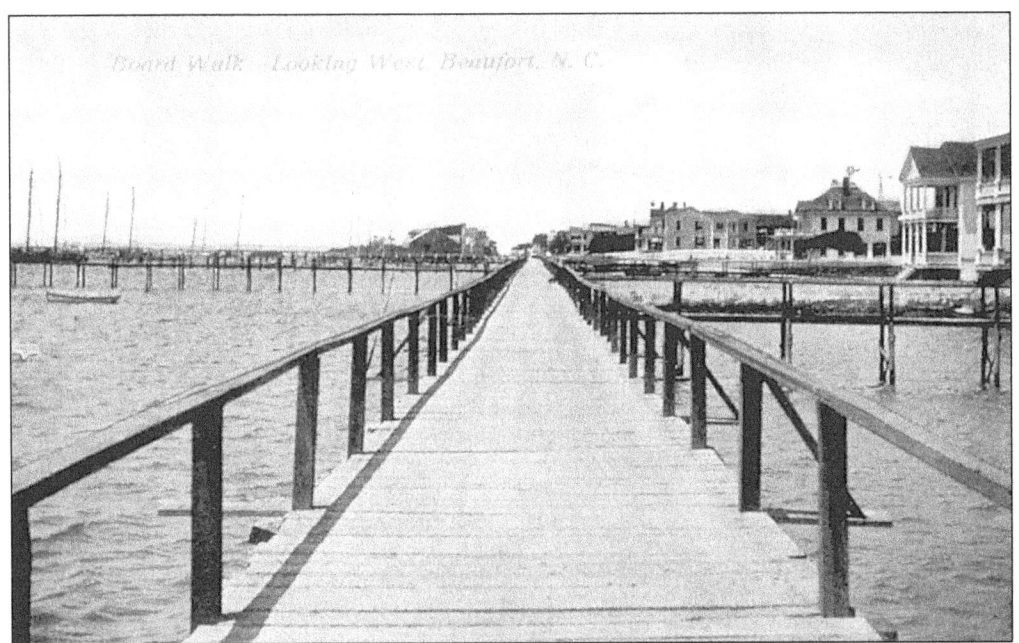

Both tourists and townspeople enjoyed taking strolls along the Beaufort waterfront boardwalk. The beach is gone; however, the boardwalk has continued being a feature of modern-day Beaufort. (Courtesy Billy Piner, private collection.)

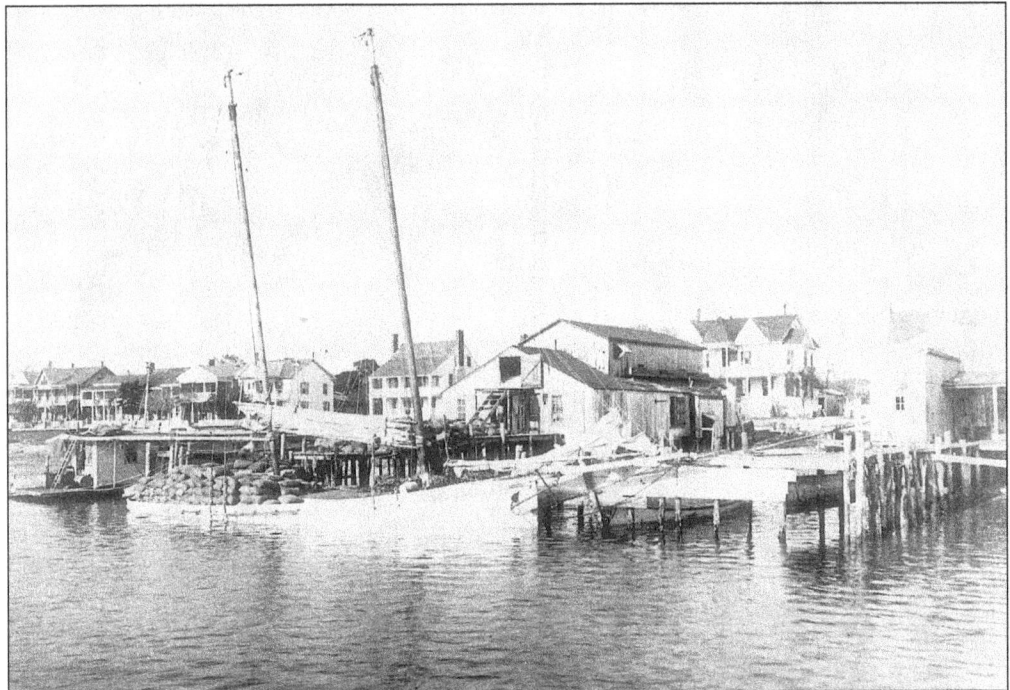

The *Alfonso* sharpie is seen fully loaded at a Beaufort dock waiting to transport the goods. The sharpies were the "workhorses" of the North Carolina coast. This one was built in Williston in 1911. When menhaden became a profitable fish to harvest, many of the sharpies worked as menhaden boats. (Courtesy North Carolina Maritime Museum.)

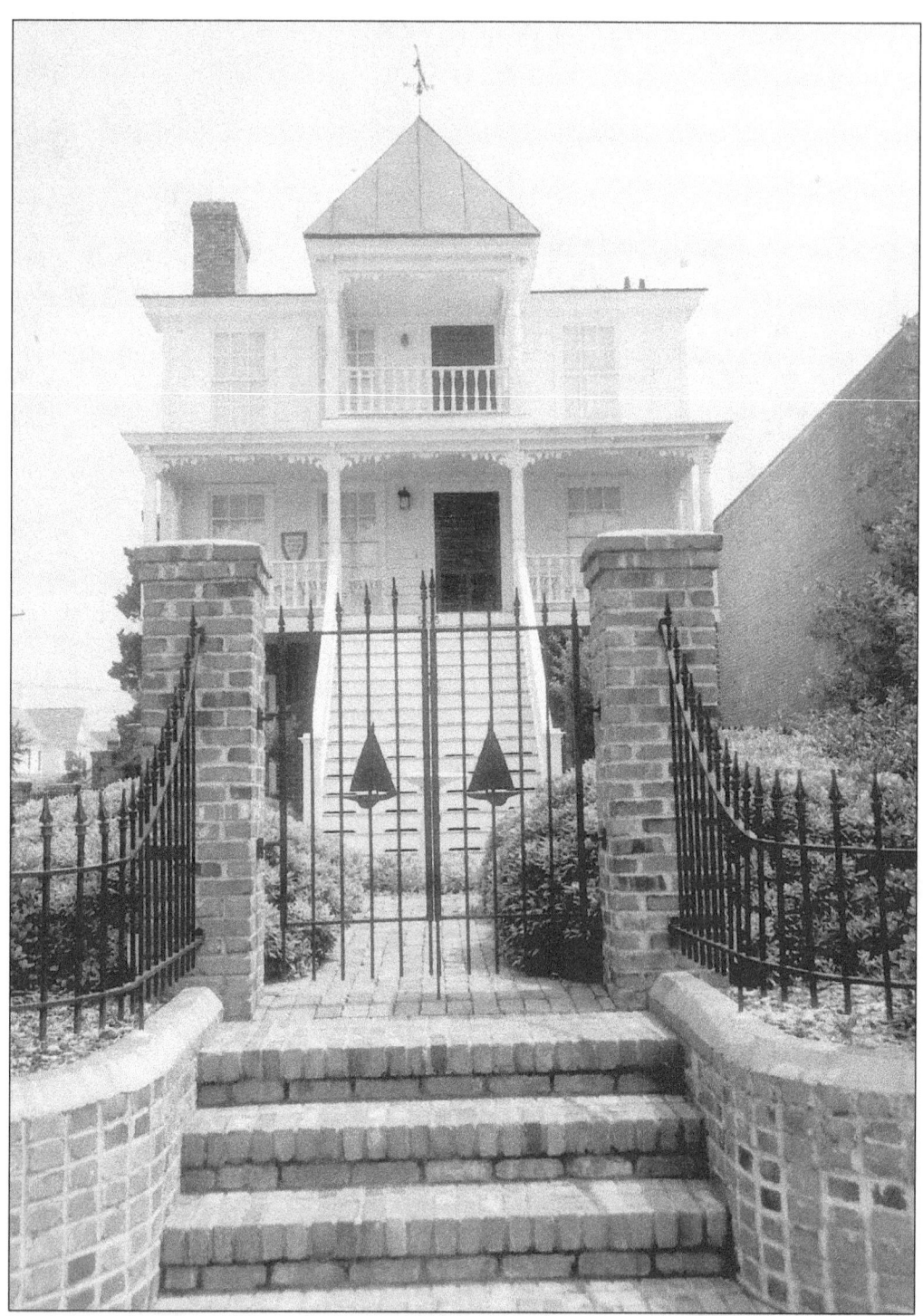

Carteret Academy was built before the Civil War and housed the Beaufort Female Academy, which was mostly attended by girls who lived on the Banks. The three-story structure possesses an 8-foot-high English basement. The elaborate brick and wrought-iron fence was added in recent years. (Photo by Frances Eubanks.)

Originally constructed as the Beaufort Academy in 1877, this unassuming frame structure on Turner Street became the Masonic Lodge after they moved from the building that is now the Odd Fellows Lodge. (Photo by Frances Eubanks.)

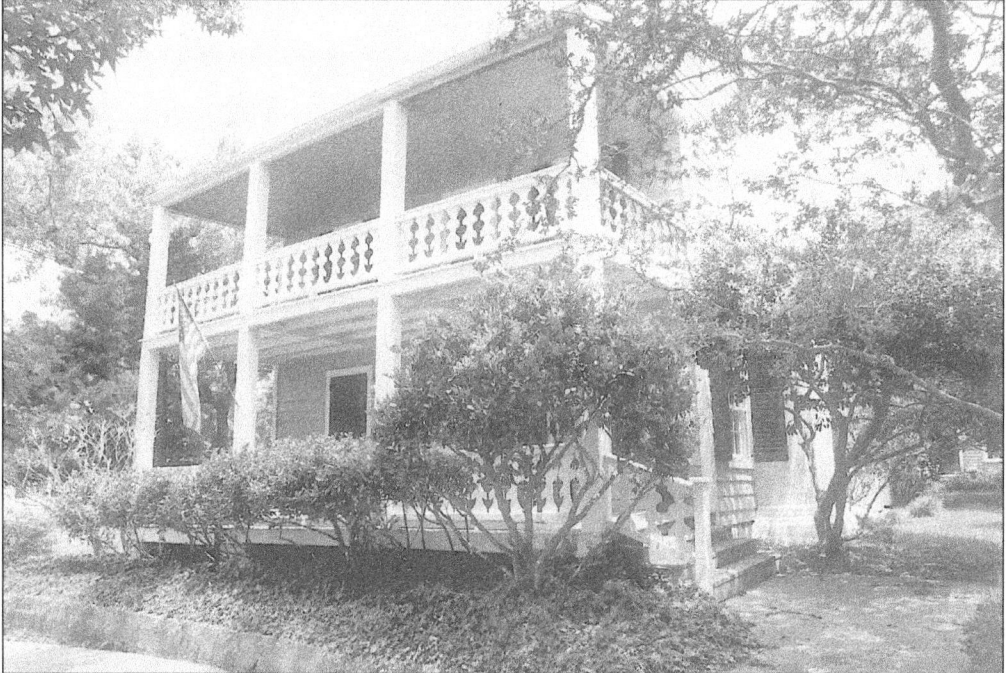

Miss Nannie P. Geoffroy was the principal of the St. Paul's School and was known for her "no-nonsense" approach to education. She made her home and office in the Davis House, pictured above, until her death. (Photo by Frances Eubanks.)

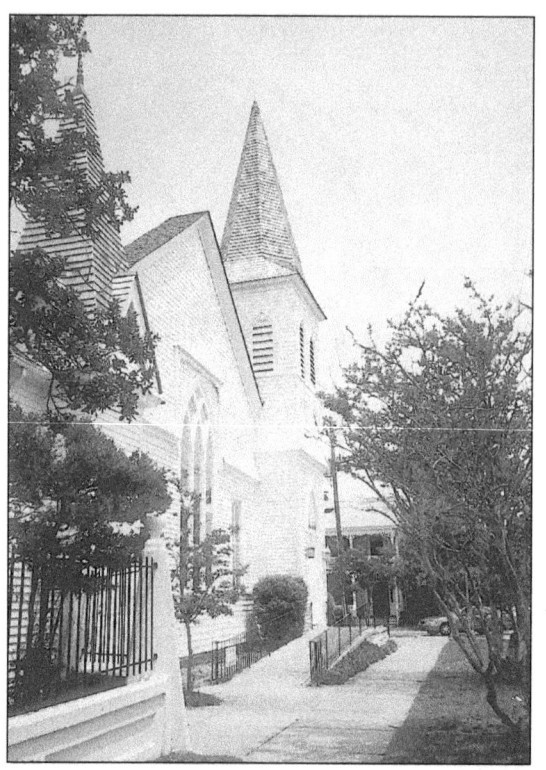

The Ann Street Methodist Church is a beautiful wooden structure built in 1854 to be the "new" home of a congregation that was formed in 1778. The church is painted a dazzling white and has an eye-catching steeple. (Photo by Burke Salsi.)

The Purvis Chapel is the oldest church building in Beaufort and was built as a Methodist church. The African Methodist Episcopal Zion Church purchased the building a number of years ago and still worships there. (Photo by Frances Eubanks)

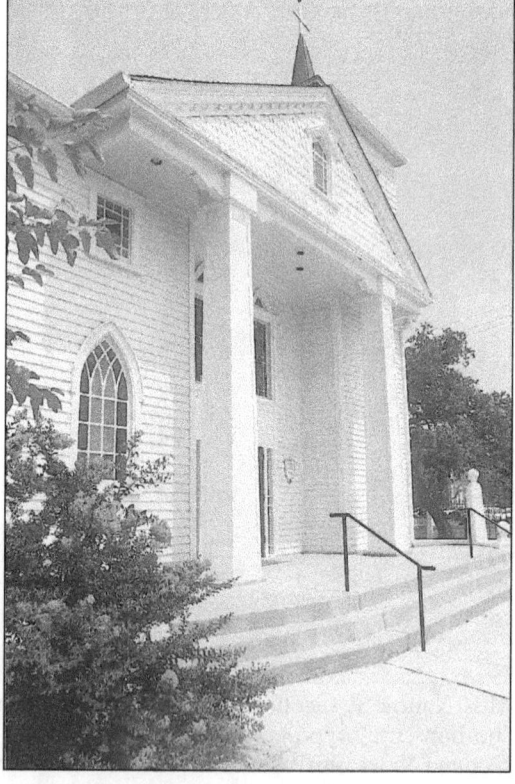

Considered an architecturally perfect structure, St. Paul's Episcopal Church has survived as it was built in the mid-1800s. The sturdy construction is attributed to having been built by shipbuilders. (Photo by Frances Eubanks.)

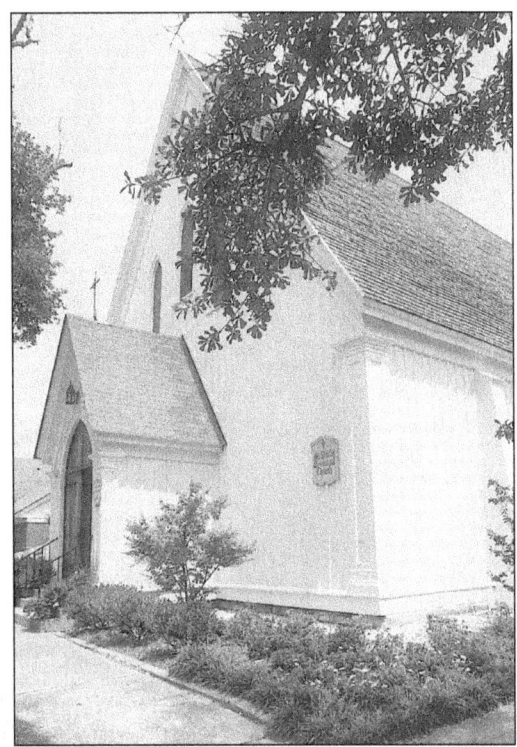

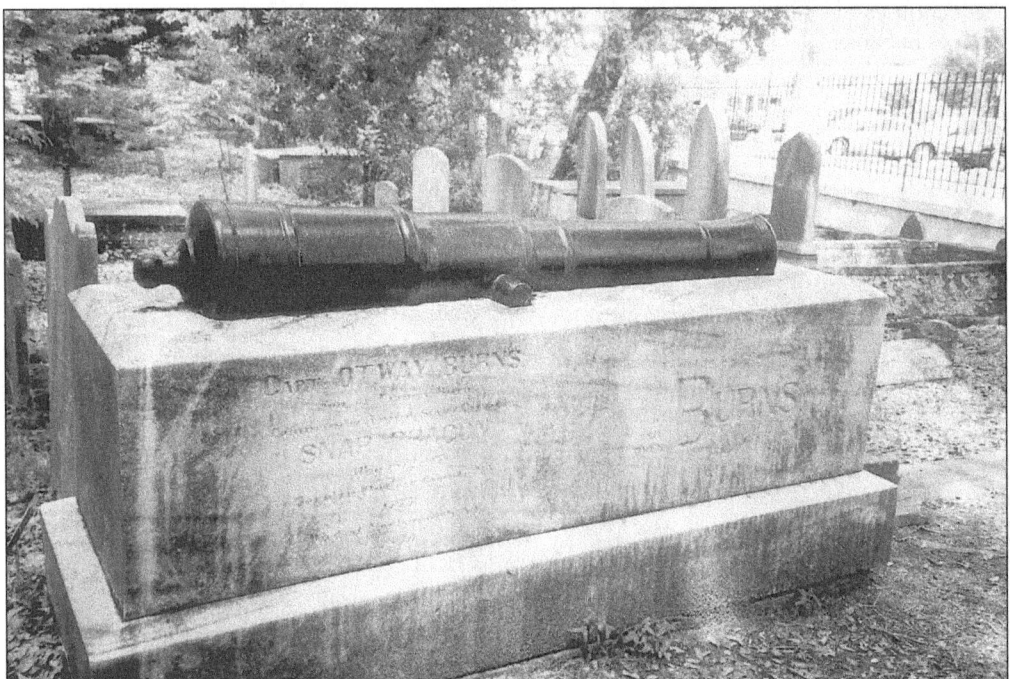

The Old Burying Ground lies between the Ann Street Methodist Church and the Purvis Chapel. Deeded by the town commissioners to the residents in 1731, it is the final resting place of hundreds. Sea captain and privateer Otway Burns's grave is marked by a cannon from his ship, *The Snap Dragon*. (Photo by Burke Salsi.)

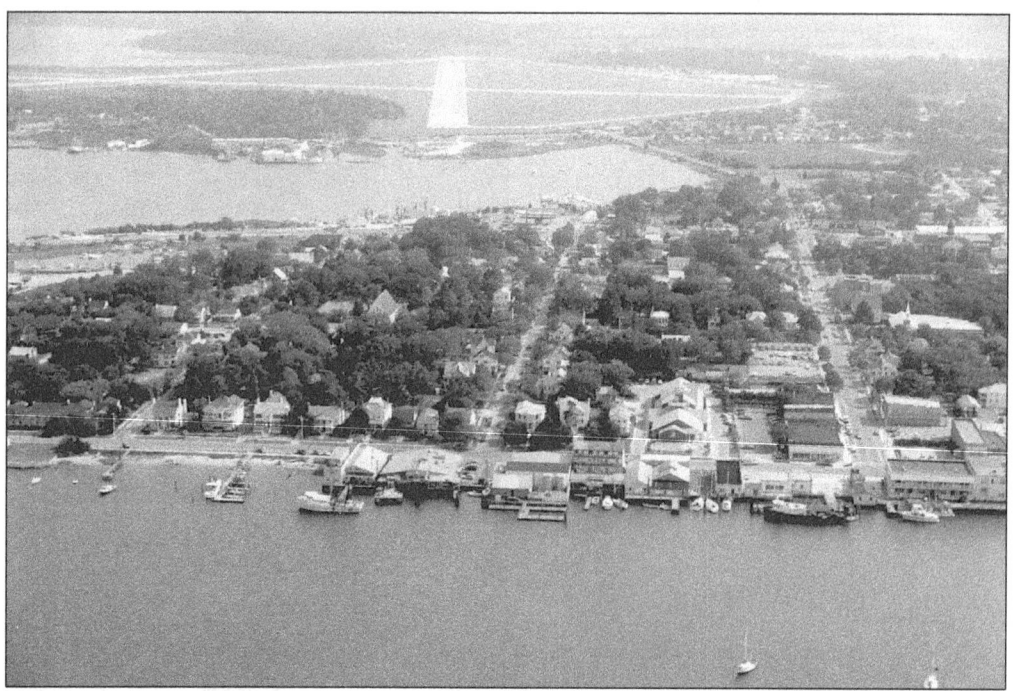

This view shows Beaufort and its natural harbor from the air. Visitors from all over the world come to soak in the charm of the past. The train no longer runs down Ann Street, yet the centuries-old houses and churches are a permanent part of the landscape. (Photo by Frances Eubanks.)

The Duncan House is thought to be the most beautiful of the old Beaufort houses. In the early 1800s, the house also served as a ship's store as well as a residence. It is the last structure on the west end of Front Street. (Photo by Frances Eubanks.)

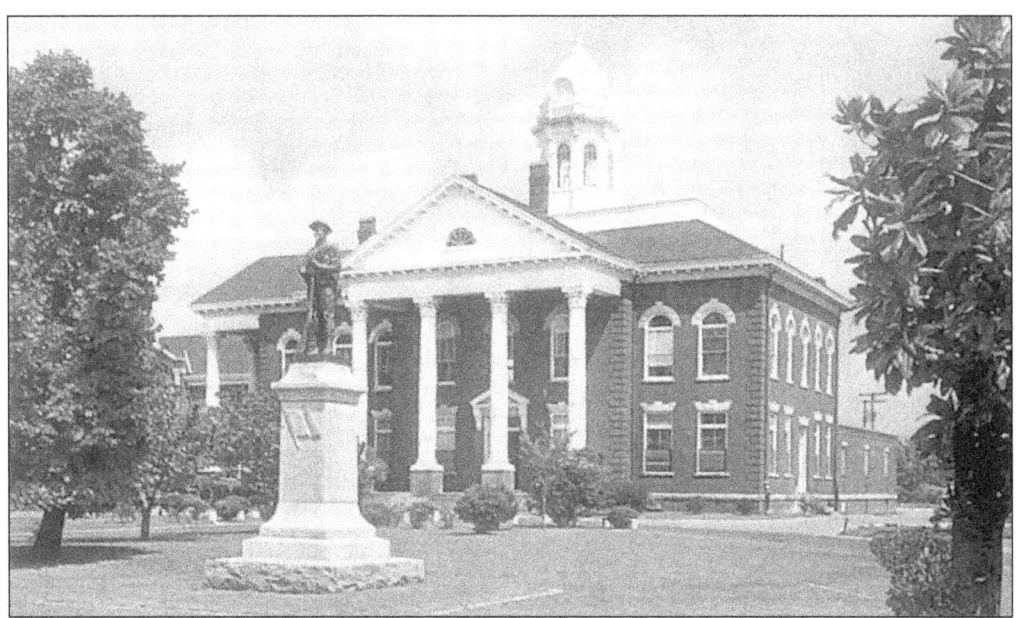

The Carteret County Court House, located in Beaufort, was built in 1907 and was the fourth courthouse built to serve the citizens. The Confederate monument in the foreground was erected by the Daughters of the Confederacy. (Courtesy Billy Piner, private collection.)

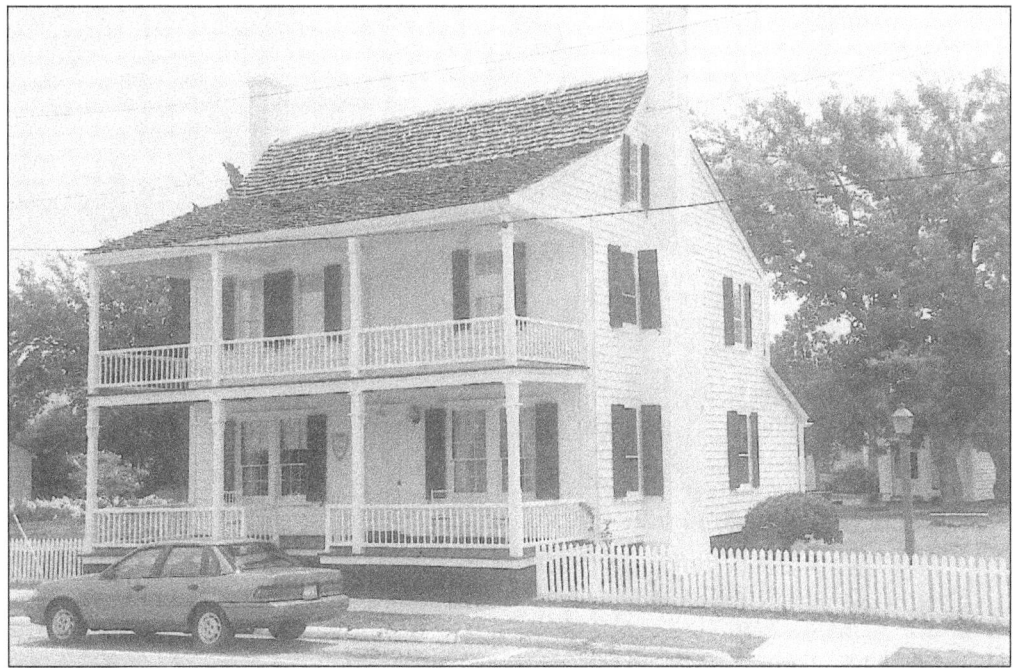

The elegant Josiah Bell House, built c. 1825, is now part of the Beaufort Historical Association Restoration Grounds. It is part of regular historical tours. The association sponsors costumed reenactments and various celebrations on the grounds next to the house throughout the year. (Photo by Frances Eubanks.)

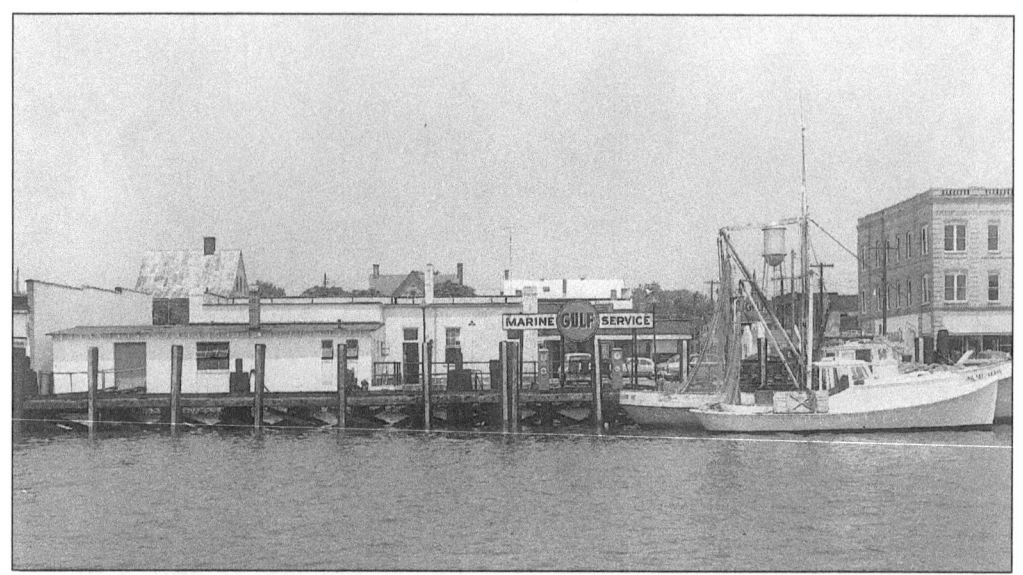

This view, c. 1950, captures Front Street from the water looking at workboats tied up at a fuel dock. The two chimneys in the background are the location of the present-day Maritime Museum. The old water tower can be seen in the background. (Courtesy Carteret County Historical Society; photograph by Jerry Schumacher.)

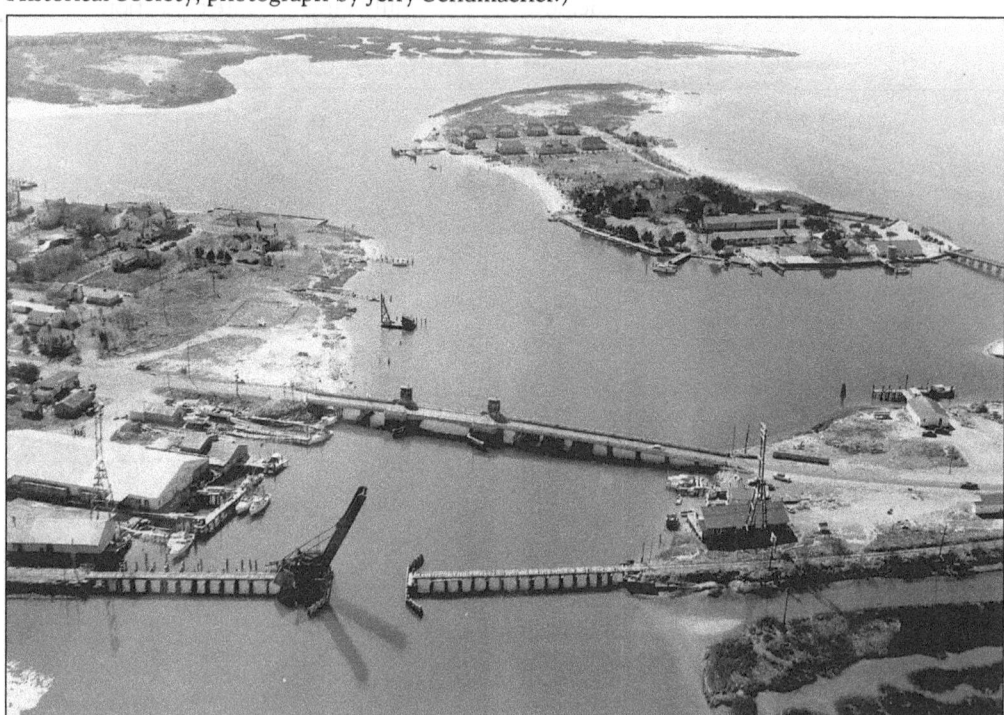

This aerial photograph shows the drawbridge connecting Morehead City and Beaufort. When the railroad bridge was first constructed in 1907, it spanned Gallant's Channel for a 2-mile link to connect Beaufort's tourist trade and seafood transporting. Piver's Island was built up from dredging the channel and can be seen in the background. (Courtesy Carteret County Historical Society; photograph by Jerry Schumacher.)

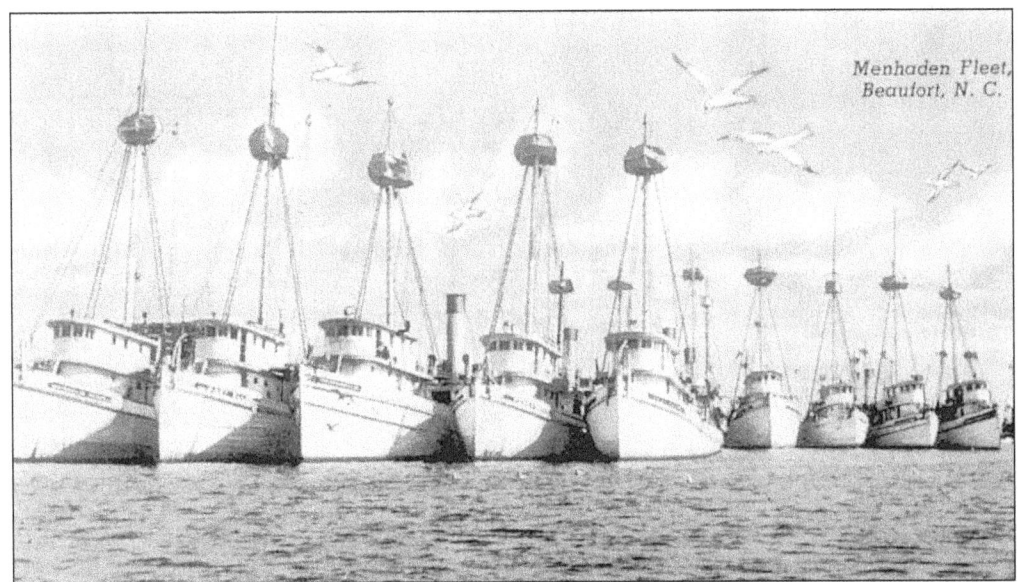

Pictured is a menhaden fleet from the 1920s at anchor in Beaufort. These sturdy vessels brought in tons of oil-bearing fish used in making fish meal and fertilizers. A crew member was stationed in the crow's nest for fish spotting. Modern-day menhaden vessels no longer rely on the human eye. They now use electronics and airplanes for locating fish. (Courtesy Billy Piner, private collection.)

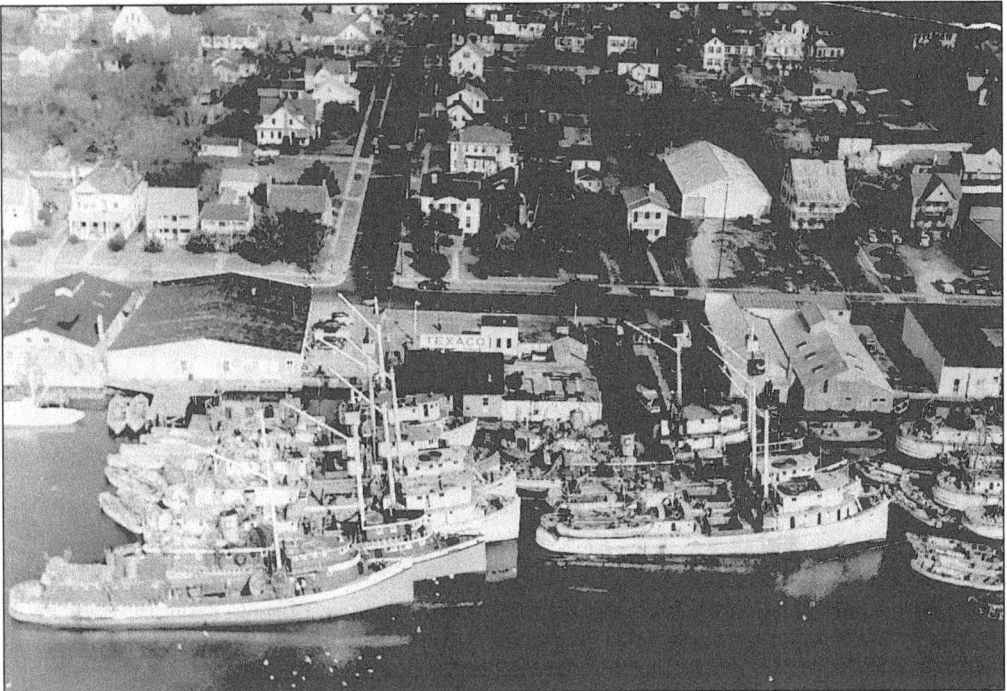

Menhaden boats, c. 1960, are shown on the Beaufort waterfront. Menhaden fishing created an industry in Carteret County. Since the turn of the century, tons of fish have created employment for local residents. (Courtesy Carteret County Historical Society; photograph by Roy Eubanks.)

Fish houses, once dotting the traditional landscape throughout Carteret County, were small structures constructed on docks to facilitate the handling of fish in the days before ice was readily available. This is one of the rare "houses" still standing. (Photo by Frances Eubanks.)

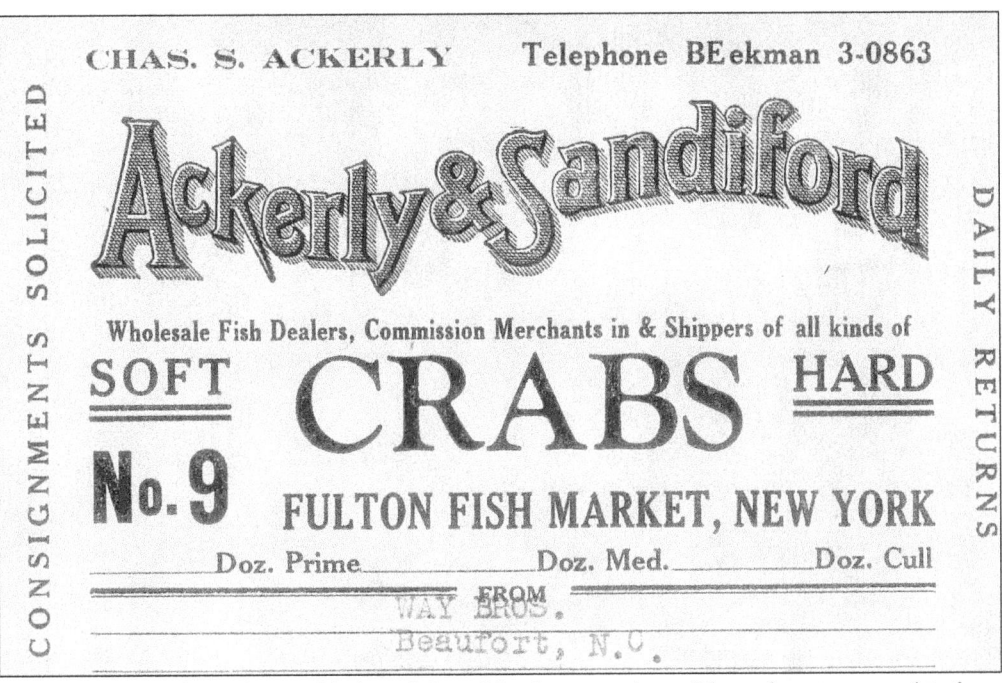

Way Brothers Fish Packers sold their fish to Northern markets. This advertising card is from Ackerly and Sandiford at the Fulton Fish Market in New York City. (Courtesy Billy Piner, private collection.)

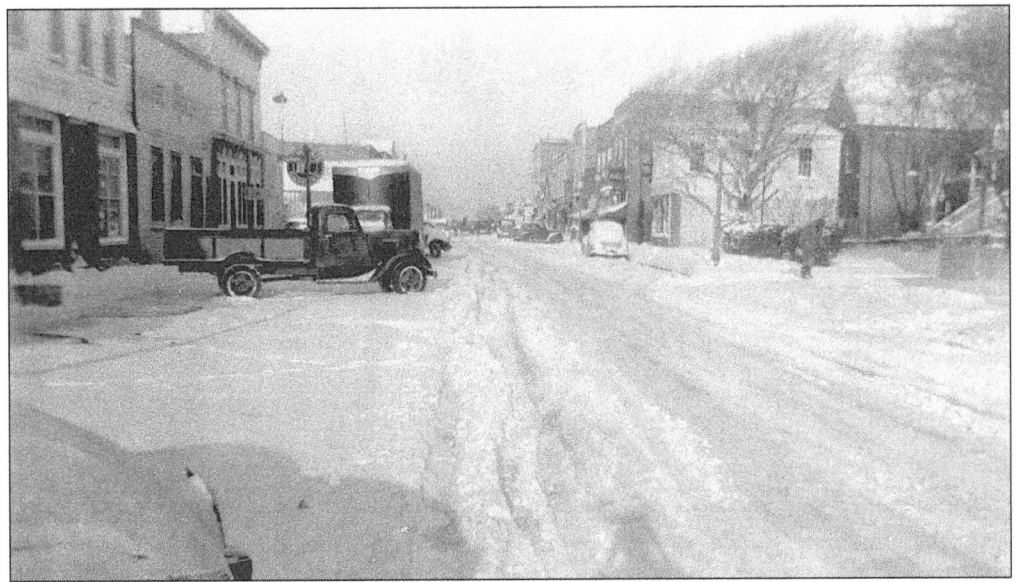

This photo shows Front Street taken from Way's Fish House after one of the rare times Beaufort has seen ice and snow. (Courtesy Carteret County Historical Society.)

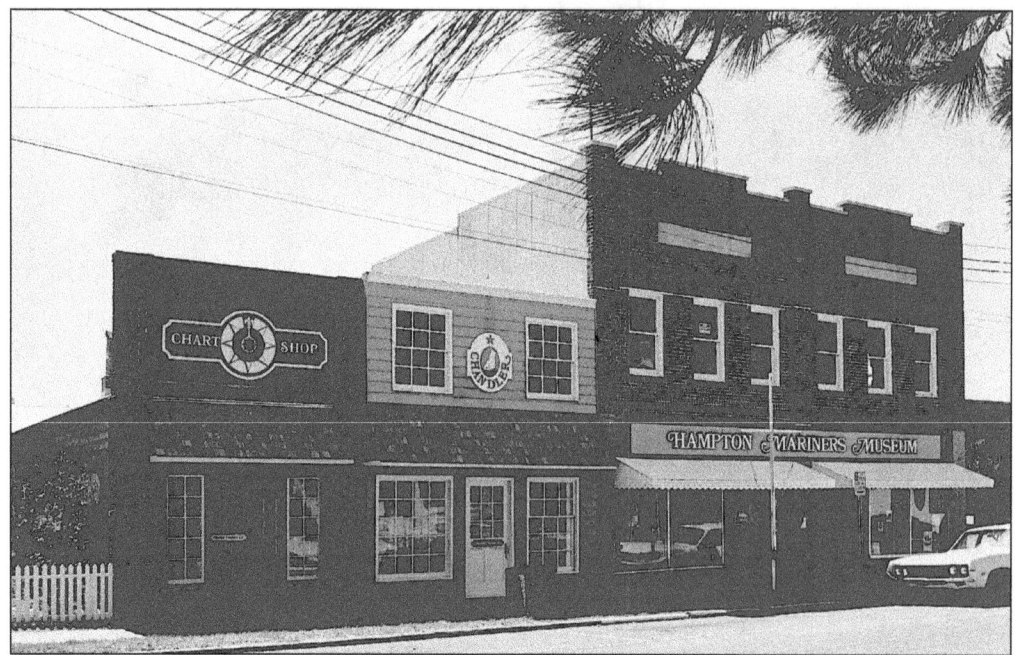

The Hampton Mariner's Museum was begun to interpret the North Carolina maritime history. It promoted heritage programs, housed artifacts, and offered nature programs. The museum moved to larger quarters on Front Street and is now known as the North Carolina Maritime Museum. (Photo by Frances Eubanks.)

North Carolina Maritime Museum houses an impressive collection of maritime artifacts including those thought to have come from Blackbeard's ship, the *Queen Anne's Revenge*. The museum works to preserve watercraft and has continued to teach classes in traditional North Carolina boatbuilding. Nature walks, lectures, and special exhibits complement the museum's artifact displays. (Photo by Frances Eubanks.)

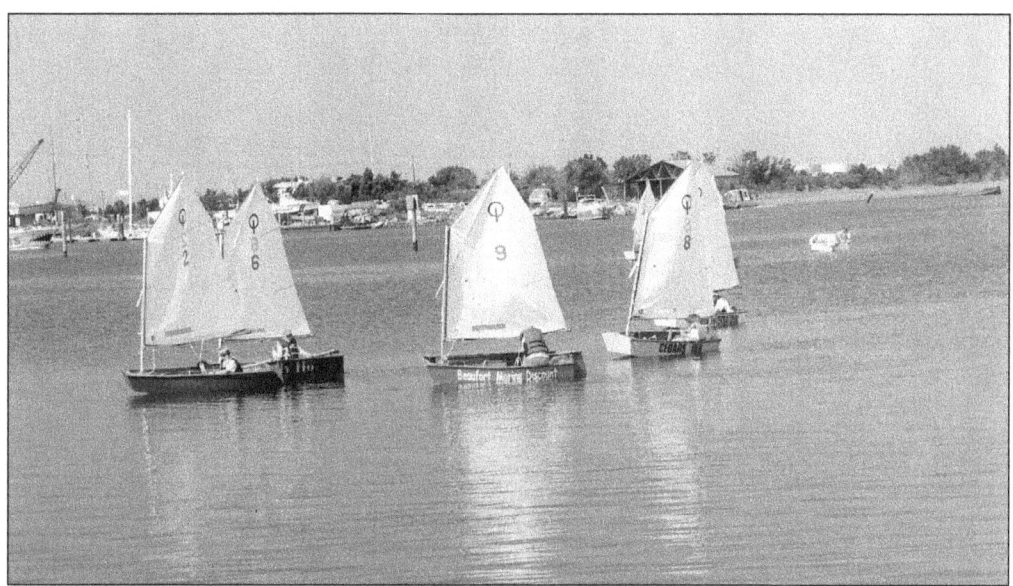

Junior Sailing is only one of the maritime-oriented classes offered at the North Carolina Maritime Museum. Each summer young students learn to sail *Optimist Class* boats that have been constructed by museum volunteers. Science classes for children are also offered. (Photo by Frances Eubanks.)

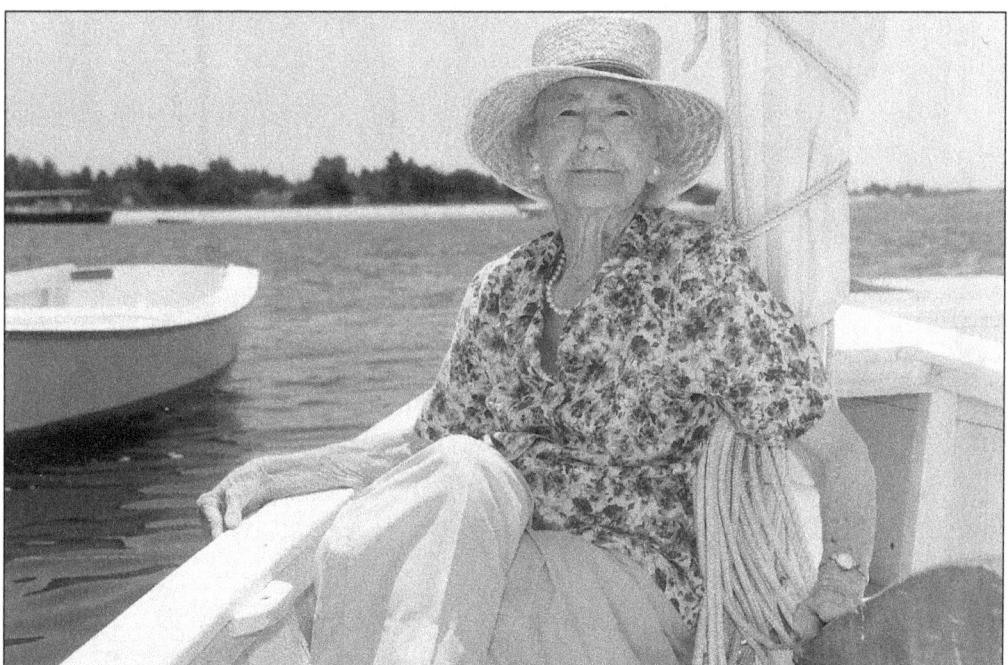

Nettie Murrill shares memories of her father's spritsail boat. The spritsail in which she is sitting is owned by the North Carolina Maritime Museum. It was constructed by her cousin, Julian Guthrie, also the builder of her father's famous spritsail the *Alma*. Nettie celebrated her 88th birthday on June 6, 1999. She is a well-known local historian as well as an accomplished artist. (Photo by Frances Eubanks.)

Carrot Island is located on the other side of the cut known as Taylor's Creek within sight of the Beaufort waterfront. Carrot Island is home to a small herd of the area's well-known wild ponies related to ancient Spanish mustangs. (Photo by Frances Eubanks.)

The modern Beaufort docks, as seen in 1985, are lined with ocean-going yachts, small sailboats, and other pleasure craft. The docks attract weekend visitors for long strolls after dining in one of the restaurants that line the waterfront. (Photo by Frances Eubanks.)

Three

MOREHEAD CITY AND WEST

One hundred fifty-seven years after Beaufort was colonized, Morehead City came into existence as a planned city. John Motley Morehead, former governor of North Carolina, first arrived to the area, originally known as Shepard Point, to study the possibility of building a deep harbor port that would be more accommodating than the port in Beaufort.

Morehead became a partner in a company that purchased land from the Arendells. In November 1857, 60 lots were sold. When the train arrived in 1858, the future of the town was guaranteed. The port was built in 1861, and the city's growth seemed to be assured—except the Civil War began. The occupation by Federal troops stopped everything, and the momentum did not recover for ten years.

In 1880 the Atlantic Hotel was built and Morehead City began attracting tourists in a continuous stream that let up only briefly during World Wars I and II. A succession of politicians and wealthy businessmen made the hotel their summer home.

As the tourist and shipping trades were growing, menhaden was discovered to be plentiful and helped the commercial fishing industry enter the twentieth century. As the twenty-first century dawns, Morehead City is in the clutches of fantastic development. Real estate prices are soaring and tourism has by far outdistanced other industries.

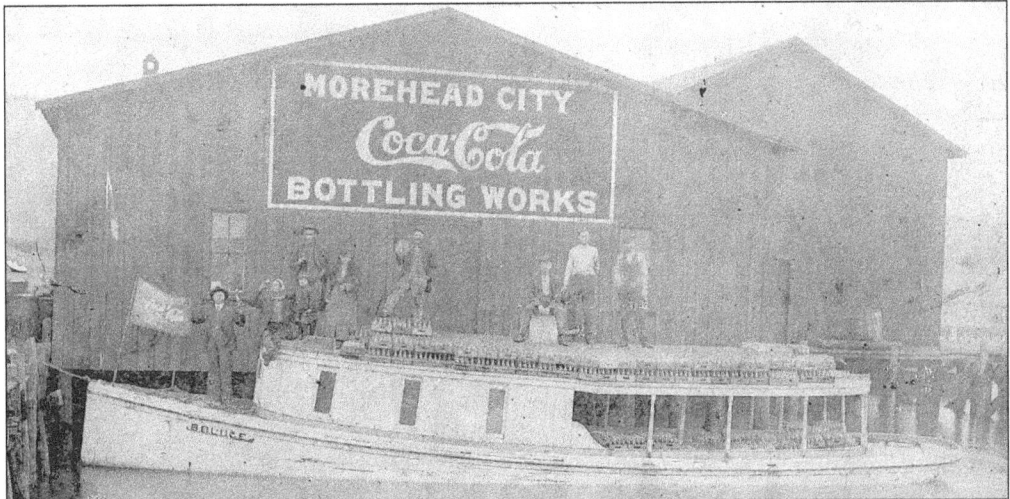

The Coca-Cola Bottling Plant was built in 1919 on the waterfront near the city dock by Durwood Willis and Charles Seifert. This 1920 photograph shows the delivery boat *B.D. Luce* at the dock. Judging from the boat's waterline, it is fully loaded with cases of "Coke." Boats were the only means of delivery for the small Down East communities and Portsmouth Village. (Courtesy Carteret County Historical Society.)

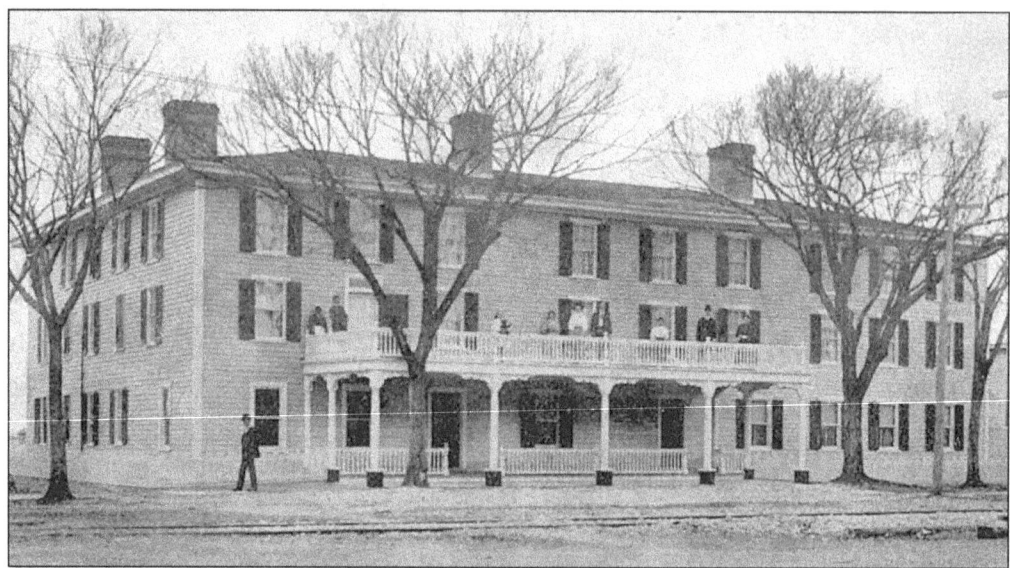

The Hotel Charles was built in 1860 on the corner of Ninth and Arendell Streets and started out as the Macon House. It was also known as the Hibbard House and the New Bern House. The hotel was used as a Federal hospital and quarters for Generals Grant, Butler, and Sherman during the Civil War. Charles Wallace bought the property in 1907 and renamed it the Hotel Charles, which stayed in operation as a hotel until 1935. (Courtesy Carteret County Historical Society.)

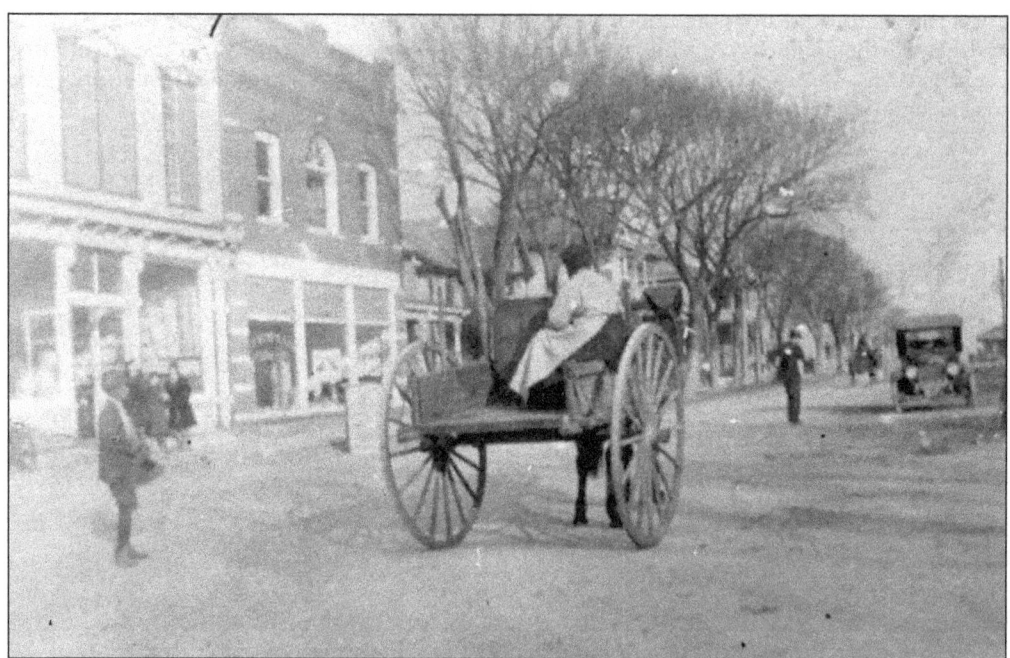

At the turn of the century, the dray cart was used to transport heavy luggage to and from the train. Visitors often stayed the entire summer, and the horse-drawn cart was needed for the many trunks of clothing that the ladies would need to transport their ball gowns, floor-length day dresses, and tea attire for months of respite. (Courtesy Carteret County Historical Society.)

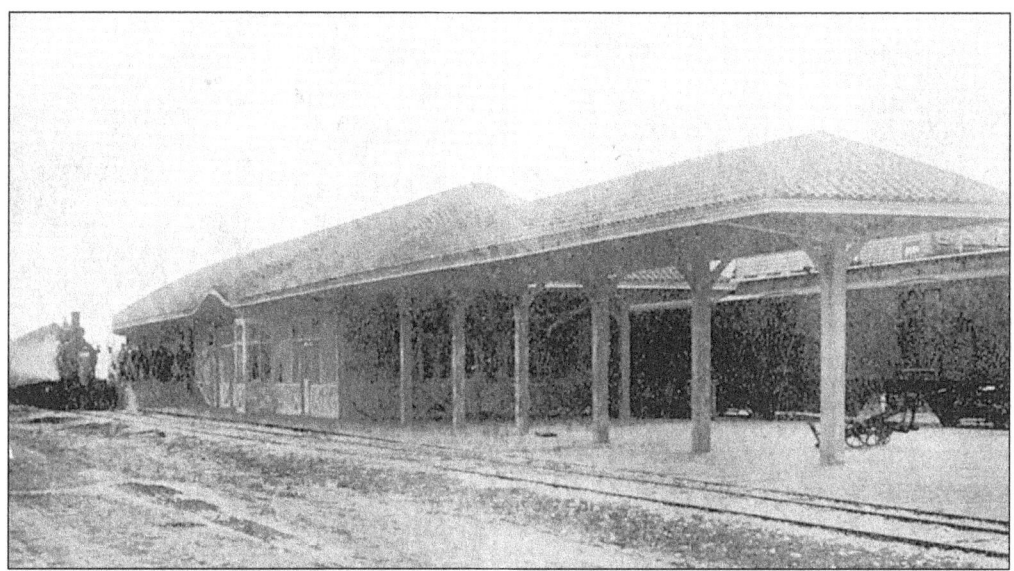

The railroad brought modern times to Morehead City. It became the artery connecting Carteret County to the rest of the state. The railroad brought settlement, industry, tourists, and mail. Train number 5 of the Atlantic and North Carolina Line is shown unloading mail and passengers in 1937. (Courtesy North Carolina Department of Archives and History.)

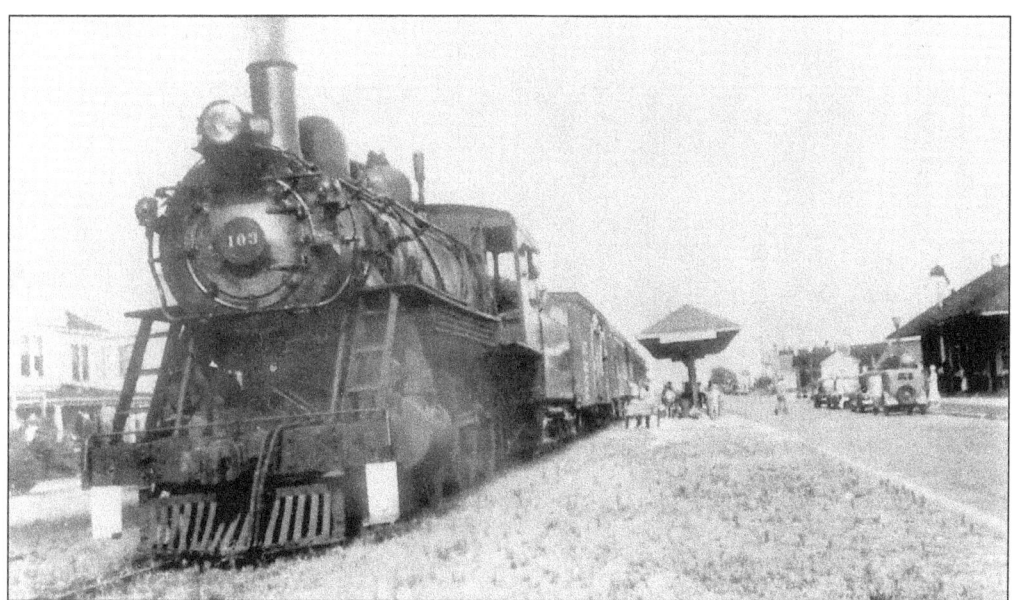

The railroad was everything to the development of Morehead City. The tracks ran right beside Arendell Street and later bisected the street when it became four lanes. The Atlantic and North Carolina seen above was referred to as "the Mullet Line" due to the large quantities of fish that were shipped by rail. (North Carolina Department of Archives and History.)

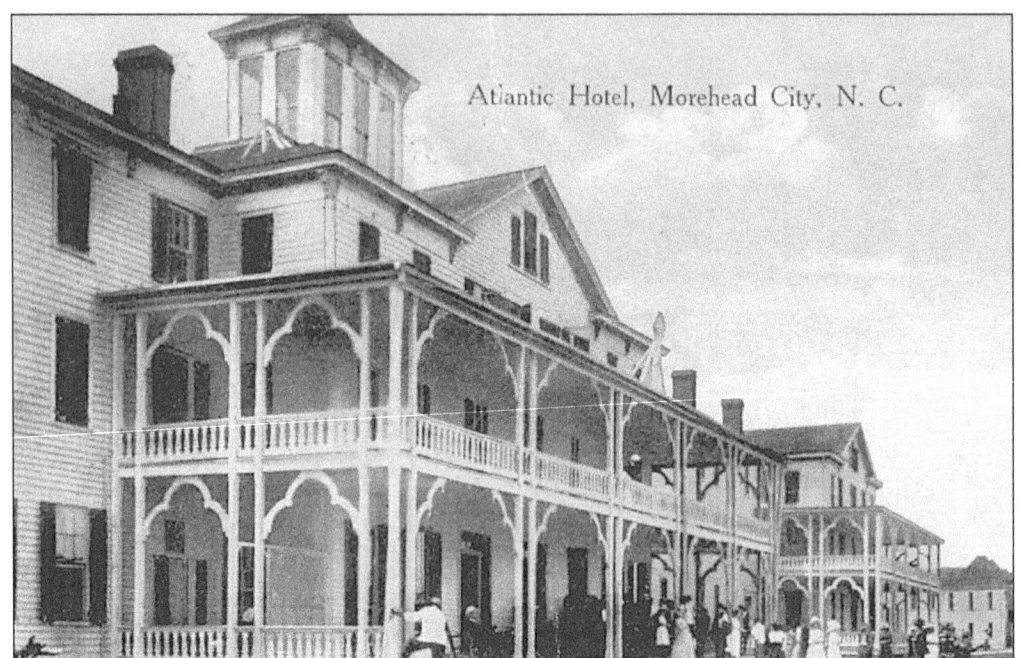

The Atlantic Hotel was called the "Summer Capitol by the Sea." The front of the Atlantic Hotel was on Arendell Street, a convenient distance from the train depot. Two trains left daily from Goldsboro on the Atlantic and North Carolina line bringing summer visitors. (Courtesy Carteret County Historical Society.)

Guests and townspeople strolled on the 16-foot-wide Atlantic Hotel piers that extended from the waterfront into the sound. Sailboats were ready to carry guests on cruises or to the banks for surf bathing. (Courtesy Carteret County Historical Society.)

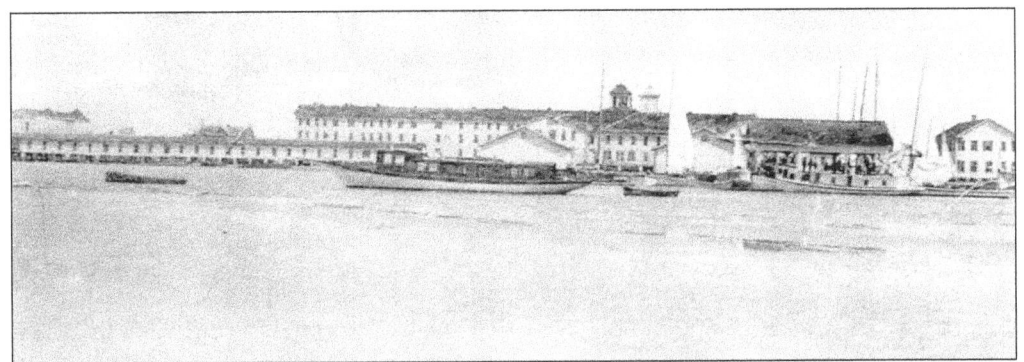

The 223-room Atlantic Hotel was built in 1880 and was located on Bogue Sound. Ahead of its time, it had a steam laundry, post office, telegraph, and long distance telephone service. Rates were $3.00 a day. The long structure to the left is a row of bathhouses. (Courtesy Carteret County Historical Society.)

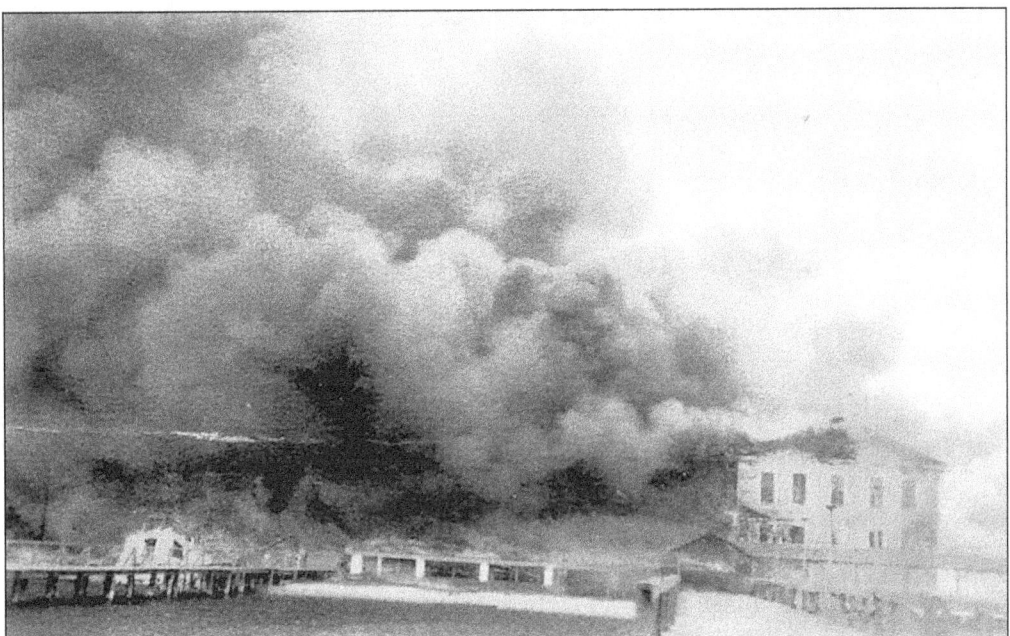

The end of an era—the Atlantic Hotel is seen here going up in smoke. The fire alarm went off at noon, the same time the daily alarm let residents know that it was noon. When the sound continued non-stop, citizens rushed from their homes knowing that something was wrong. Nettie Murrill ran from her home on Shackleford Street and watched the fire from the front porch of the John Motley Morehead summer cottage. By 1:00 p.m., only the chimneys were standing. (Courtesy Carteret County Historical Society.)

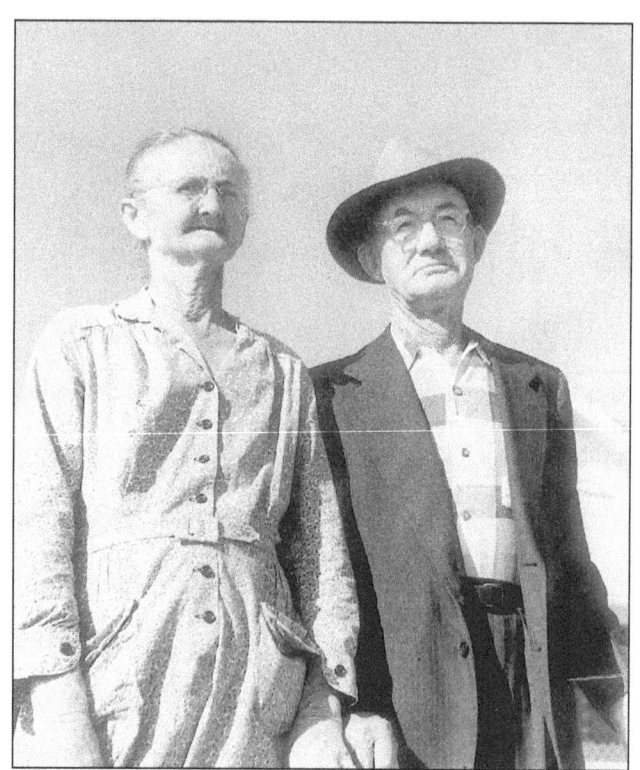

Captain Gib Willis and his wife, Hannah Guthrie Willis, were descendants of original Core Banks families. They moved to "the Promised Land" area of Morehead City at young ages and remained for the rest of their lives. Mrs. Willis is wearing a simple cotton house dress of the period. Captain Gib worked his entire adult life as a boat captain, and Mrs. Willis cared for their four daughters in their house on the Bogue Sound on Shackleford Street. (Courtesy Nettie Murrill, private collection; photograph by Josiah W. Bailey.)

In 1931 young friends made their own fun. The young ladies in the photograph decided on an outing in the country. They are, from left to right, as follows: (in the front) Annie Mae Parker, Esley Mae Willis, and Nettie Willis; (in the back) Sadie Willis and Marian Fulcher. (Courtesy Nettie Murrill, private collection.)

Hannah Willis is shown on a visit to Aunt Harriette in 1922. Harriette was married to Garrison Willis, the son of Josephus Willis Sr., and they had moved to Morehead City from Harkers Island. They are sitting on a bench at the shoal near their house that was known as "the landing." Nettie Murrill was ten years old when she made this picture with a camera she earned by selling Cloverine Salve. (Courtesy Nettie Murrill, private collection.)

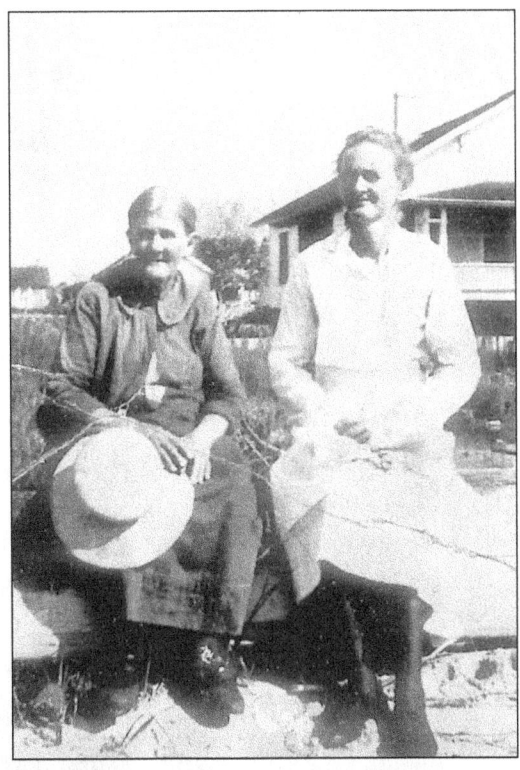

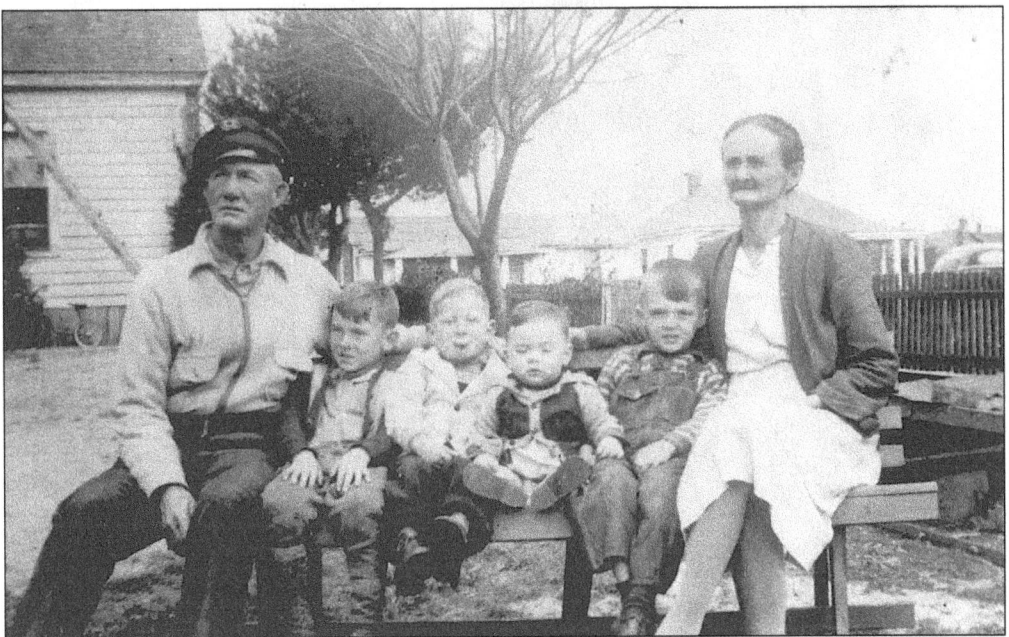

In the fall of 1942, Captain Gib and his wife, Hannah, are pictured on a bench behind their house on Shackleford Street with their four grandsons. The family members are, from left to right, as follows: Captain Willis, known as "Poppy"; Bill Murrill; John Mayberry; David Murrill; Jimmy Howland; and Hannah Guthrie Willis, known as "Mommy" to her children and grandchildren. (Courtesy Nettie Murrill, private collection.)

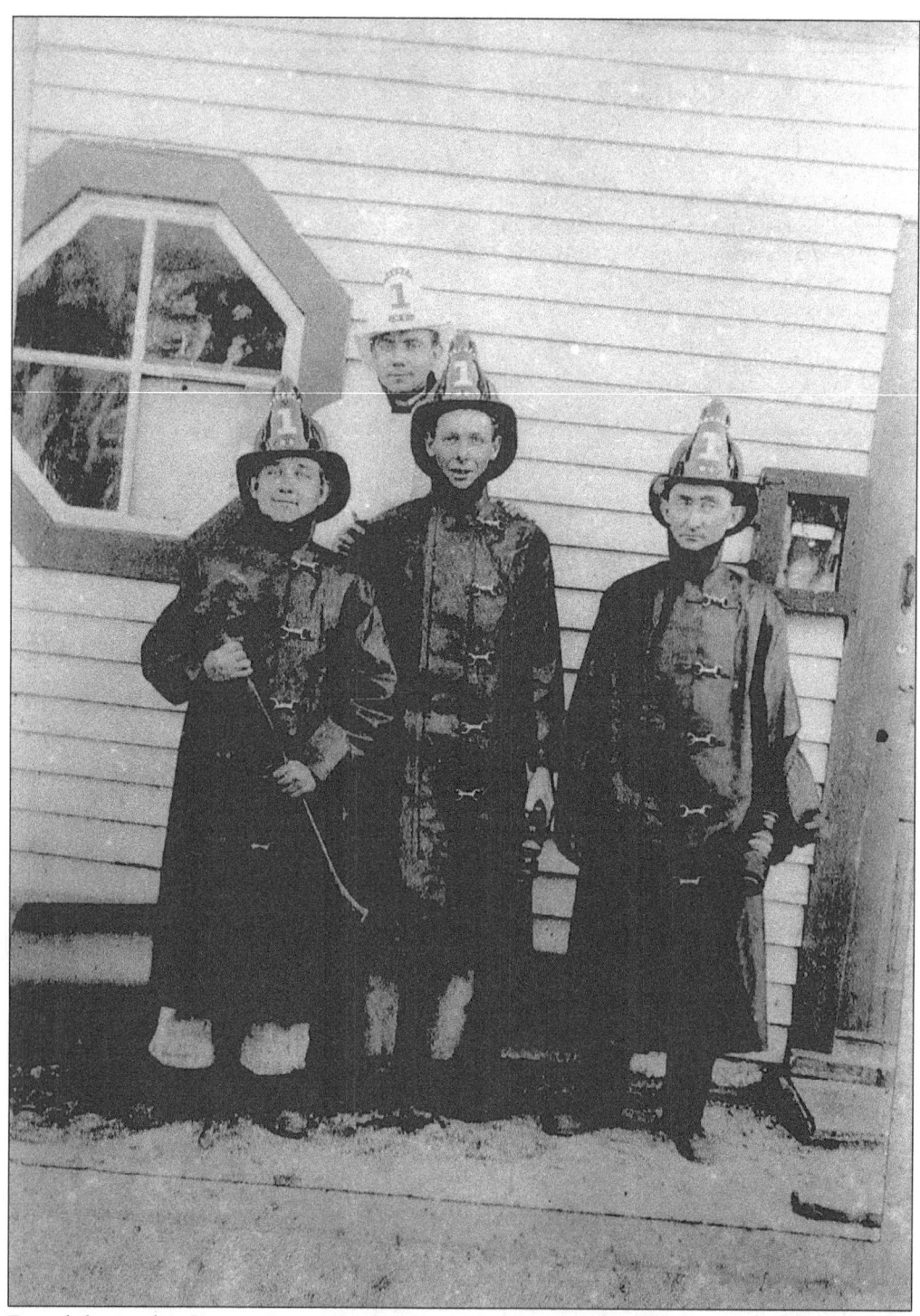
From left to right, Stamey Davis, Dr. Ben Royal (in back), George Adams (a waterman), and Fred Royal (a barber) are shown in front of the old firehouse that was located in the 800 block of Evans Street. The volunteer force represented every walk of life. (Courtesy Carteret County Historical Society.)

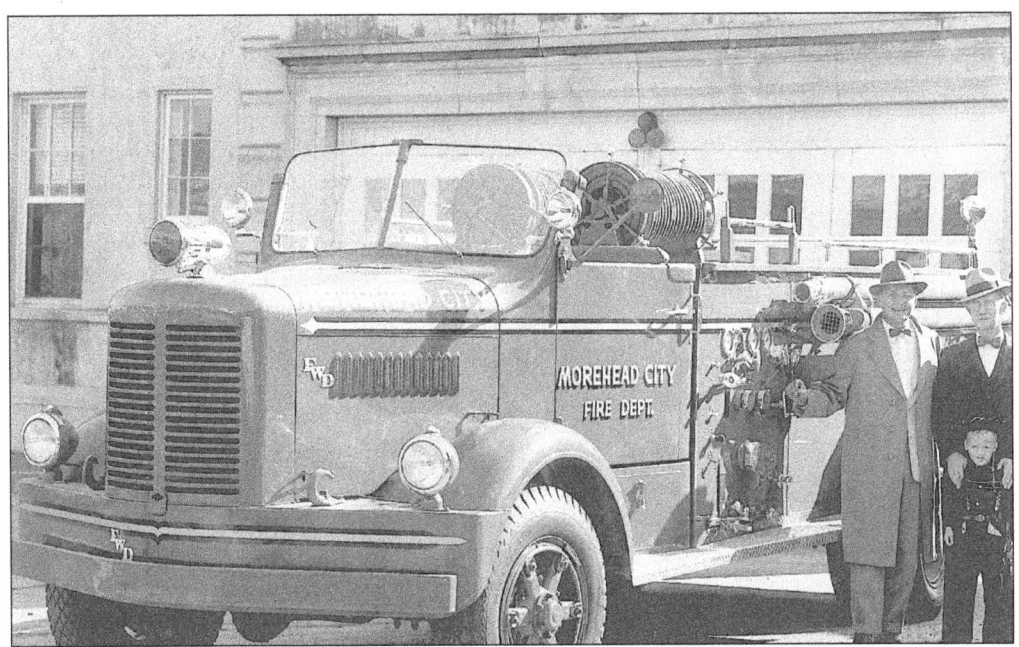

Volunteers are posed with a modern firetruck in front of the new Morehead City Fire Station, which was built in 1927 and is still in use today. A municipal building was built with the fire station that opened onto Evans Street. Pictured from left to right are the following: Bud Dixon, George Dill, and George Dill Jr. (in front). (Courtesy Carteret County Historical Society.)

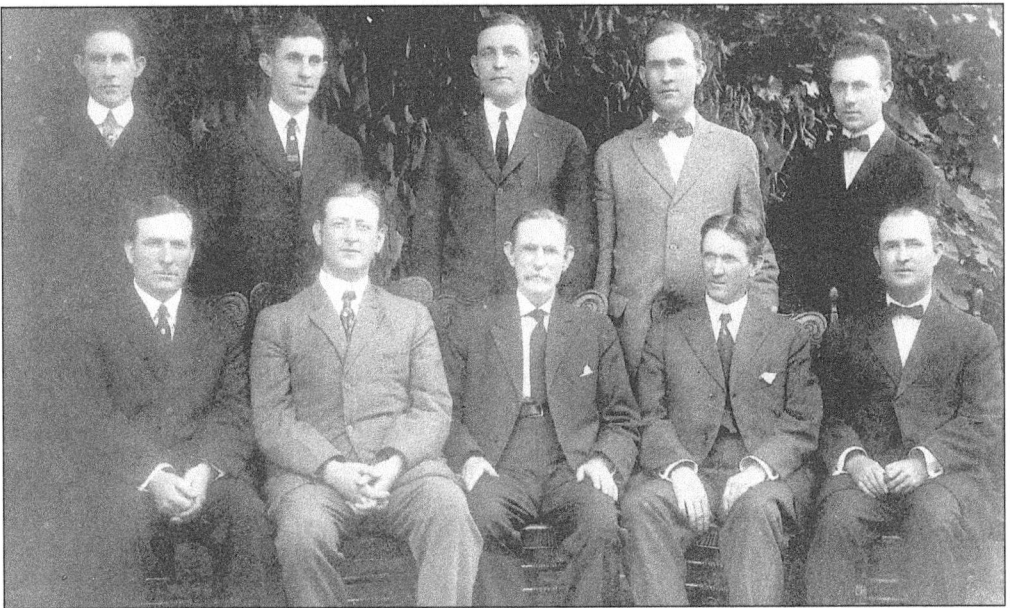

Mr. Alexander Webb is pictured with his sons. The Webb family members, are from left to right, as follows: (front row) Charles Vorheer, William McLean, Alexander (father), Alexander Haywood Jr., and Harry; (back row) George Henderson, John Davis, Earle Wayne, Paul, and Theodore Ray. The Webbs were a prominent family. Earle is known for donating the present public library, Webb Memorial Library. Nina Webb Wallace was the only daughter. (Courtesy Carteret County Historical Society.)

Dr. Ben Royal was raised in Morehead City, and upon completing medical school, he returned home. After two years he opened the city's first hospital. His skills saved many lives during World War II, when wounded servicemen from U-boat torpedoes were brought by boat to the hospital. (Courtesy Carteret County Historical Society.)

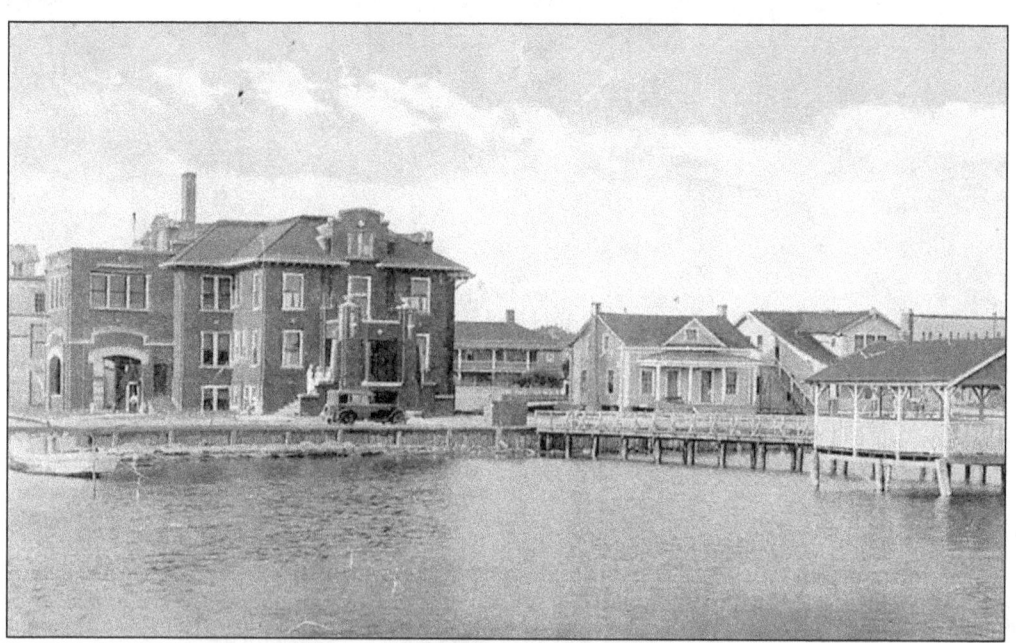

Dr. Royal established the first hospital in Morehead City. It was organized in 1912 and quickly outgrew the facility. In 1919 Dr. Royal led a group in building the 28-bed hospital pictured above. In 1925 he began a nurses' school and employed Nurse Edith Broadway as an instructor. (Courtesy Carteret County Historical Society.)

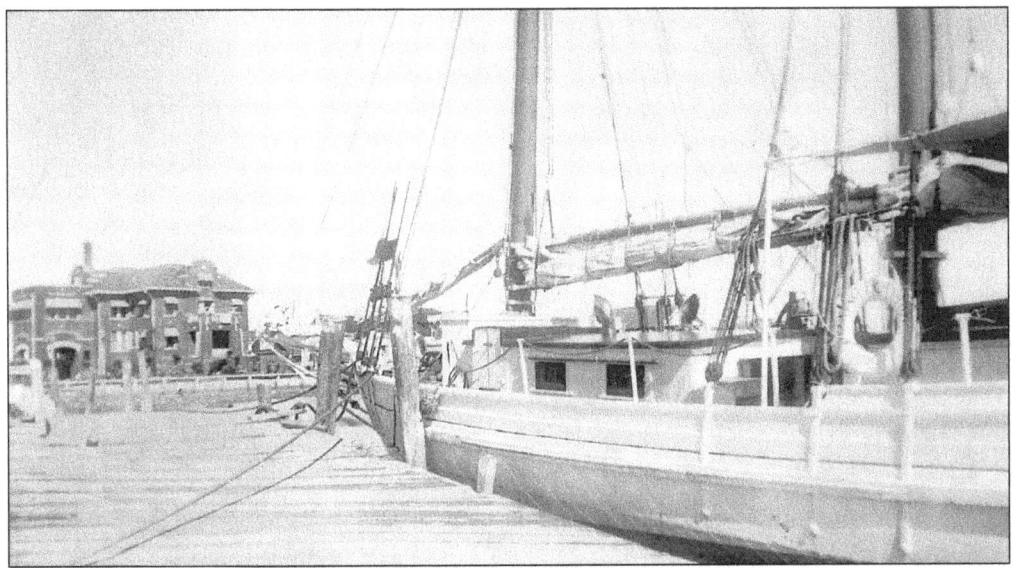

The hospital dock is shown with a schooner tied up. The Morehead City Hospital can be seen in the background. Since there were few roads in the county, the waterfront location was essential. Before the invention of gurneys, Dr. Royal was seen personally carrying patients to the hospital. The governor's yacht was often seen tied up to the end of the dock; it is said to have been there the day the photo was made. (Courtesy Carteret County Historical Museum.)

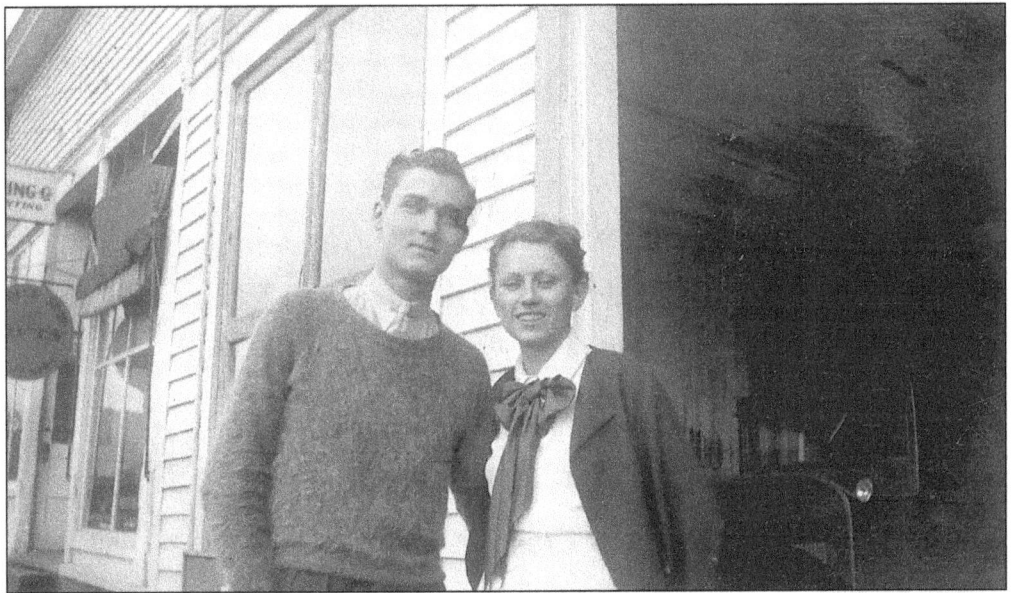

While Dr. Ben was saving lives at home, his son served in World War II. Benjamin Franklin Royal Jr. is pictured with Winifred Willis. He was killed during the war. (Courtesy Carteret County Historical Society.)

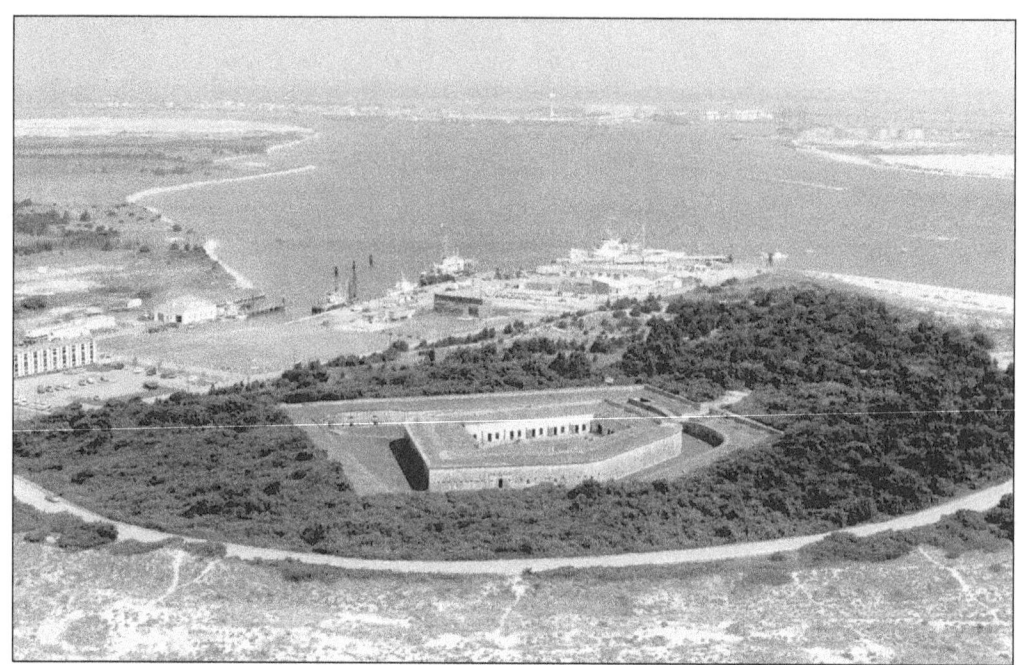

During World War II, Fort Macon was recommissioned as part of the United States Coastal defense. Troops were garrisoned in the old fort and it became part of the United States coastal defenses and the guardian of Beaufort Inlet. (Photo by Frances Eubanks.)

The area known as Camp Glenn was the location of the New Section Naval facility, and recruits were stationed there for coastal defense training. The sudden influx of military personnel caused a housing shortage. (Courtesy Carteret County Historical Society.)

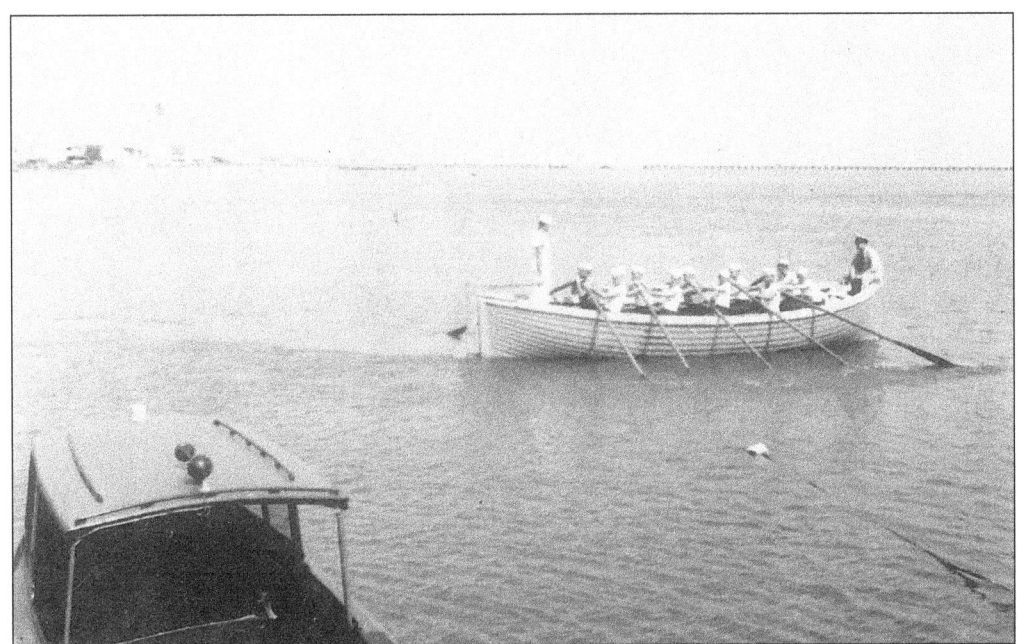

A Navy Section Base was established in 1942 as part of America's coastal defense. Military activity gave a greater feeling of security to the residents, who were well aware of the U-boat activities right off the coast. Seaplanes left the base to hunt enemy submarines in an effort to protect merchant marine vessels. (Courtesy Carteret County Historical Society.)

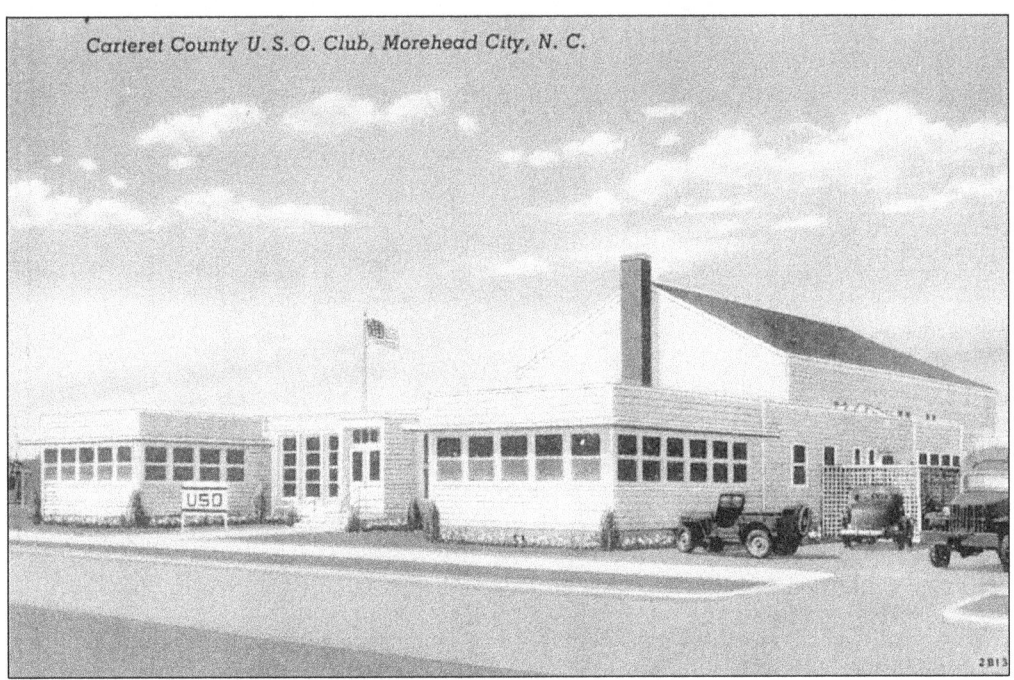

With the influx of hundreds of military personnel, organization of the USO was important. It was located where Shevans Park is today. Dances, music, and entertainment were provided to ease wartime tensions. (Courtesy Billy Piner, private collection.)

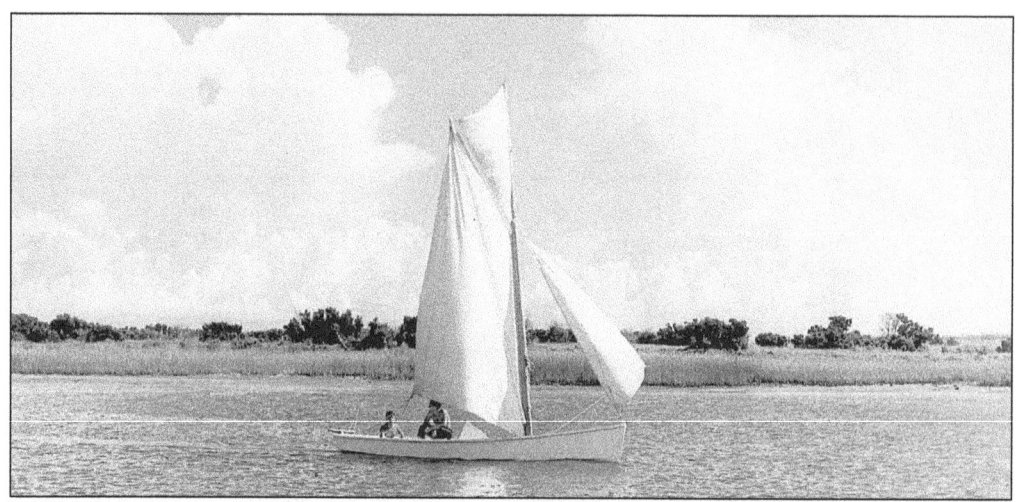

When Captain Gib had his cousin Julian Guthrie build his spritsail the *Alma*, he told Julian, "You'll have to build me a skiff before fall." Even though he captained John Motley Morehead II's yacht, the little spritsail was Captain Gib's chosen boat. He was recognized for years as the best sailor in the area due to the number of sailboat races he won. Buddy Bailey is shown sailing with David Murrill, Captain Gib's grandson, coming through the cut in front of Sugar Loaf Island. David would cry to go, and Buddy would take him. (Courtesy Nettie Murrill, private collection.)

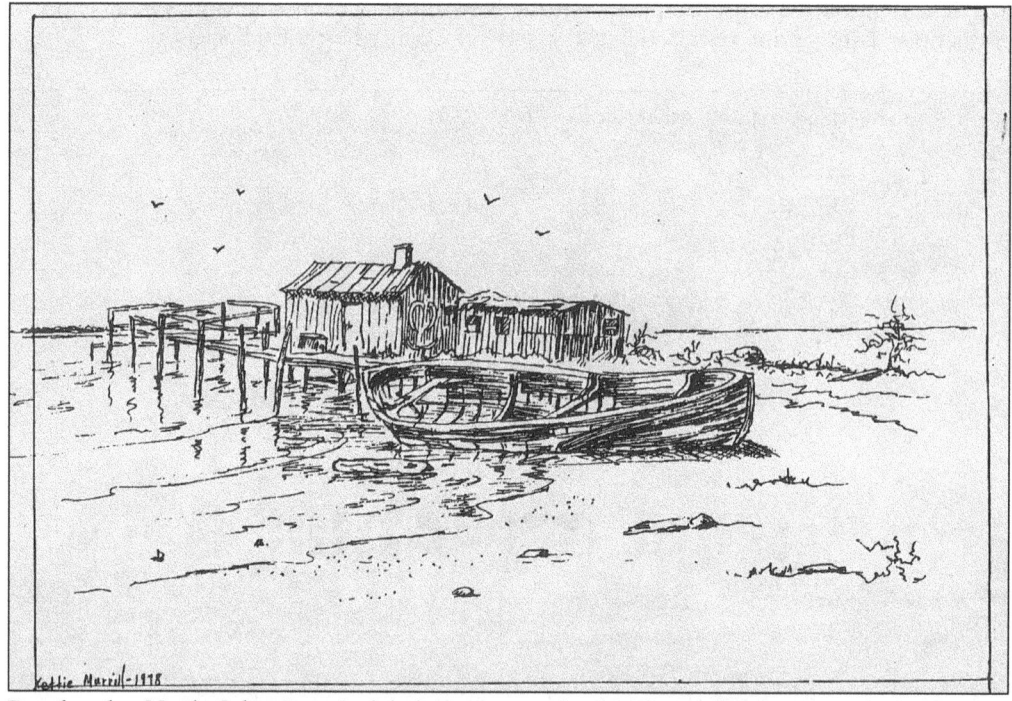

For decades Uncle John Lewis's fish house was a landmark on the Bogue Sound shore on Shepherd Street, west of where Thomas A. Bennett Law offices are today. The old whaling boat had been dragged up and is part of the image Nettie Murrill immortalized in a pen and ink she drew from a famous Dan Wade photograph. Many Morehead City citizens have memories of learning to swim there.

Ancient docks and small boats are still part of the daily waterscapes. Calico Creek flows from the sound and cuts into the land mass passing the Bay Street Cemetery on one side and the former Pigott farmland (now modern housing) on the other side. These scenes are quickly passing from Carteret County history. (Photo by Frances Eubanks.)

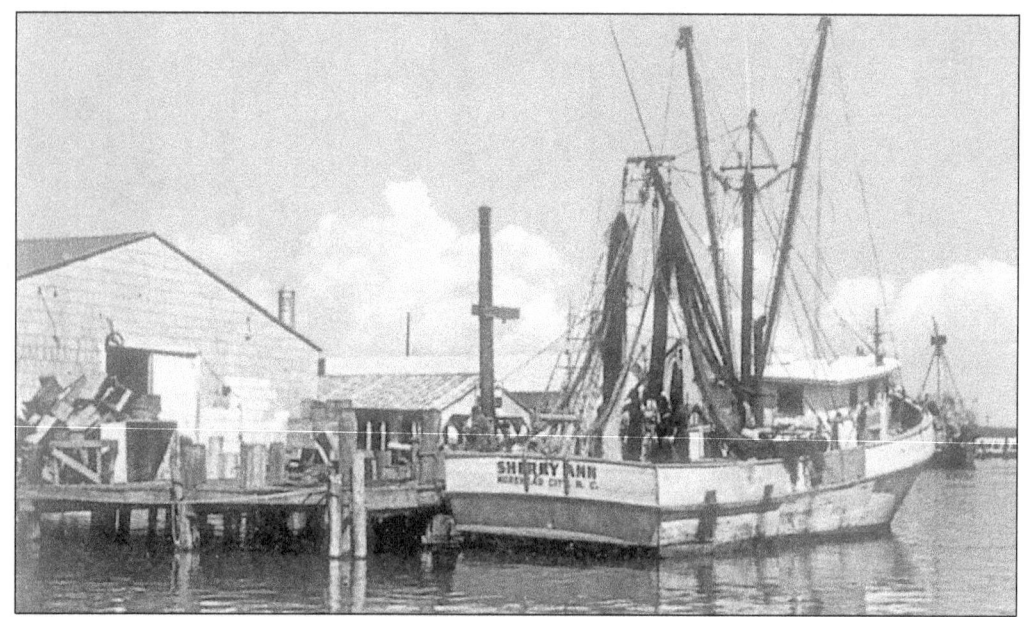
Shrimp trawlers and other work boats have been an integral part of the Carteret County waterways since the founding of the county. Commercial fishing is often referred to as America's first industry. (Courtesy Billy Piner, private collection.)

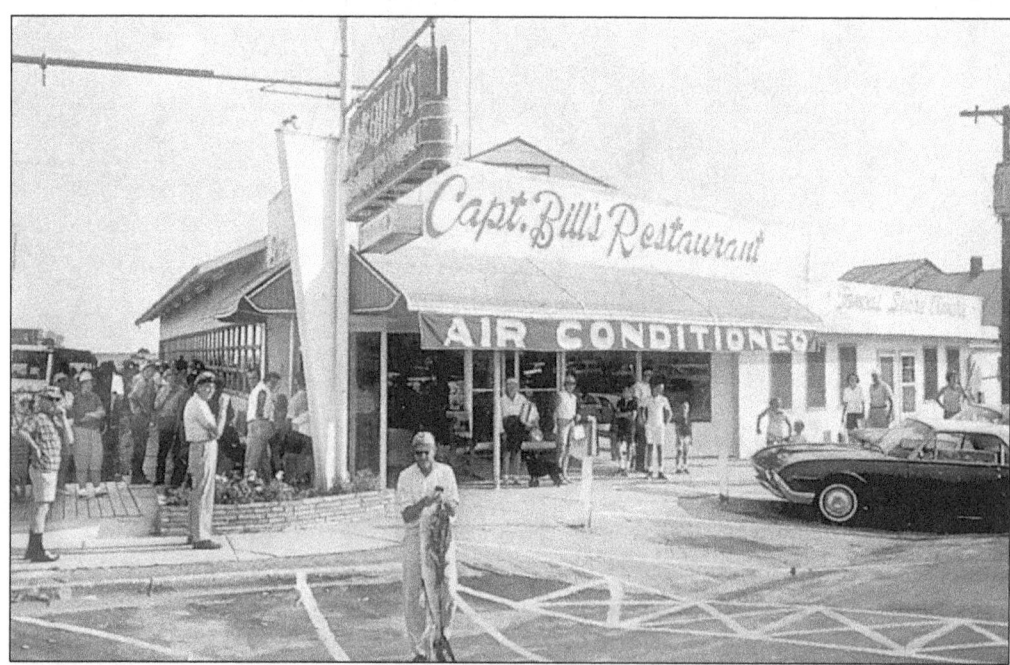
Captain Bill Headen Ballou remodeled a sailing club that had been an old fish house into a restaurant in 1945. Captain Bill's Waterfront Restaurant was one of the first in the area to have air conditioning. (Courtesy Billy Piner, private collection.)

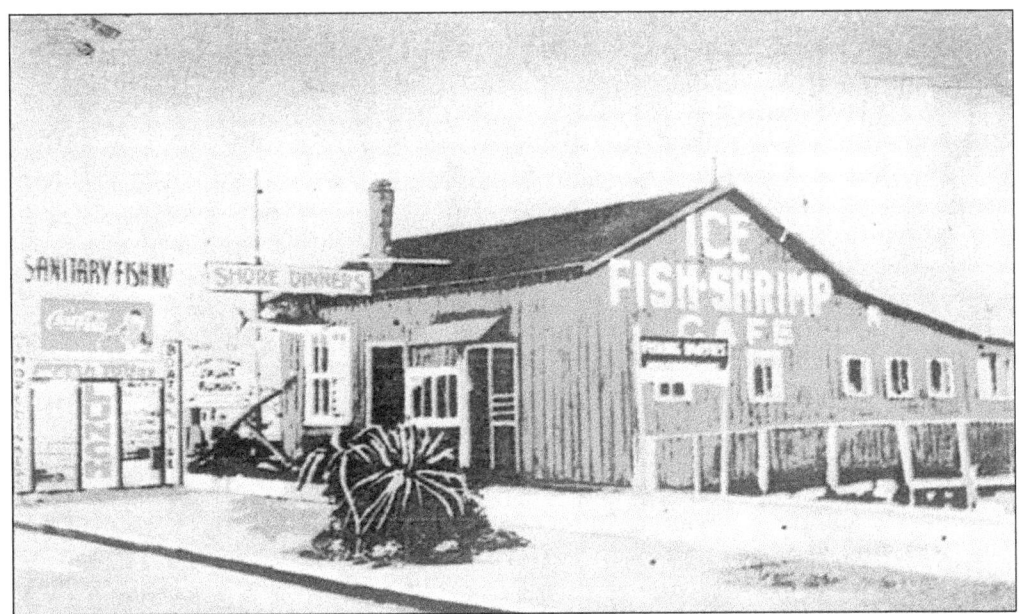

Tony Seamon and Ted Garner founded the Sanitary Restaurant on February 10, 1938. Seamon bought a boat, and Garner "drummed" up business. When they moved their cooking from the party boat to the land, word passed that the "Sanitary" had fresh seafood and clean surroundings. (Courtesy Billy Piner, private collection.)

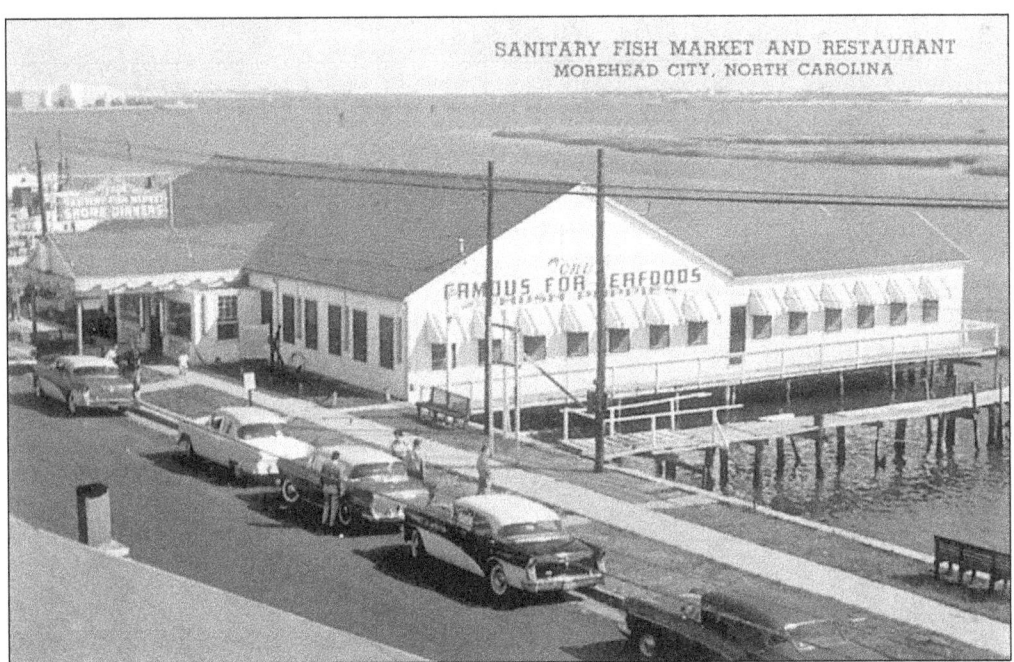

The Sanitary Restaurant outgrew its first location, and in 1949, Seamon and Garner moved it to its present location on the waterside. In the early days their slogan was "They slept in the ocean last night." (Courtesy Billy Piner, private collection.)

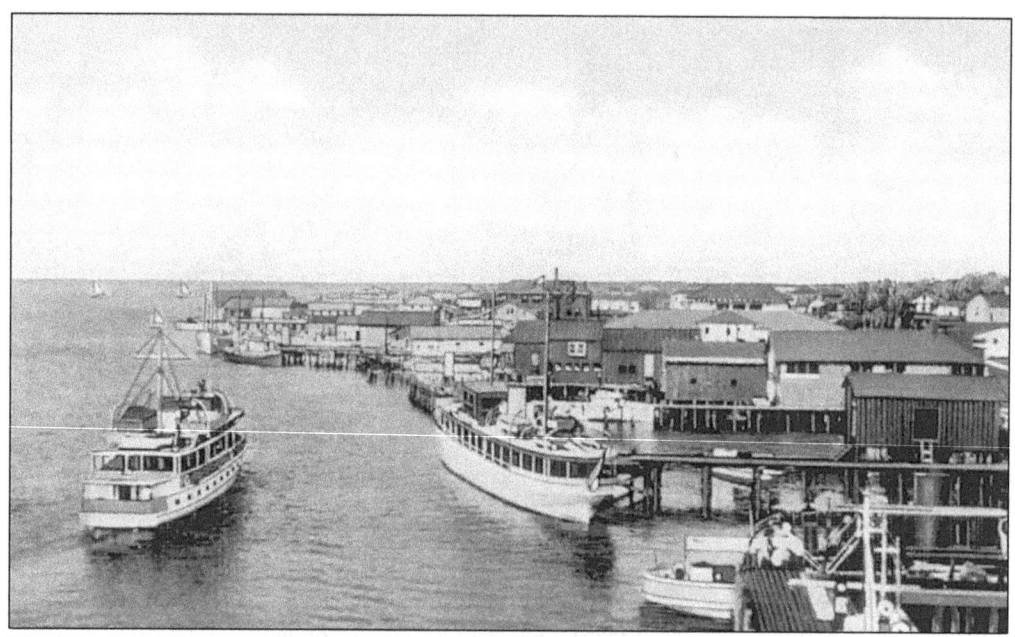
The Morehead City waterfront was home to commercial boats, fuel docks, and fish houses. The Sanitary Restaurant and Captain Bill's Restaurant led the way to developing a resort image. (Courtesy Billy Piner, private collection)

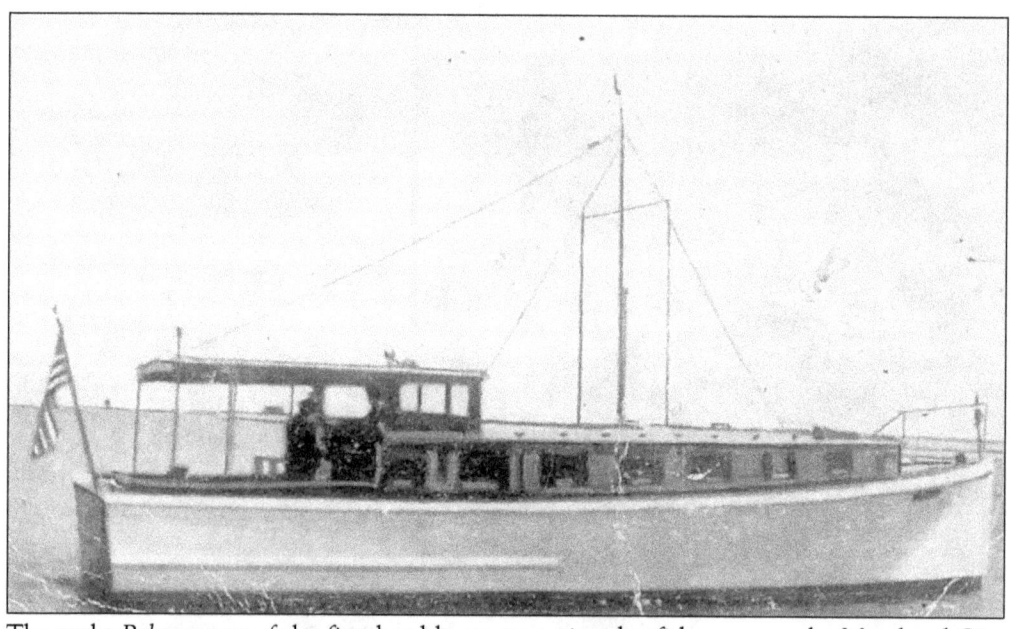
The yacht *Pal* was one of the first head boats attracting day fishermen to the Morehead City waterfront. Carteret County became popular with sports fishermen because the eastern location meant more time in the Gulf Stream fishing. (Courtesy Billy Piner, private collection.)

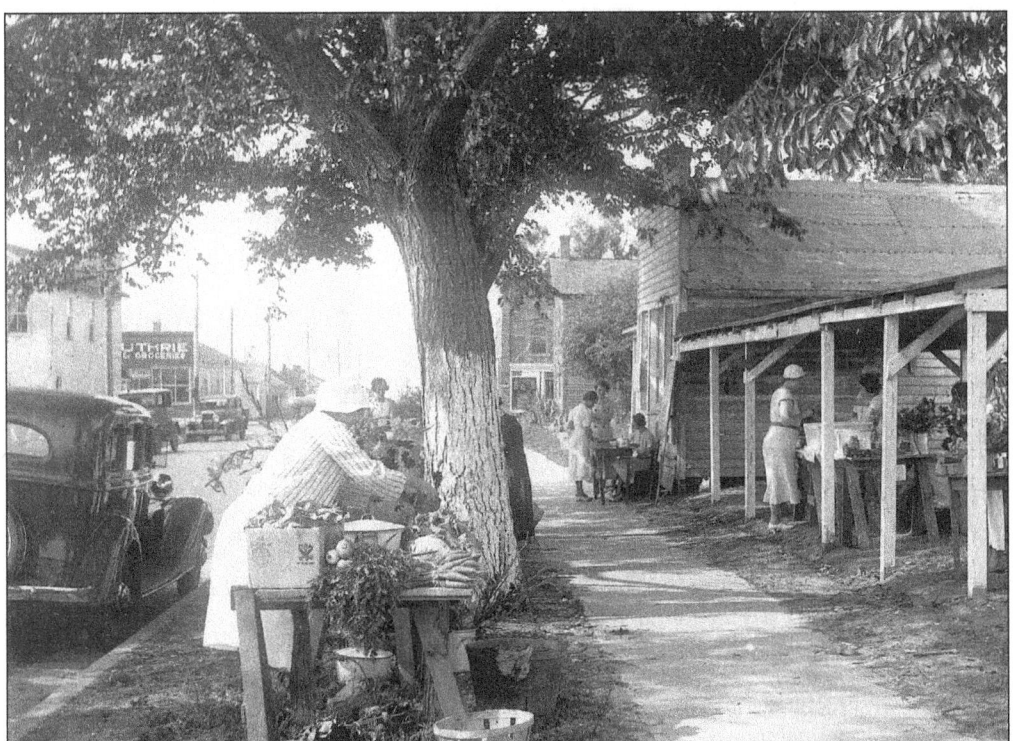

The 1928 Morehead City curb market was the first one in the state. In 1932 it was located on Twelfth Street between Evans and Arendell. The tables that displayed produce were planks attached to the elm trees. Town people and cottagers came on Wednesday, Friday, and Saturday. Kib Guthrie's store can be seen in the background. (Courtesy Carteret County Historical Society.)

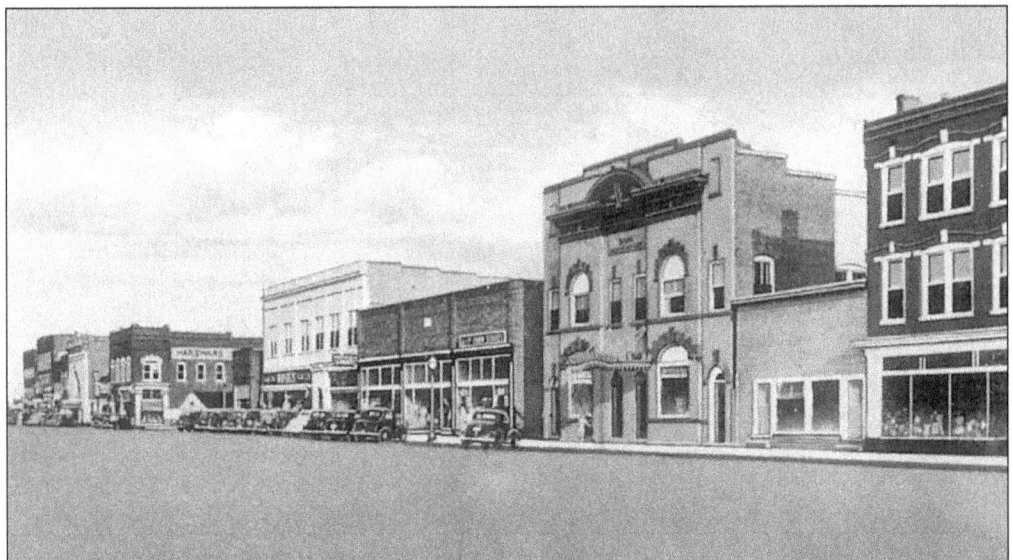

In 1937 Morehead City was coming into its own. Arendell Street, seen here, had emerged as the main street, and businesses lined both sides after it had been enlarged to a four-lane paved street with the railroad right down the middle. (Courtesy Billy Piner, private collection.)

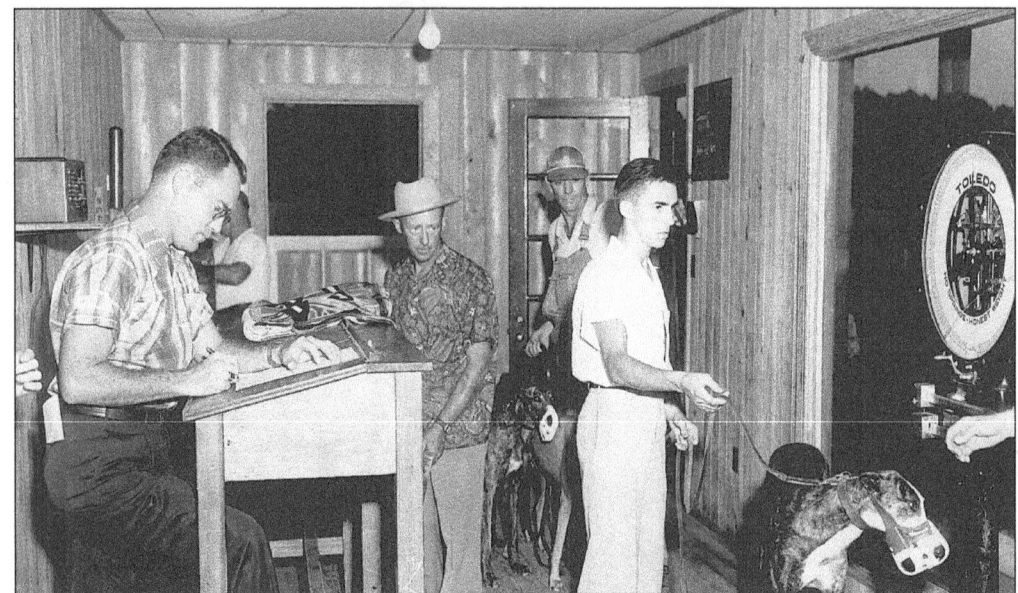

After World War II a greyhound race track was constructed. People came from all over the southeastern part of the state and Virginia to place bets. It was a profitable business and an attraction for locals and visitors. Nettie Murrill remembers people who couldn't afford to go to the races sitting in their cars in the parking lot and enjoying hearing Ray Cumming's announcements. The pre-race weigh-in room is pictured. (Courtesy Carteret County Historical Society.)

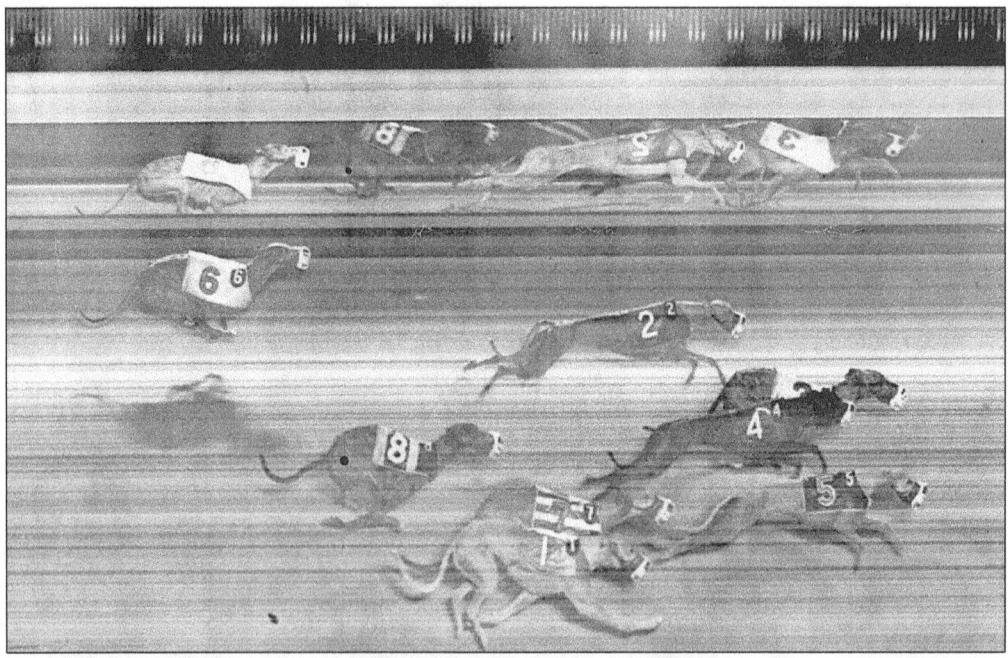

Photo finish endings at the dog track provided an exciting moment for bettors. Kolaka was the favorite dog and won so many races that he had to be retired to keep the betting competitive. After five years the state legislature determined that all betting was illegal, putting an end to gambling and thus to the end of the track. (Courtesy Carteret County Historical Society.)

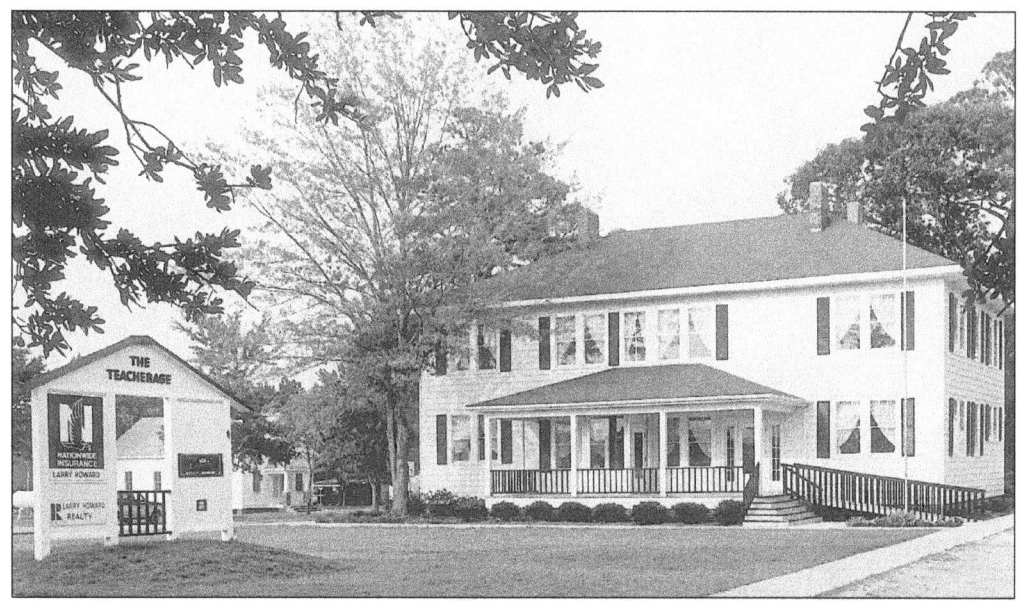

Teacherages were constructed to provide housing for schoolteachers who would move to the county for the school term. At the turn of the century, Newport was but a tiny village and owes its growth to the railroad that passed through and then later Highway 10, which connected Morehead City to the state of Tennessee. (Photo by Frances Eubanks.)

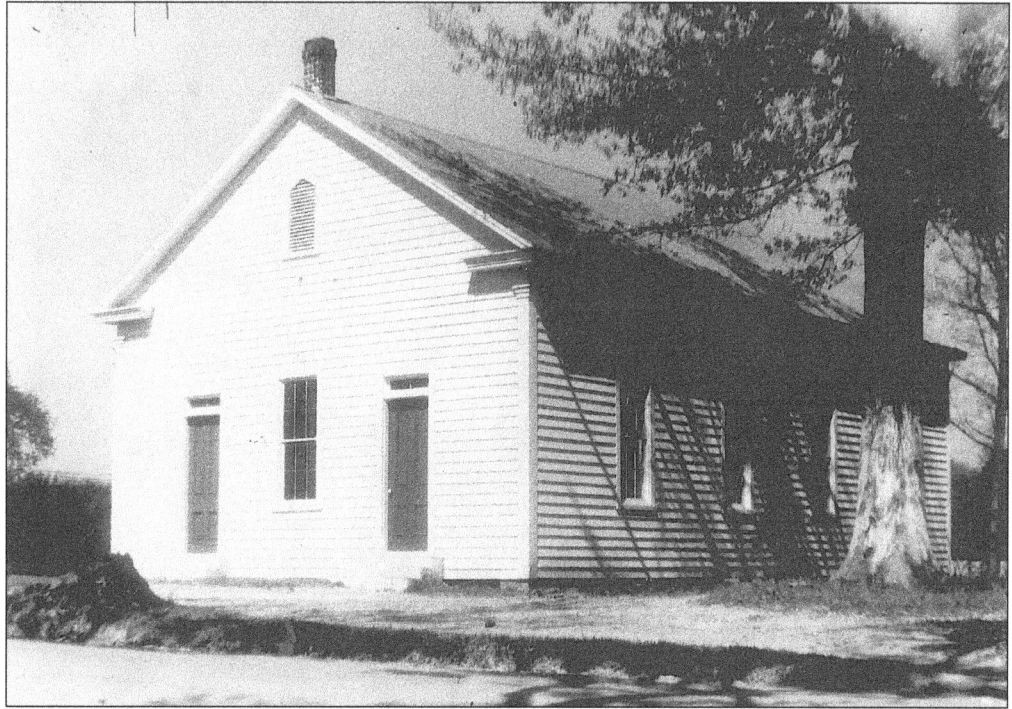

In 1701 a Primitive Baptist church was organized in the area now known as Newport. It is the oldest known religious group in the county. During the Civil War, the Union soldiers took over the church building, and Confederate soldiers burned it to the ground. In 1885 the above structure was built. (Courtesy Carteret County Historical Society.)

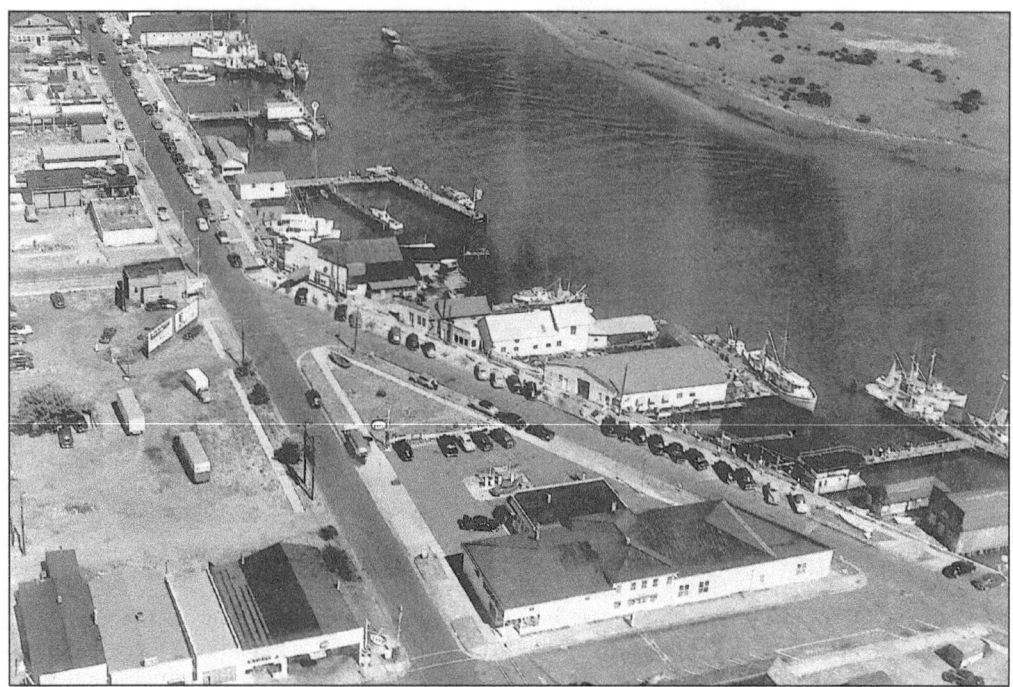

Taken by Jerry Schumacher, this aerial of Morehead City in the 1940s was taken looking east. It shows the business district, an improved waterfront on the Bogue Sound, and paved streets. The state docks and Beaufort are visible in the distance. (Courtesy Carteret County Historical Society.)

The building that houses the collection of the Carteret County Museum of History and Art is also home to the Carteret County Historical Society. It was constructed as a one-room school in 1907 and was known as the Carolina City School House. In 1921 it became a Methodist church, and in 1985 it was moved to its present sight and became a museum. (Photo by Frances Eubanks.)

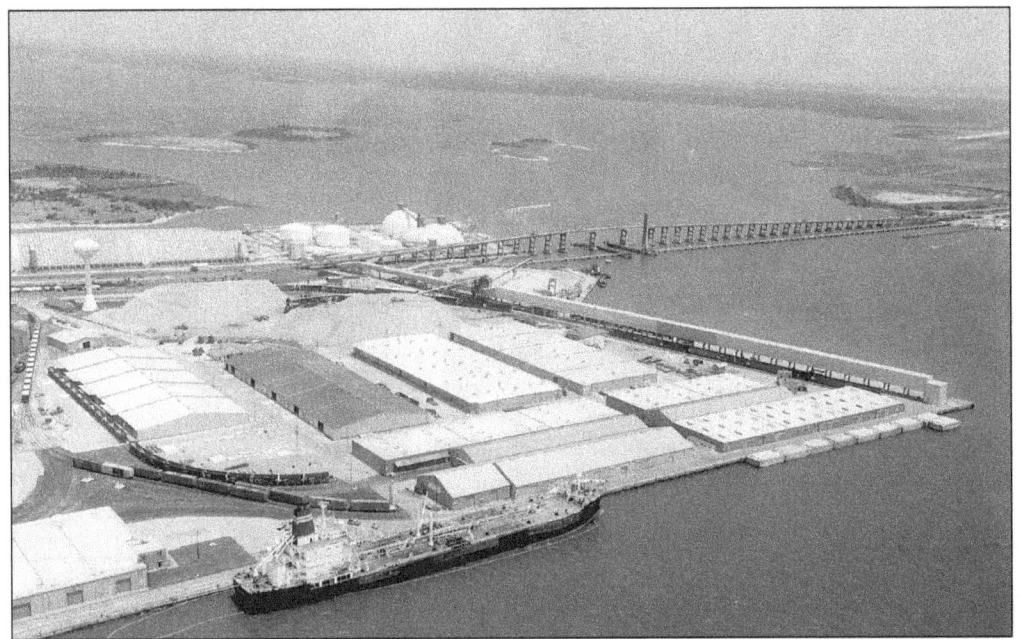

Establishing a port in Morehead City was the vision of John Motley Morehead. The port was returned to the county after the Civil War and has continued operation from that time. It was reconstructed in 1936, and the Morehead City Port Commission was formed. After the Navy took over in World War II, it was returned to the State Port Authority in 1945. (Photo by Frances Eubanks.)

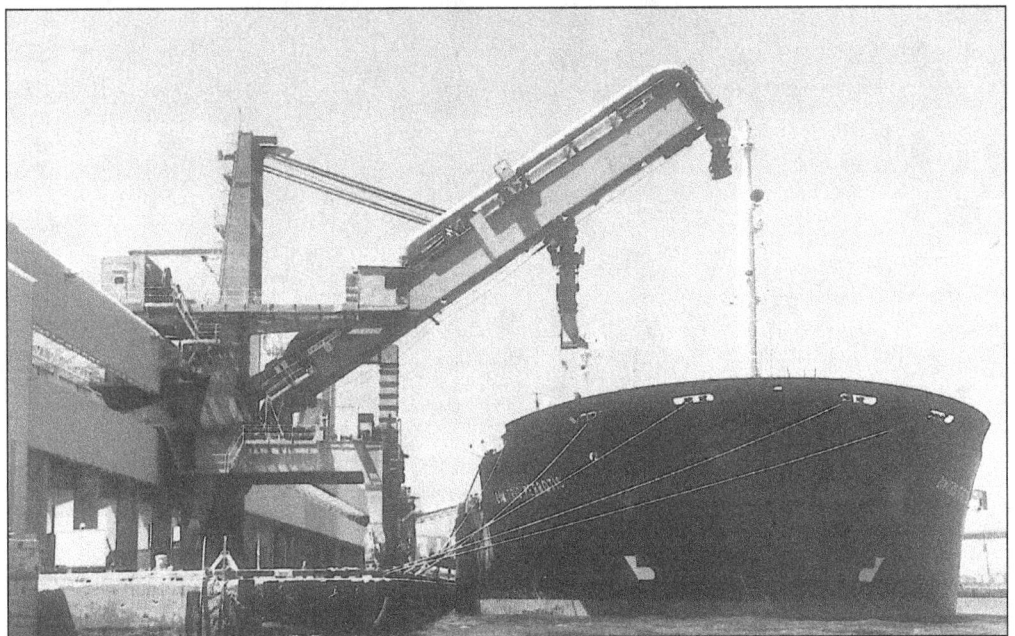

Ships from all over the world call on the Morehead City Port. It has warehouses, oil tanks, coal handling, and a phosphate facility. The train tracks connect the port with the rest of the United States. The port is an important asset for the county and the state of North Carolina. (Photo by Frances Eubanks.)

It has been said that the town of Newport was founded when a group wanted to find a location for a new port for the county. Established on the Newport River, which is part of the waterway connecting to the Beaufort Inlet, it was natural for people to seek a way for trade. They envisioned a new port taking the place of the old port at Beaufort. Pictured above is the mill pond extension of the New Port River. (Photo by Frances Eubanks.)

Four

Down East Communities

The history of the Down East communities is as old as the history of Carteret County. Self-reliant is the best way to describe the original residents of Harkers Island, Cedar Island, and the mainland communities of Bettie, Otway, Straits, Marshallberg, Atlantic, Smyrna, Sea Level, Gloucester, Williston, Stacy, and Davis.

The communities were built by settlers who wished to fish the bounty of the sea and farm the rich soil. These little hamlets stayed small and separate until the hurricanes of the late 1890s drove settlers from the banks of Cape Lookout, Shackleford Banks, and Portsmouth Island, increasing the numbers of residents. Generations of descendants have been gifted in fishing and boatbuilding. To this day the area is known for a history of master boatbuilders.

In 1992 the Core Sound Waterfowl Museum was founded to honor the heritage of waterfowl that have proliferated in the area since hunters came from all over the world for decades following the turn of the century. It is no secret that many master decoy carvers have passed on the gift of carving to generation after generation. In the 1990s the quaint fishing village appeal of the Down East communities and the close-knit lifestyle have been threatened by the development of land which has attracted second-home owners, retirees, and vacationers.

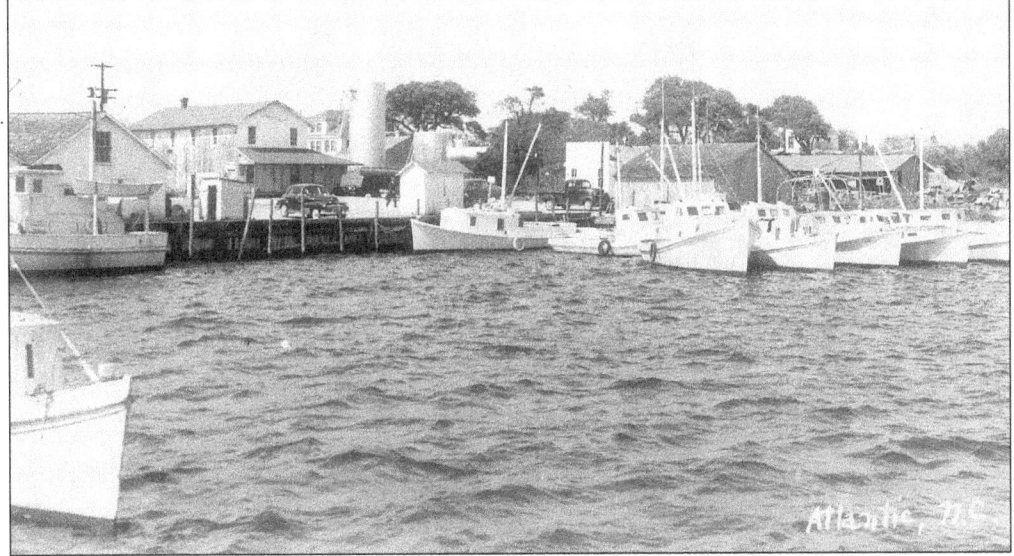

Atlantic Harbor in the Atlantic community has changed little over the decades. The natural harbor is home to commercial fishing boats and is still populated by many descendants of original families. (Courtesy Billy Piner, private collection.)

Roads were not built in the county until the mid-1920s. The first ones were paved with crushed shells and were often impassable. The main mode of transportation remained by water. Building roads Down East required volunteer citizens providing their own tools. The road to Merrimon was not paved until 1950. (Courtesy Core Sound Waterfowl Museum.)

This image shows a preaching service at Henry Davis's fish house, located near the present-day fishing center on Harkers Island. (Courtesy Core Sound Waterfowl Museum.)

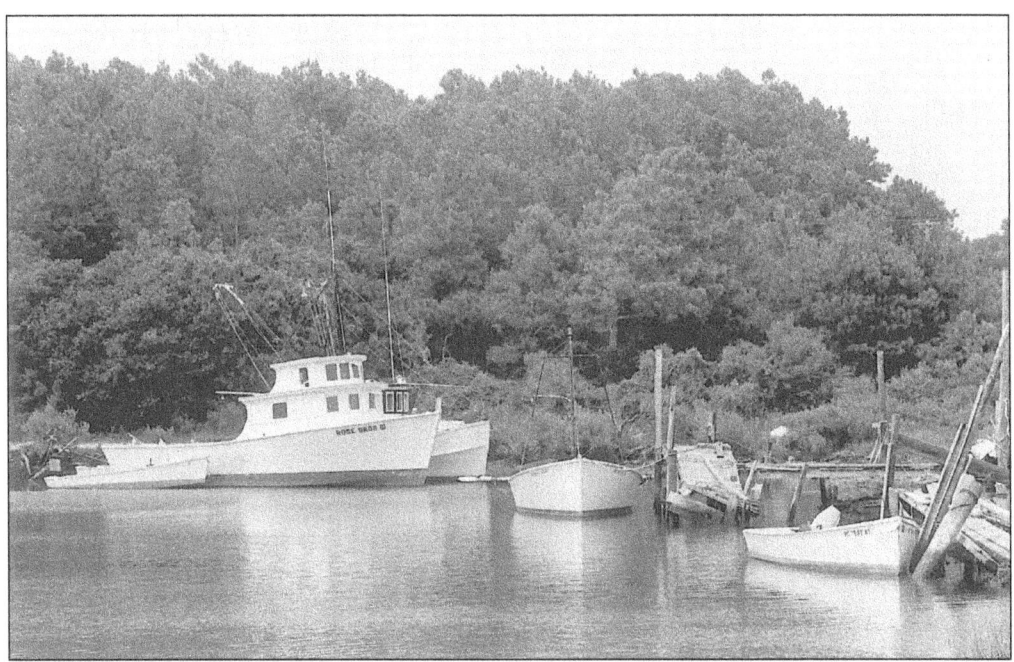

In 1984 Harkers Island had the quaint appeal of a fishing village. The population grew at the turn of the century when boatbuilders and watermen moved their families from the Banks to the island. (Photo by Frances Eubanks.)

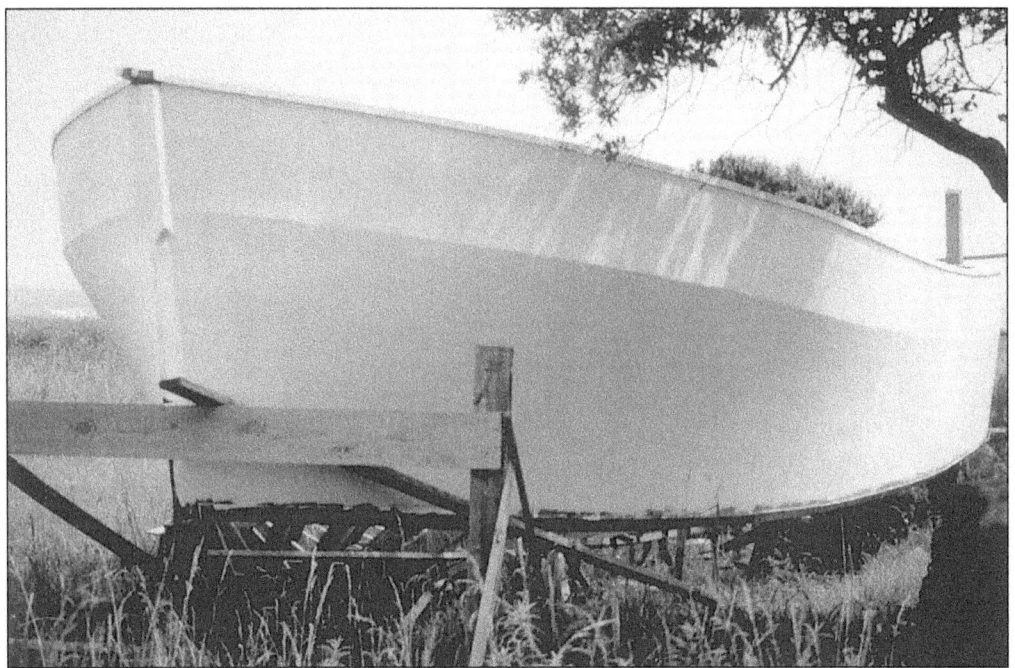

Harkers Island is famous for its boatbuilding. Many builders are known for building boats in their backyards. It is an art that has passed from generation to generation. This boat was photographed in a side yard. (Photo by Frances Eubanks.)

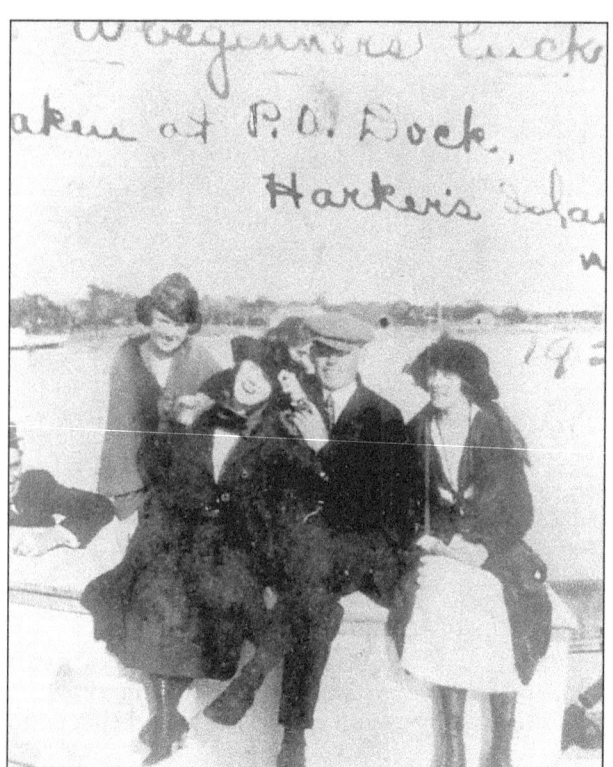

There was no road to Harkers Island when these schoolteachers arrived at the post office dock. The mailboat carried visitors, goods, and the mail from Beaufort to Harkers Island. (Courtesy Core Sound Waterfowl Museum.)

Captain Kelly Willis was the mailboat captain. The first mailboats were sailing vessels and changed to engines in the early 1900s. Mail, messages, products, and people were transported by mailboat to and from Harkers Island until 1941, when the bridge to the mainland was completed. (Courtesy Core Sound Waterfowl Museum.)

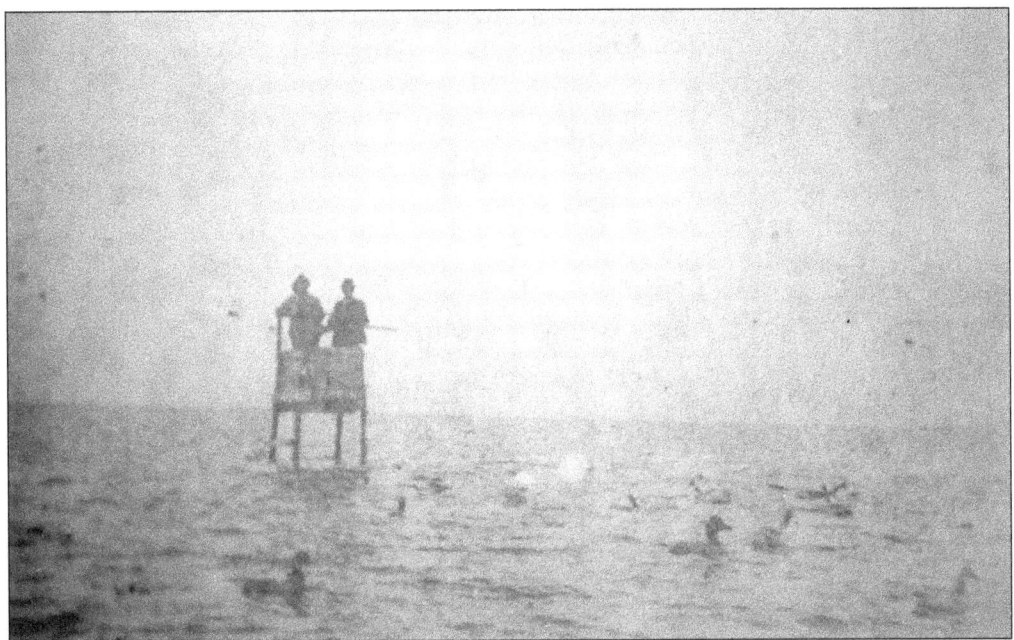

Sport hunting became popular when Northern hunters discovered that vast numbers of waterfowl migrated to rural Down East communities. For decades duck hunting blinds in Core Sound were a familiar sight. (Courtesy Core Sound Waterfowl Museum.)

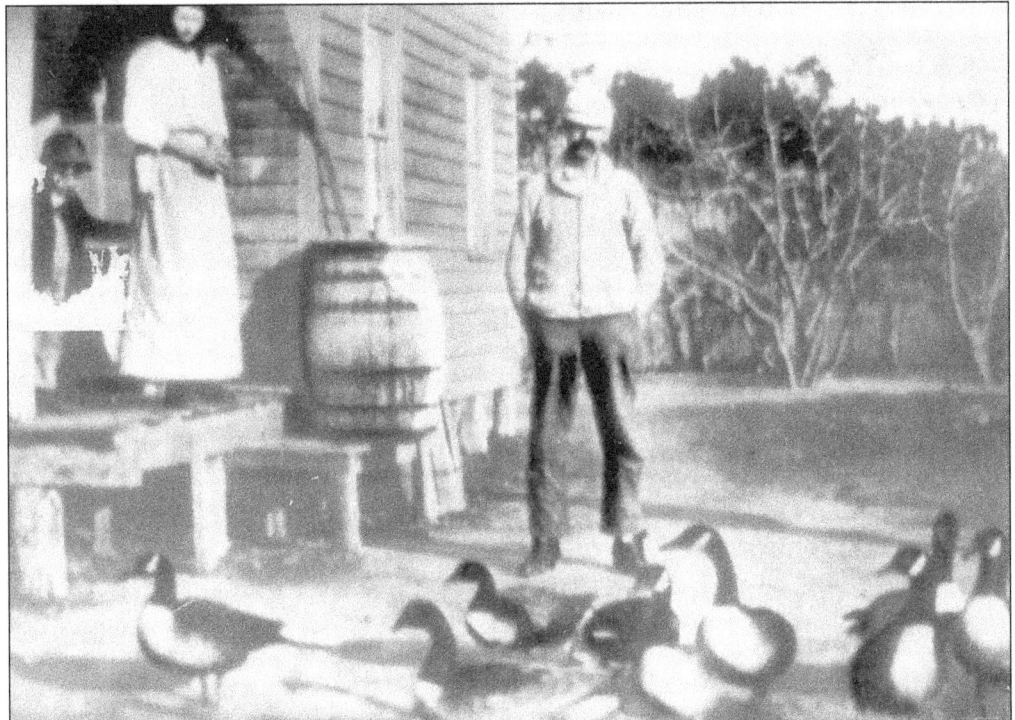

Mitchell Fulcher is shown in his yard in Stacy with live decoys. He worked as a hunting guide for the Carteret Rod and Gun Club and was a well-known decoy maker. His wife and young son are on the porch. (Courtesy Core Sound Waterfowl Museum.)

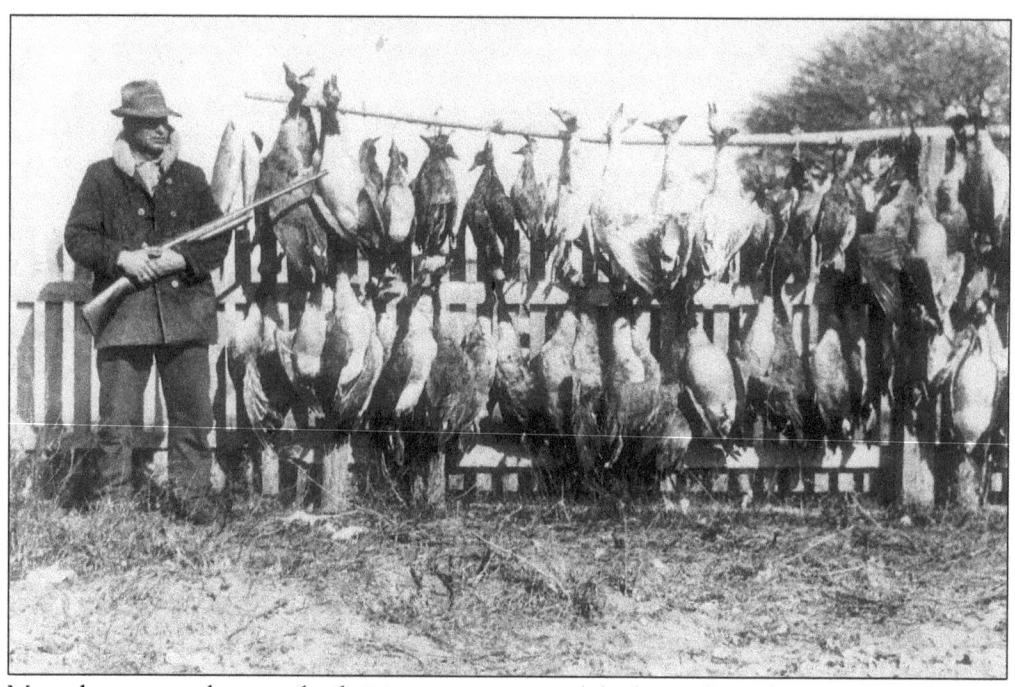

Many hunters made annual pilgrimages to private clubs located on the sounds of Carteret County. Local watermen made extra money as hunting guides and by transporting men, munitions, and supplies. (Courtesy North Carolina Maritime Museum.)

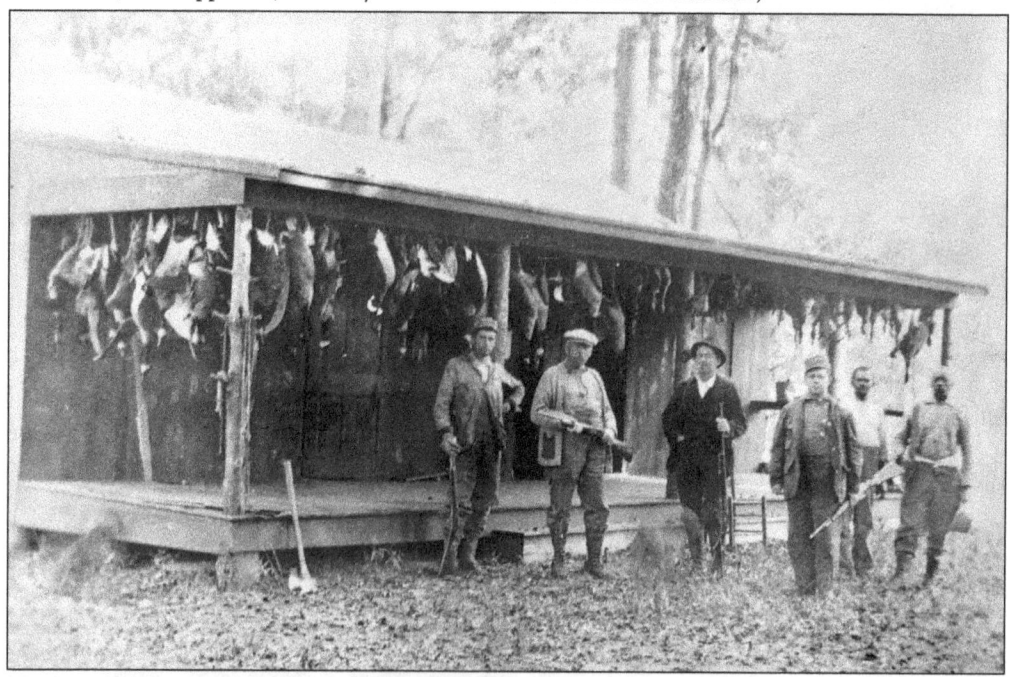

No matter how rough the terrain or how vast the waterways, hunters found their way to one of many hunting clubs. Wealthy businessmen purchased acreage at low prices and sold club memberships. For decades the fowl was plentiful. (Courtesy North Carolina Maritime Museum.)

Don Nierling was a founder and builder of the Davis Ridge Hunting Lodge on Core Sound, which was built with surplus World War II materials from Camp Glenn. After the war, hunting picked up until the 1950s, when there was a decline in waterfowl. Don became a decoy carver. (Courtesy Core Sound Waterfowl Museum.)

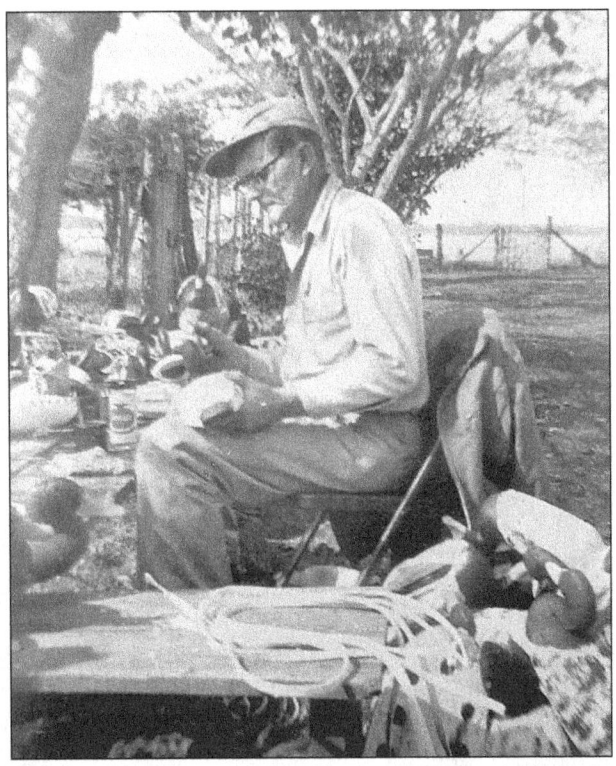

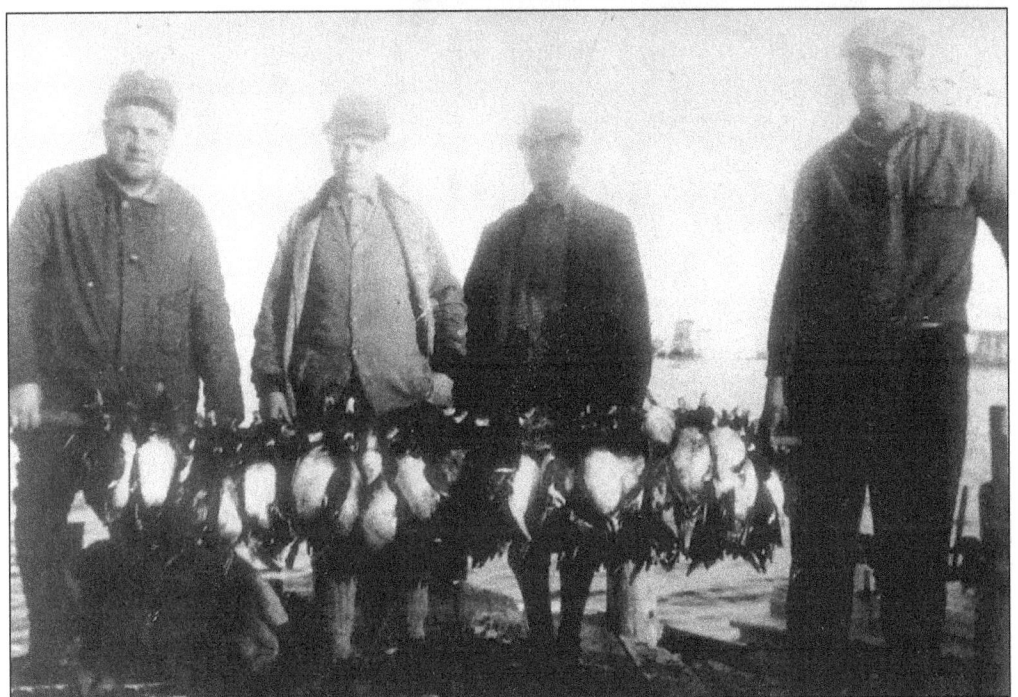

Men came from New York to North Carolina to be entertained or to entertain. The wealthy and famous were part of the migration. Babe Ruth, pictured left, was known as a frequent visitor to the hunting lodges of Carteret County. (Courtesy Core Sound Waterfowl Museum.)

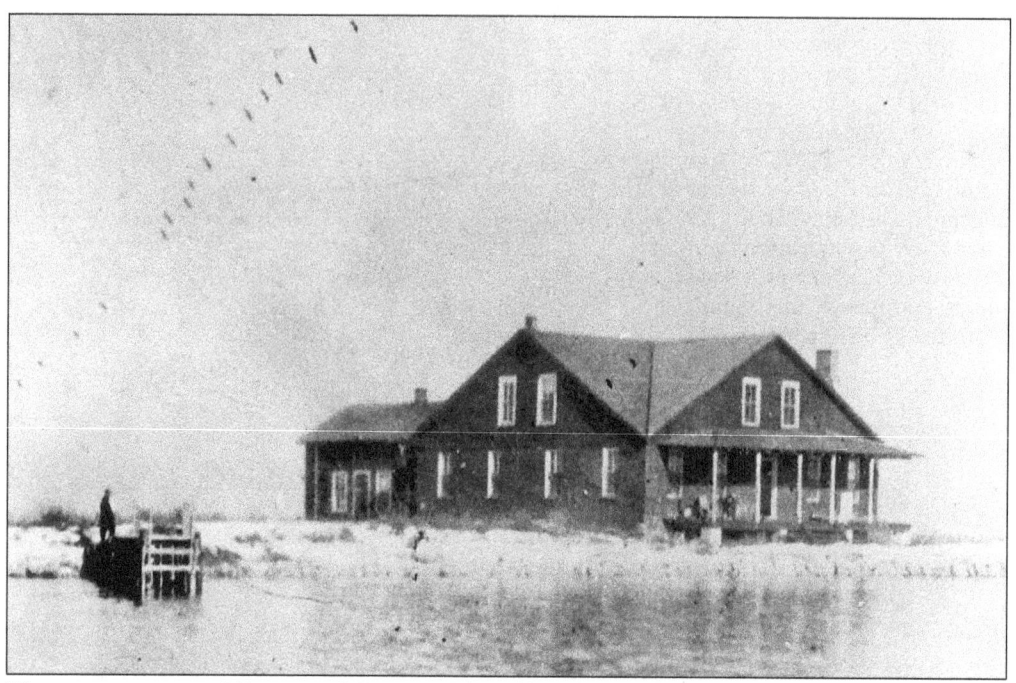
The communities of Davis and Portsmouth Village were gateways to the hunting grounds. Pictured is the Harbor Island Club. Small islands in the Core Sound were perfect places to launch hunting parties for the day's shoot. (Courtesy Core Sound Waterfowl Museum.)

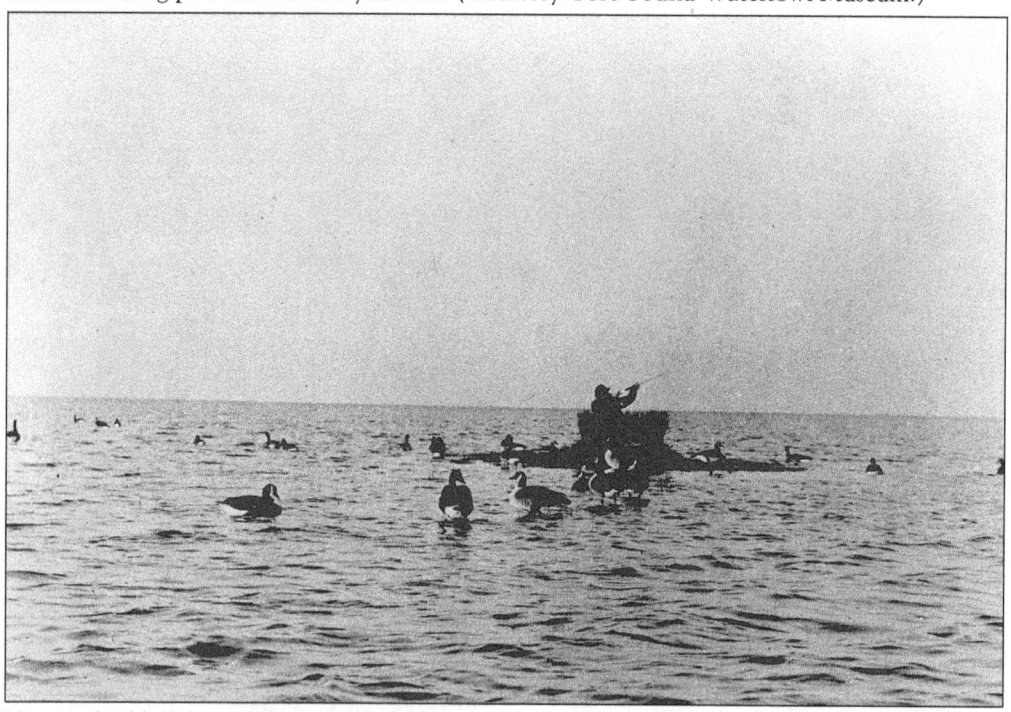
Hunters build elaborate duck blinds for concealment. The blind in the photo is surrounded by live decoys. Guides and hunters had to have a federal permit that allowed them to keep game birds to use as live decoys. (Courtesy North Carolina Maritime Museum.)

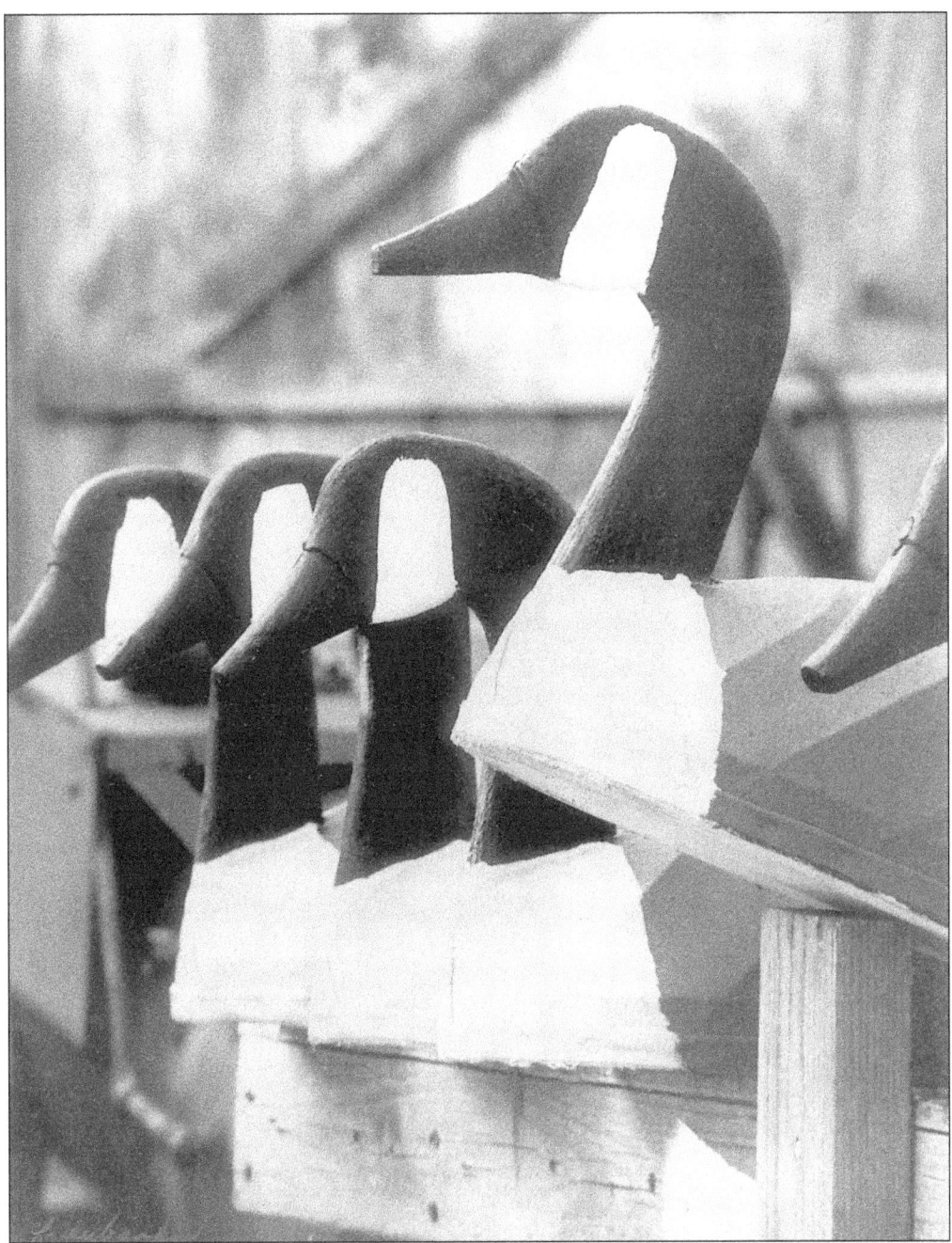

Through the years decoy carving and decoy making have gained respect as art forms. It was of necessity to have the decoy makers live all along the shores of the county. Decoy repairing and making began as a practical measure. Many guides began carving after they fixed ducks that were damaged after a hunt. These "ducks in a row" have carved heads and canvas bodies. They have just been painted and are waiting to dry. (Photo by Frances Eubanks.)

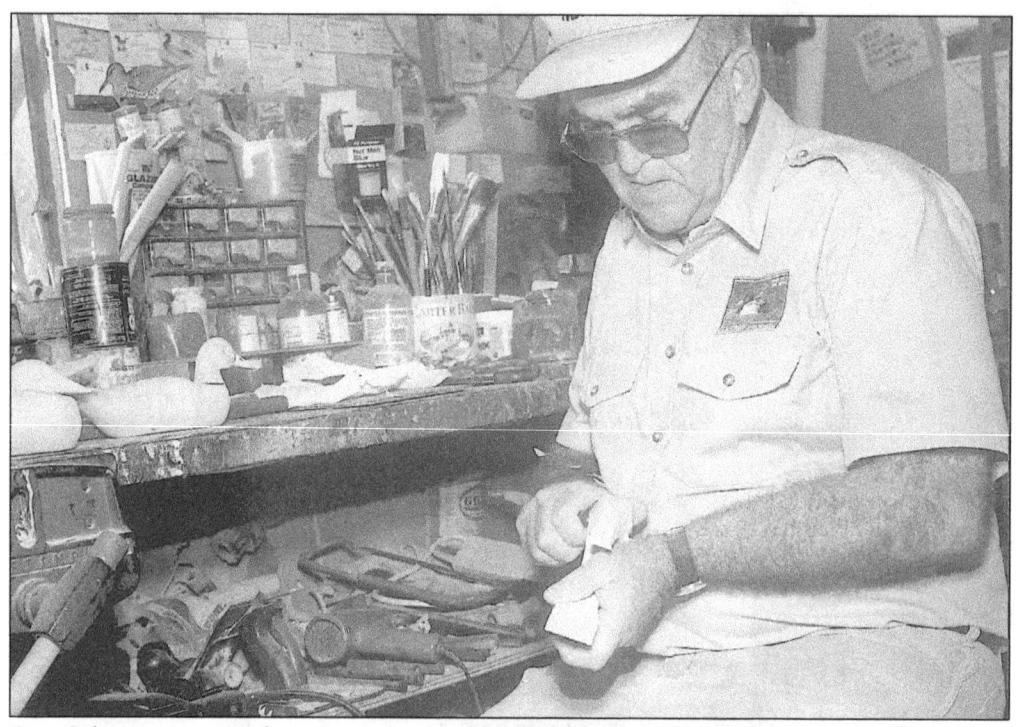

Curt Salter is a carver who is active at the Core Sound Waterfowl Museum. In fact, he may be seen often carving on the museum's front porch. He was honored as the 1993 "Featured Carver" at the Decoy Festival on Harkers Island. (Photo by Frances Eubanks.)

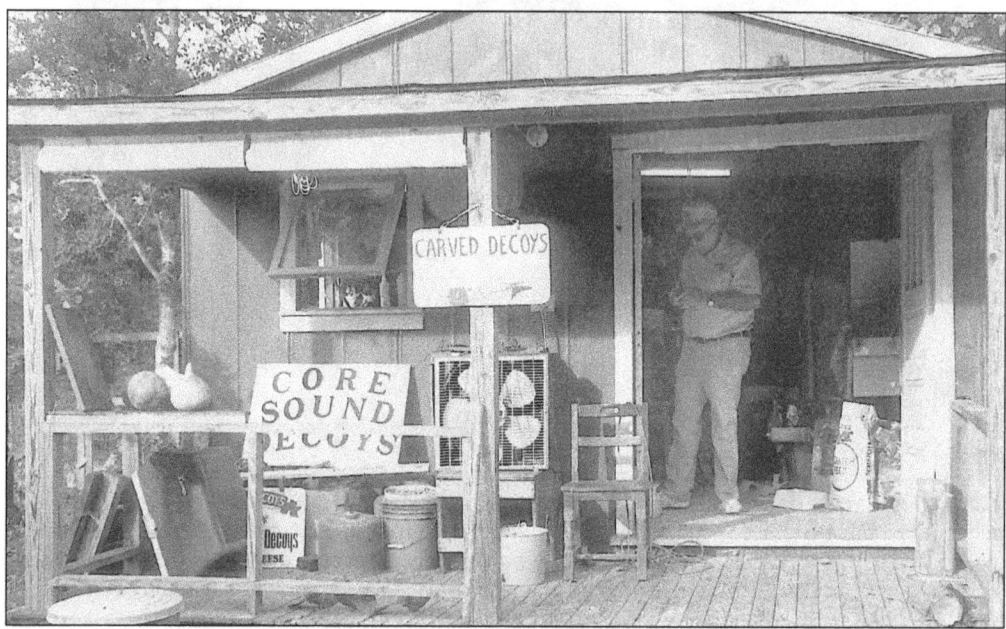

Curt Salter has his workshop behind his home on Harkers Island. There is where he works his magic—carving and painting. Visitors can view his decoy art at the museum or his shop. (Photo by Frances Eubanks.)

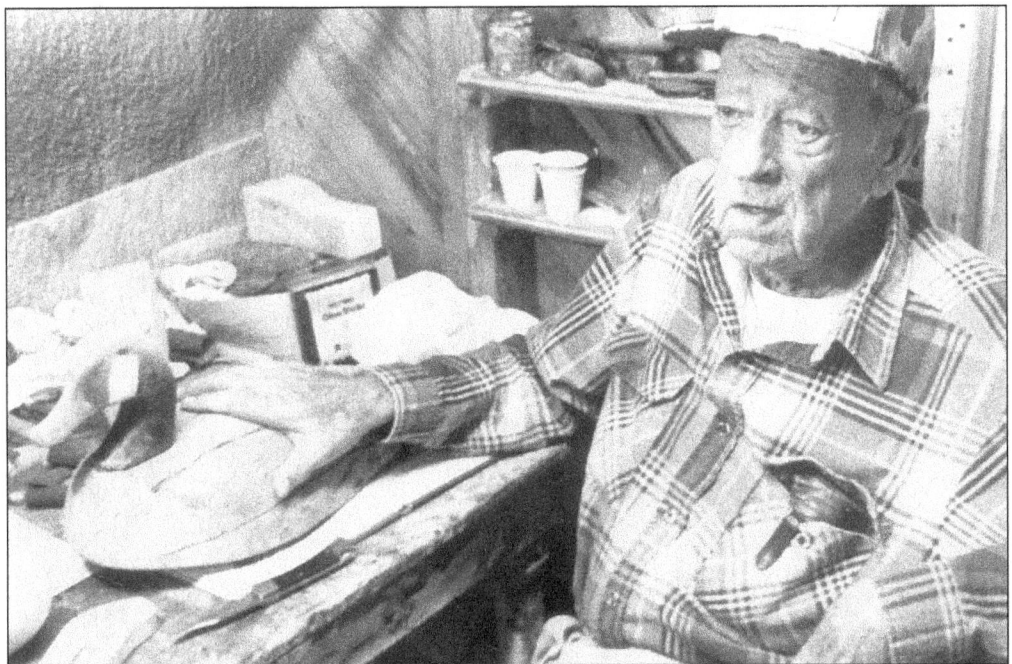

Homer Fulcher was born in 1918 in the "Promised Land" of Morehead City. He was a menhaden fisherman in his young years In his 50s, he started carving working decoys in winter months. In later years he carved decorative pieces. In 1995 he received the North Carolina Folk Heritage Award by the North Carolina Arts Council, which acknowledged his lifetime achievements. (Courtesy Core Sound Waterfowl Museum; photograph by Kerry Willis.)

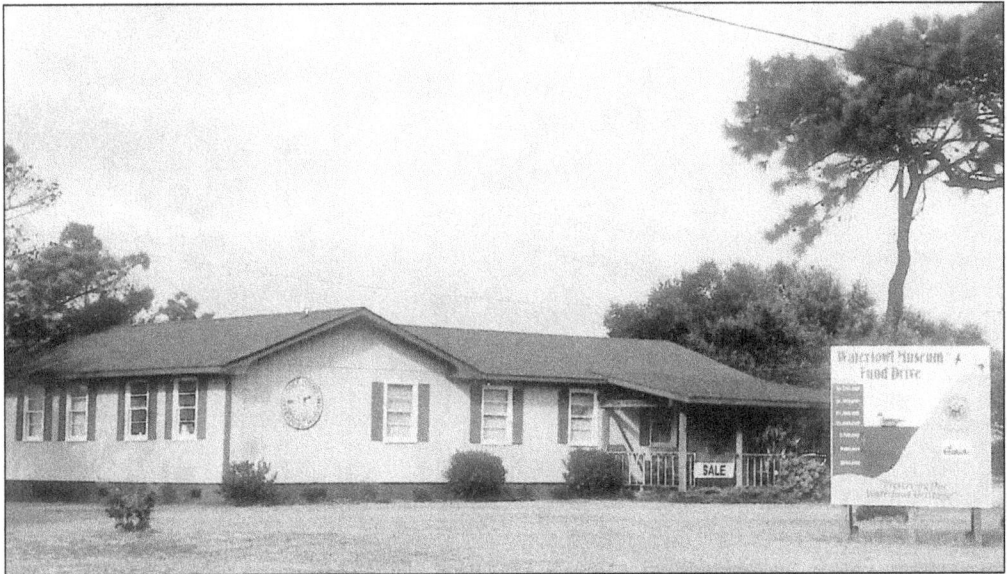

The temporary location of the Core Sound Waterfowl Museum on Harkers Island serves more than 15,000 visitors and schoolchildren during the year. The museum has been recognized statewide as an important effort to preserve local traditions as a community. The museum is open seven days a week with displays, carving demonstrations, and special programming. (Photo by Frances Eubanks.)

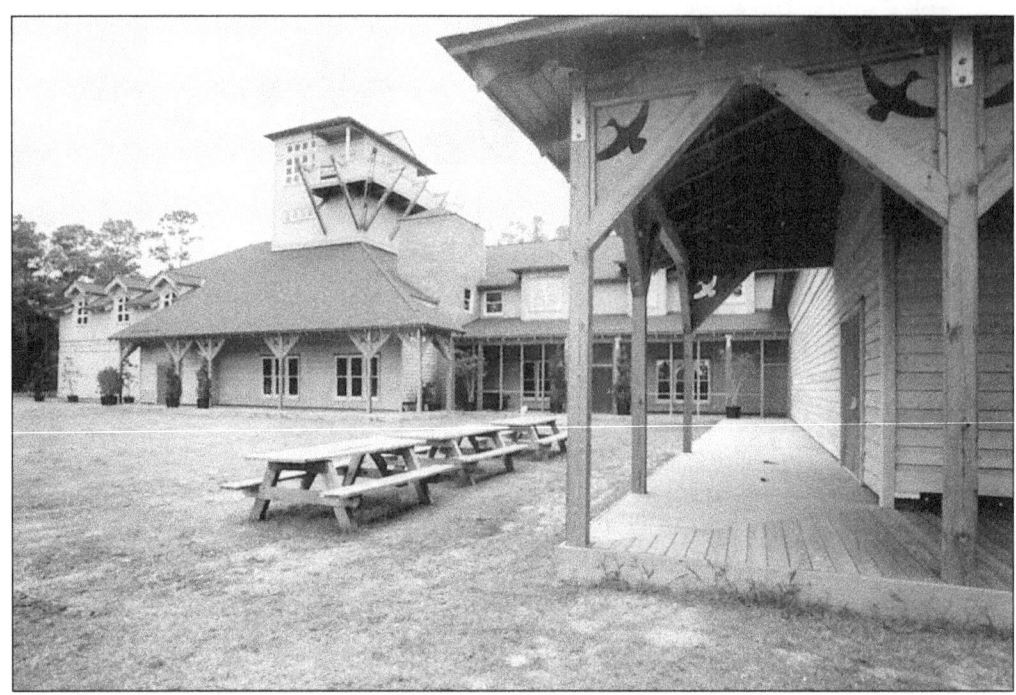

After years of planning, thousands of hours of community work, and intensive fund-raising, the Core Sound Waterfowl Museum is shown nearing completion in October 2001. The new museum is located at the eastern end of Harkers Island. (Photo by Frances Eubanks.)

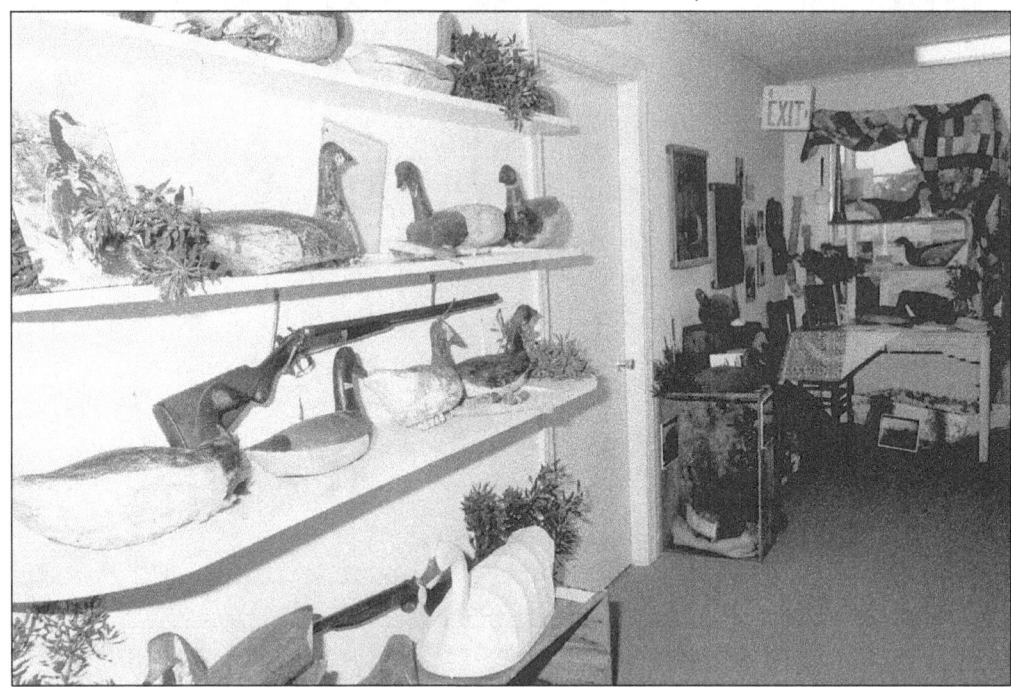

Artifact exhibits are integral to the educational programs at the Core Sound Waterfowl Museum. Exhibits will be moved and expanded, and the large collection of waterfowl carvings and art will be housed in the new facility. (Photo by Frances Eubanks.)

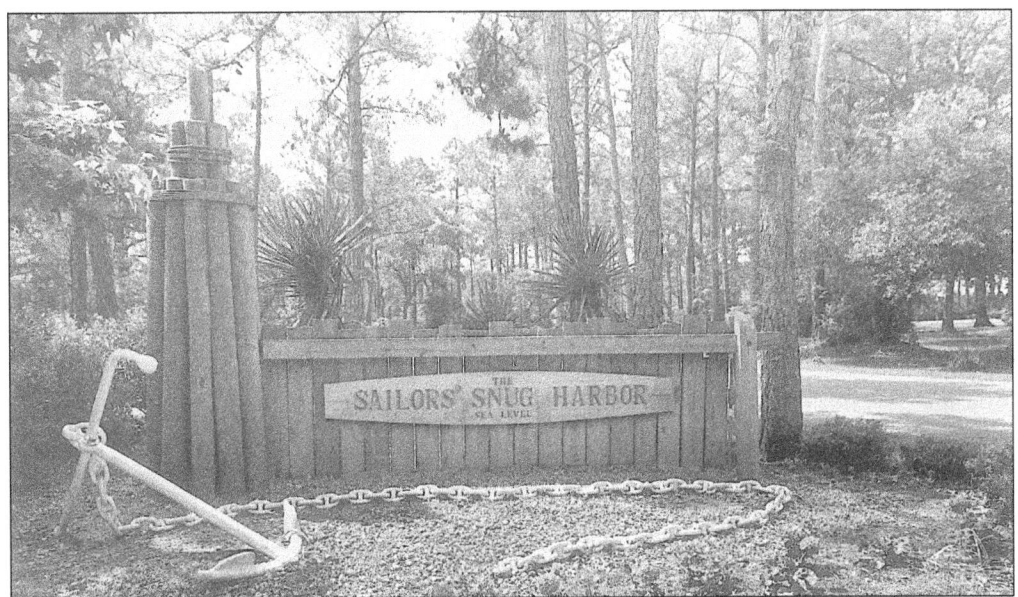

Snug Harbor, located in Sea Level, is a retirement home for mariners. Originally located in New York, the facility moved south for the warmer climate. (Photo by Frances Eubanks.)

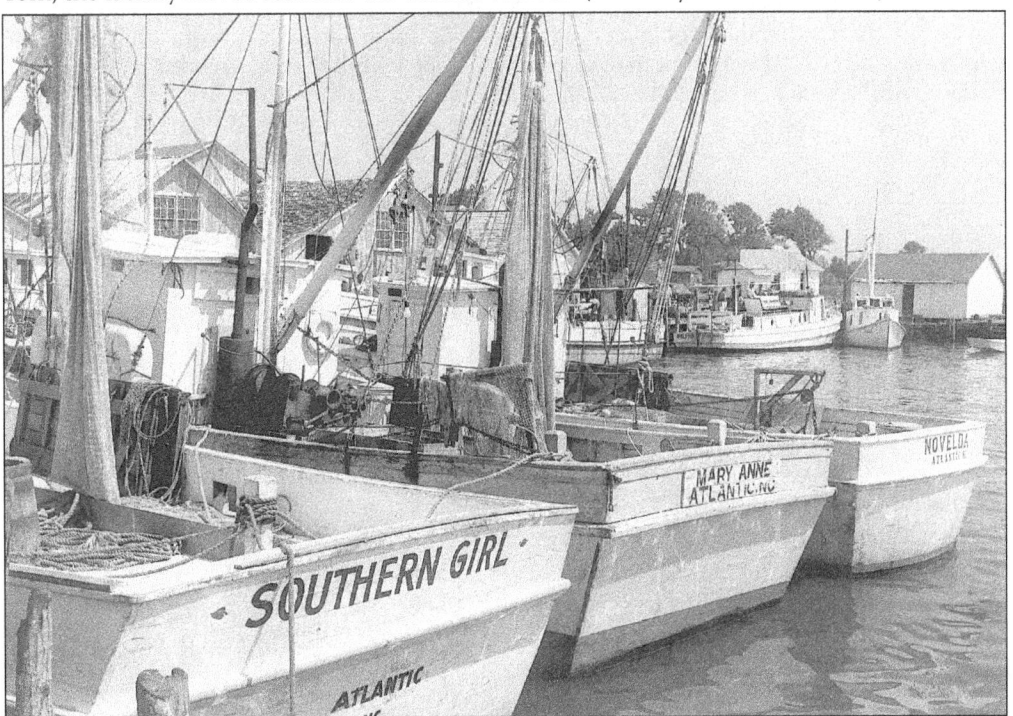

Commercial fishing is an important way of life and has always been vital to the Down East communities. Commercial fishing boats have filled community harbors since the first settlers, and boats and fishing have been a traditional part of daily life in the Atlantic community. Boats pictured in the Atlantic Harbor c. 1950 include the *Mailboat Dolphin* captained by Ansley O'Neal at the dock (far right). (Courtesy Carteret County Historical Society; photograph by Jerry Schumaker.)

The Sea Level Hospital was conceived and donated by the Taylor Brothers so that the rural isolated Down East families would have adequate medical facilities. It is now a division of the Carteret General Hospital as a clinic known as Taylor Hospital and Extended Care Facility. (Courtesy Billy Piner, private collection.)

The Sea Level Inn is located on U.S. Highway 70 and overlooks Nelson Bay. Every room is on the waterfront. The inn has been an attraction for hunters and fishermen for decades. (Courtesy Billy Piner, private collection.)

Five

PORTSMOUTH ISLAND AND THE BANKS

Portsmouth Village is located on Portsmouth Island on North Core Banks and was founded in 1753. From its earliest days until the Civil War, the islanders were engaged in shipping. The port was the busiest in the state, and hundreds of ships from all over the world could be seen waiting to unload at one of the wharves. In 1860 the population reached a high of 700. The Civil War drove hundreds of residents from the island, and after the war only 220 people remained. In the late 1800s shipping was diverted from waterways to railroads and fierce hurricanes washed over the islands. Both phenomena drove hundreds more residents off the island to seek safety and their livelihood on the mainland.

After World War II it became apparent that Portsmouth Village was in an irreversible decline. The village post office closed its doors in 1959 and the last two residents left in 1971. Even though the island lifestyle is gone forever, the village became a part of the Cape Lookout National Seashore in 1976 and is now on the National Register of Historic Sites. The spirit of the island still lives in the hearts of descendants who formed an organization, Friends of Portsmouth Island, to assist the national park and its efforts to preserve the remaining homes and buildings.

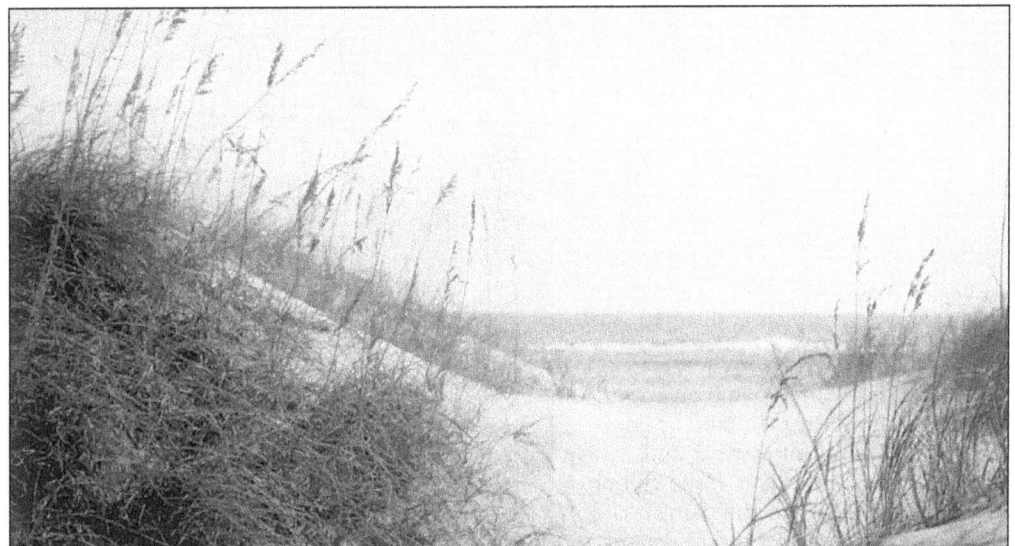

Ocean sand dunes are a stone's throw from Portsmouth Village. The dunes were sculpted from the winds of time that have built layer upon layer of pristine sand and topped them with sea oats. (Photo by Frances Eubanks.)

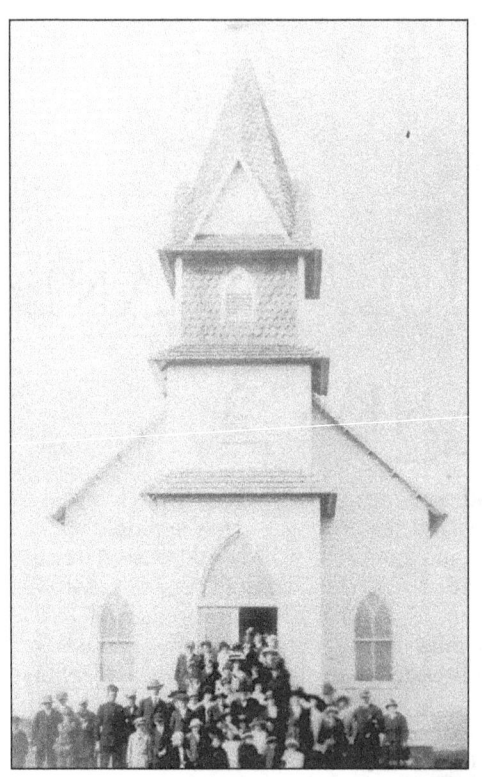

The Portsmouth Methodist Church, seen here c. 1914, offers refuge from the storms and the storms of life. Built at the turn of the century, the church was the center of the community. During the 1944 storm, the church was moved off its northwest corner foundation, resulting in a gradual list to the east over the years. It now awaits the occasional return of congregations for weddings, reunions, and celebrations. (Courtesy Dorothy Louise S. Pospisil, private collection.)

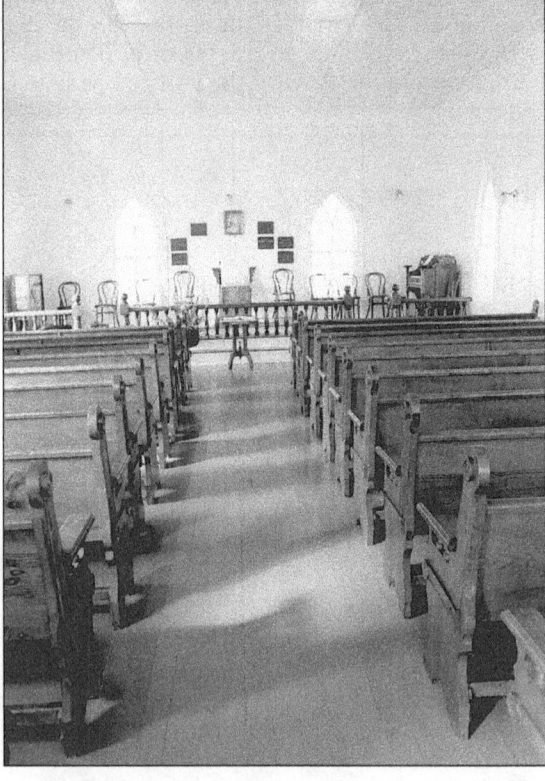

The Methodist church pump organ was transported from the mainland by boat. It has survived moisture, wind, and hurricanes since its arrival at the church in the early 1900s. The pump organ is played at Friends of Portsmouth Island Homecomings every even-numbered year. It awaits the next homecoming in 2000. (Photo by Frances Eubanks.)

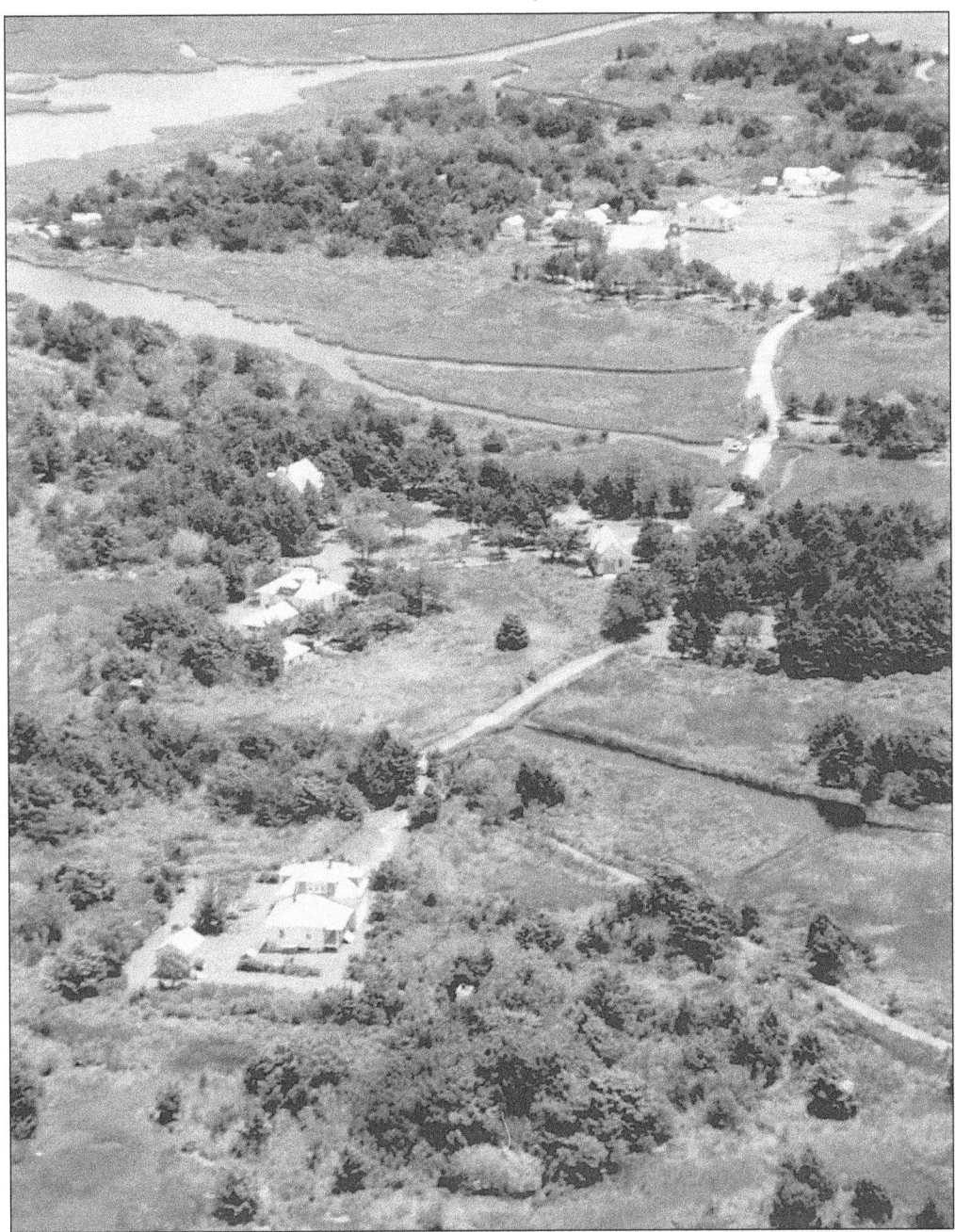

This aerial view shows Portsmouth Village in repose. In the foreground is the Bragg/Styron house and the Dixon/Salter house. Through the trees to the left is the Styron/Grace house. The road leads to the post office and Methodist church. Marian Babb's house is seen close to the church. (Photo by Frances Eubanks.)

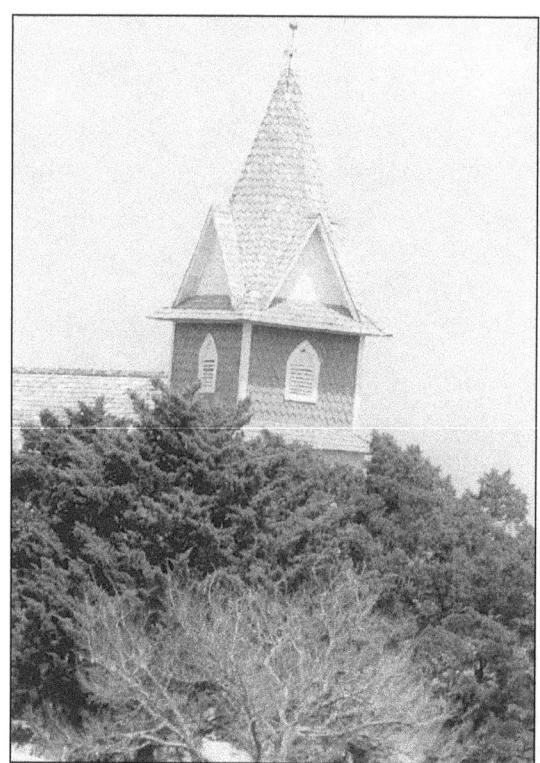

The Portsmouth Methodist Church steeple, as seen over the tree tops from the road, is an architectural landmark of Portsmouth Village. The church evokes memories from all island descendants. Church services are held several times a year by various church groups and is the scene of an occasional christening by great-grandchildren of descendants. (Photo by Frances Eubanks.)

Elma Dixon, one of the island's last residents, is seen in the church sanctuary. She and Marian Babb along with Henry Pigott were the last full-time residents of the island. The ladies stayed until Henry Pigott's death in 1971. (Courtesy Dorothy Louise S. Pospisil, private collection.)

In 1908 Nora Dixon was photographed standing beside the organ in the elaborate living room of the George Dixon house. Residents took pride in their homes and underwent great effort to bring luxuries as well as necessities by boat. (Courtesy Dorothy Louise S. Pospisil, private collection.)

Photographed c. 1920s, these young friends of Portsmouth Island are, from left to right, as follows: Sarah (Sade) Roberts Styron; Elizabeth (Daisy) Daly Gaskins; and Claudia (Sissy) Daly Babb. (Courtesy Dorothy Louise S. Pospisil, private collection.)

Members of the Lifesaving Service stand at attention on the porch of the Portsmouth Lifesaving Station. The station was completed on June 24, 1894, and was in charge of Watchman A.J. Styron. The men drilled, patrolled the coast, and ultimately saved lives from boats in distress. (Courtesy Dorothy Louise S. Pospisil, private collection.)

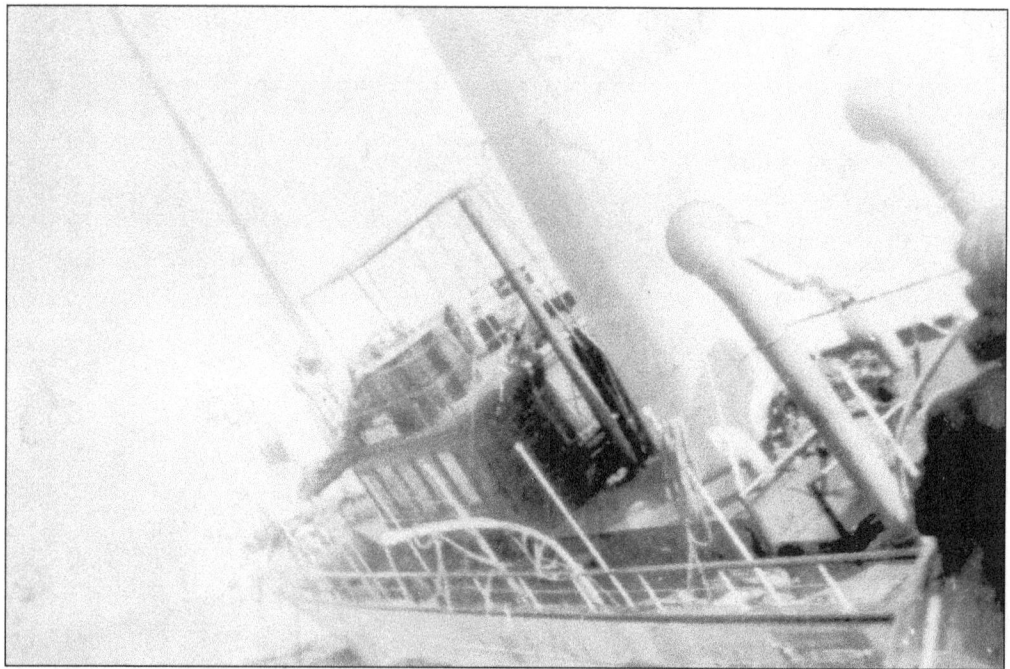

Vessels aground were not an unusual sight off Portsmouth. Members of the Lifesaving Service risked their lives to save others from boats aground and those overboard. Many islanders collected part of their possessions from shipwrecks that washed up on the beach. The steamship in the picture is hard aground. (Courtesy Dorothy Louise S. Pospisil, private collection.)

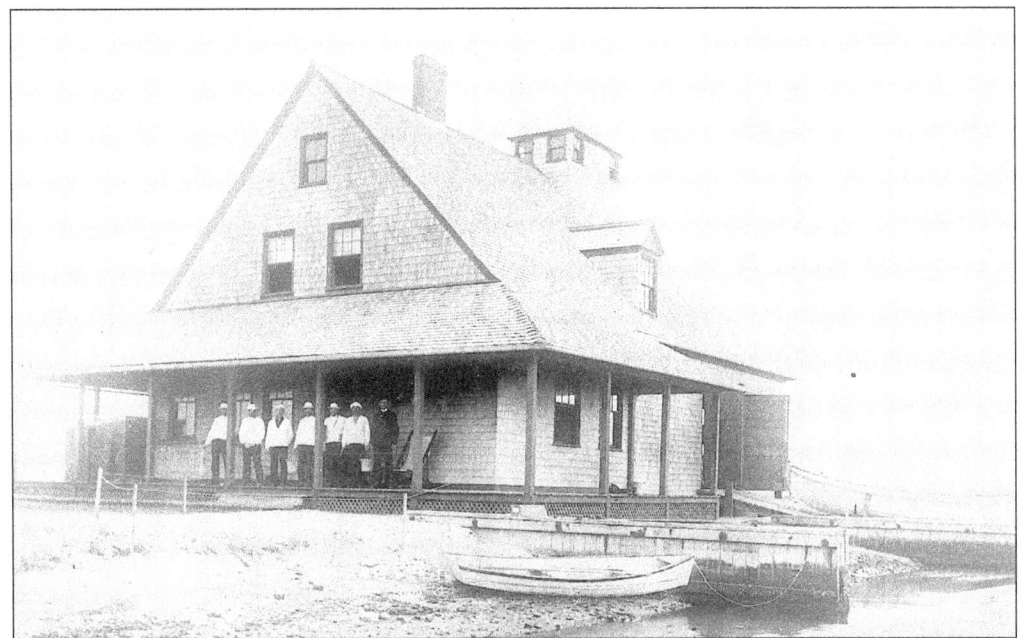

On July 15, 1893, the U.S. secretary of the treasury gave permission for part of the Marine Hospital grounds to be used as a site for building the Portsmouth Lifesaving Station. The station saw service into the twentieth century and then became the United States Coast Guard. (Courtesy North Carolina Department of Archives and History.)

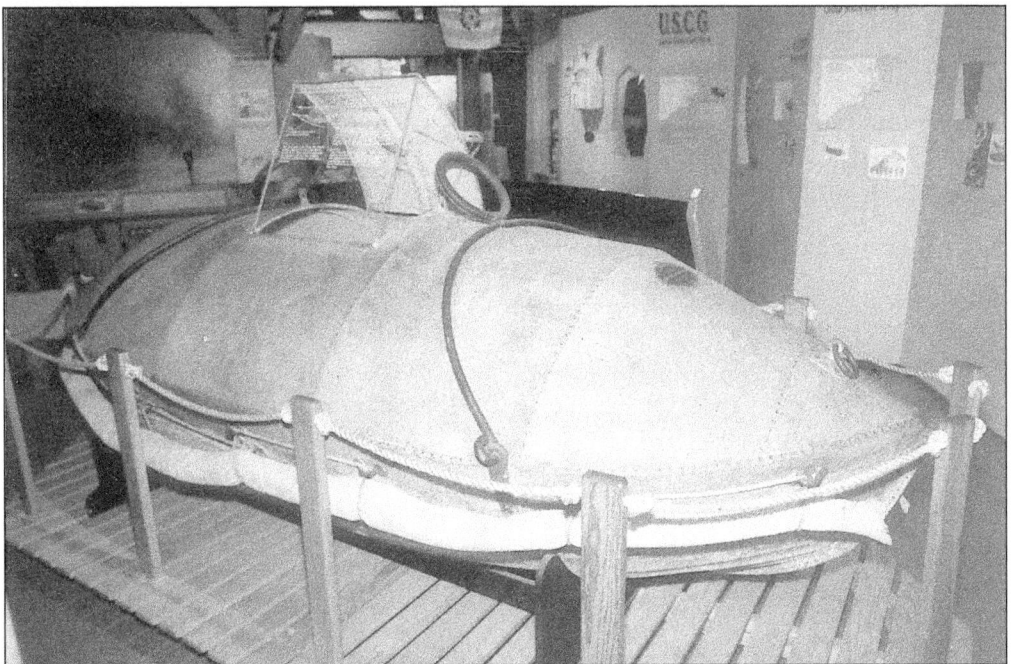

The life car in the photo is part of an exhibit at the North Carolina Maritime Museum in Beaufort. When a vessel was aground and a line could be rigged from the ship to the shore, the "car" could be controlled by the surfmen to transport crew and passengers from the ship to shore. (Photo by Frances Eubanks.)

Lionel Gilgo is perched on the hood of Walter Styron's car as it is towed by scow from Core Banks to Atlantic. The Styron family had invited Gilgo on a trip to Norfolk. Eight-year-old Dorothy Louise was in the car when Captain Will Mason snapped the photo. (Courtesy Dorothy Louise S. Pospisil, private collection.)

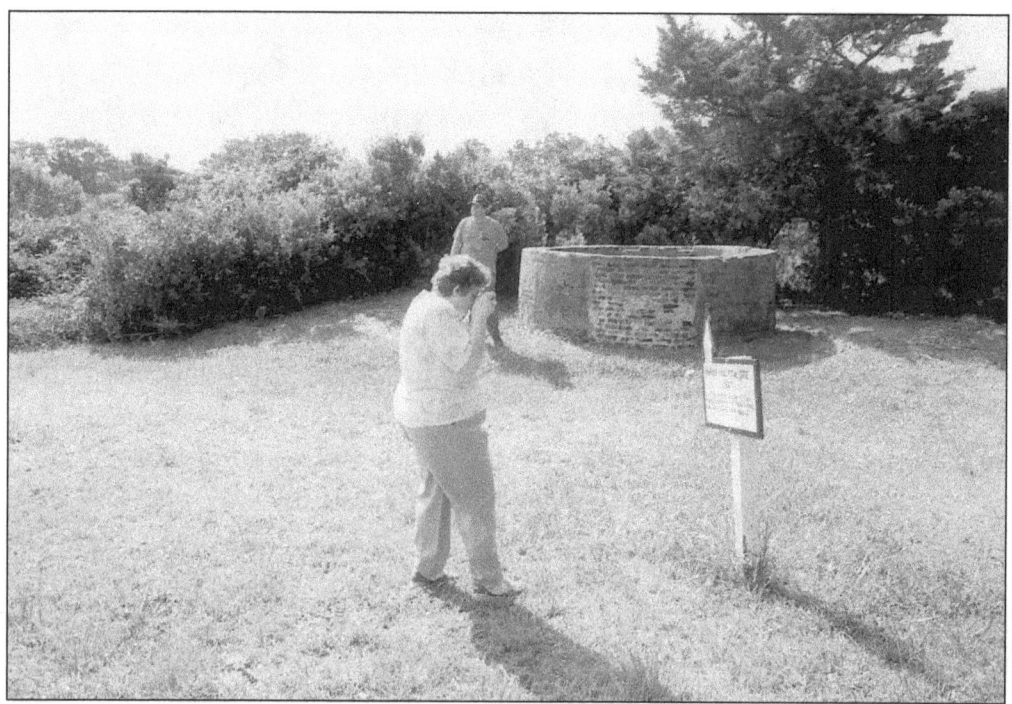

The cistern is all that is left of the Marine Hospital on Portsmouth, which was built in 1834. Pictured are William Swindell Dudley III and Ann Dudley Grant, the great-great-grandchildren of Dr. Samuel Dudley, Portsmouth's only doctor for many years. (Photo by Frances Eubanks.)

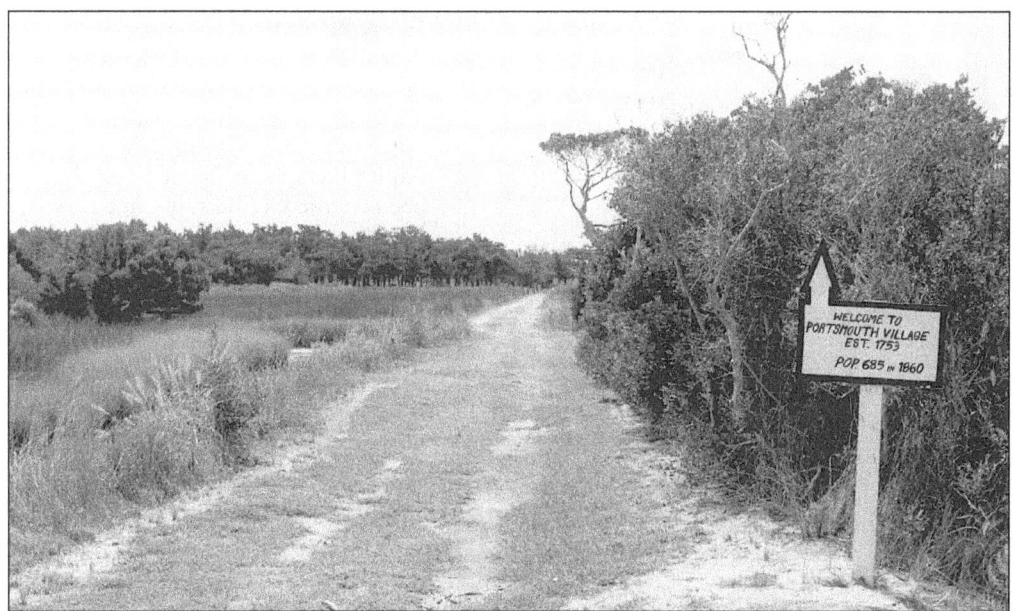

The main road into Portsmouth runs from the haulover dock, where the passenger ferry off-loads visitors to the island. The road leads straight to the post office, which was decommissioned in 1959. (Photo by Frances Eubanks.)

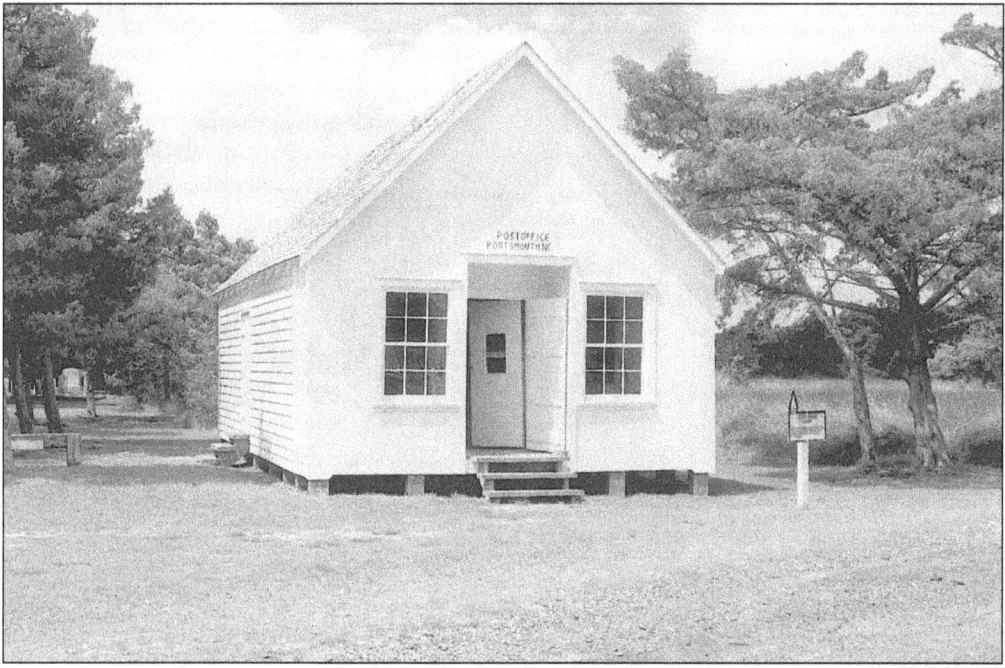

The post office was refurbished by the Park Service and was opened to visitors in 1996. In its hey day, it was the daily gathering place for islanders and visitors. Many people came and awaited the mail delivery. The other side of the building served as the general store. (Photo by Frances Eubanks.)

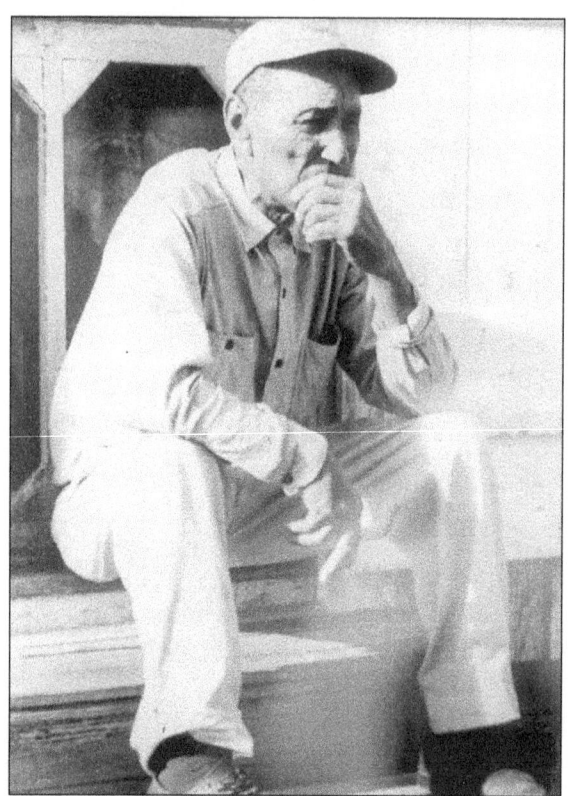

Henry Pigott lived his entire life on Portsmouth. He was the island's last mail carrier and remained on the island as one of the last three residents—the other two being Marian Babb and her Aunt Elma Dixon. Their houses have been restored. (Courtesy Cape Lookout National Seashore.)

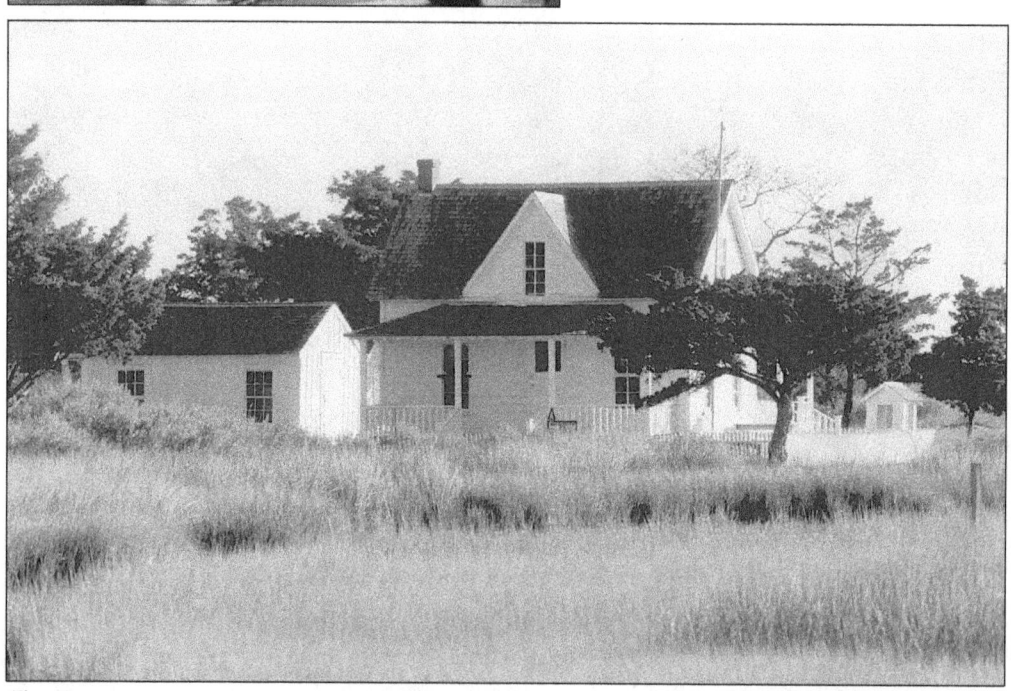

The Pigott House, where Henry lived with his sister Lizzie, has been preserved by the Cape Lookout National Seashore. Ill health forced him to move to Ocracoke, where he lived under the care of Junius Austin until his death in 1971. (Photo by Frances Eubanks.)

In this photo taken in October 1956, the people are, from left to right, as follows: Sarah Styron, her grandson Junior Pospisil, and Lizzie Pigott, who was Henry's sister. At the time Portsmouth Village's population was small, but it was still an active community with many family visitors returning to see friends and relatives. (Courtesy Dorothy S. Pospisil, private collection.)

Henry Pigott and Walker Styron are seen socializing in Lizzie Pigott's summer kitchen in November 1955. Most of the island's kitchens were detached from the houses as a protection against fire and to keep the heat out of the main house in the summer. (Courtesy Dorothy Louise S. Pospisil, private collection.)

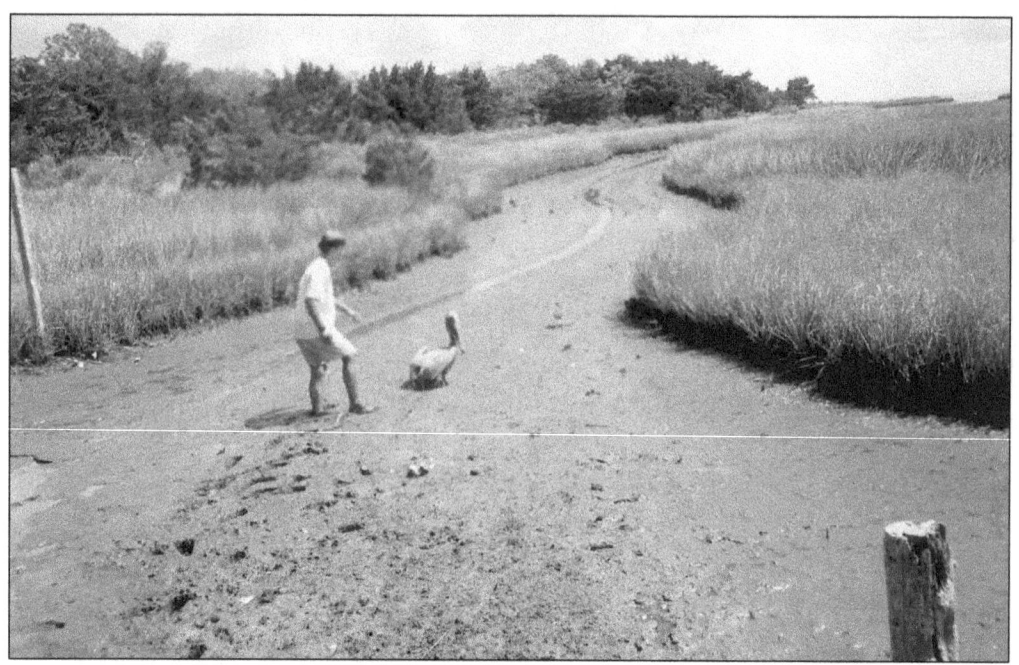

Doctor's Creek is pictured at low tide. A Park Service employee is rescuing an ailing pelican. On high tide, flat-bottom skiffs can pull up to the dock. (Photo by Frances Eubanks.)

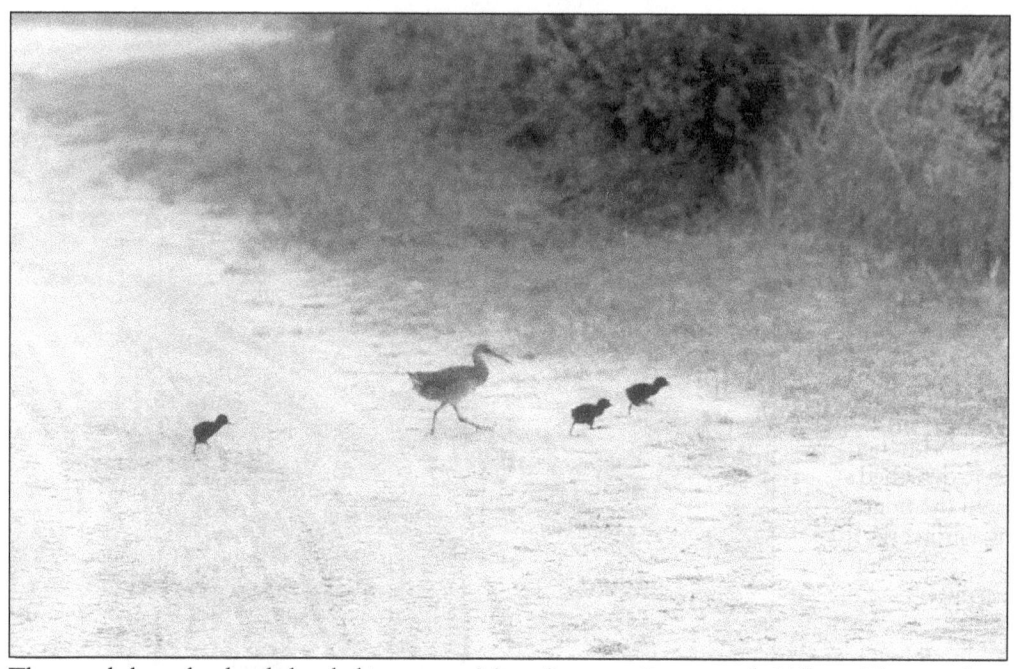

The marsh hen shepherds her babies across Main Street in Portsmouth Village. The one-lane sandy avenue has always welcomed the island's natural inhabitants to share the road. (Photo by Frances Eubanks.)

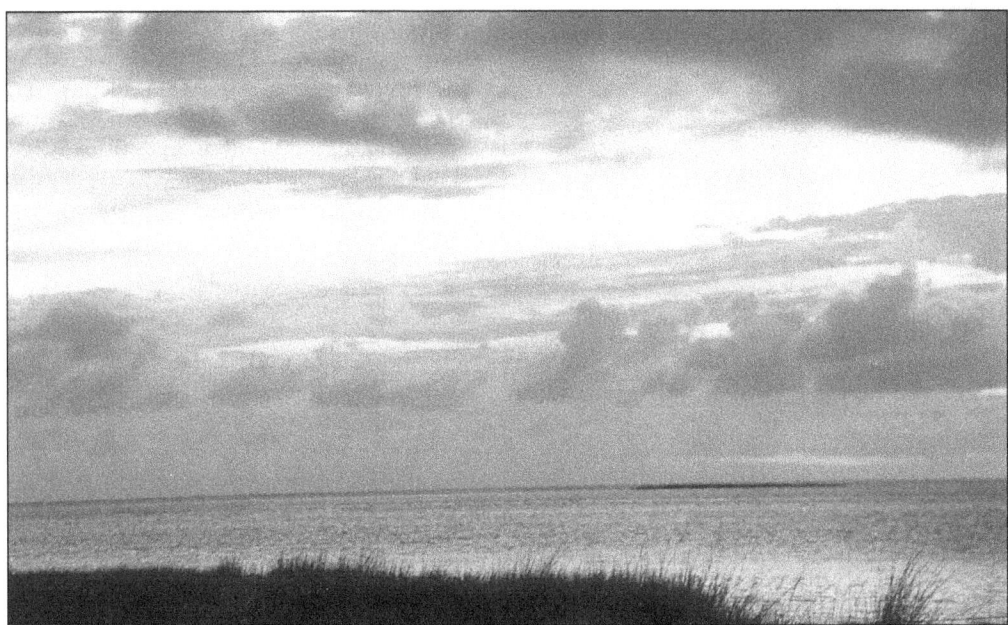

The sun sets on Portsmouth looking out over Core Sound. The photo was made near the haulover dock, where daytime visitors come and go. Approximately 700 people visit Portsmouth Village per month during spring and summer. (Photo by Frances Eubanks.)

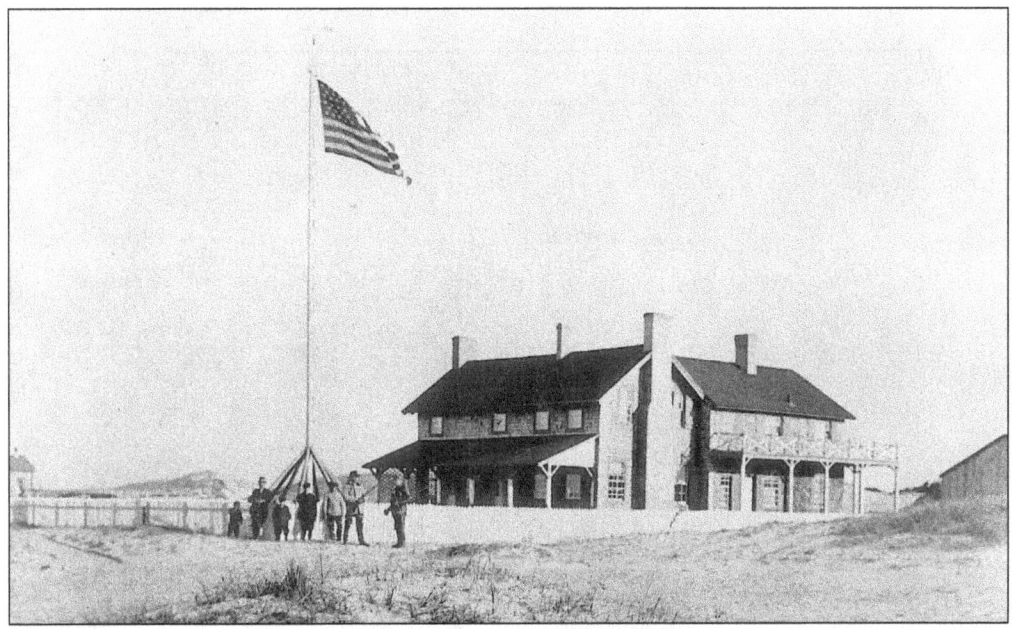

The Pilentary Hunting Club was built on Portsmouth Island about 10 miles west of the village by wealthy New Yorkers. The club was named for the Pilentary tree that once grew on the island. The area was isolated, yet no money was spared in transporting the necessary supplies to build the most elegant gun club of its day. It was host to many celebrities including Franklin D. Roosevelt. (Courtesy North Carolina Department of Archives and History.)

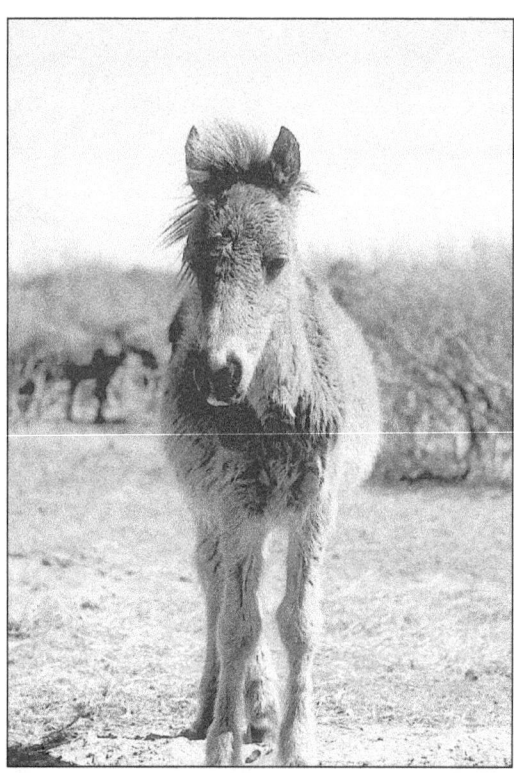

Banker ponies are widely known for their history, stamina, and beauty. Considered an endangered species and now protected by legislation, they have run free and wild on Shackleford Banks for hundreds of years. (Photo by Frances Eubanks.)

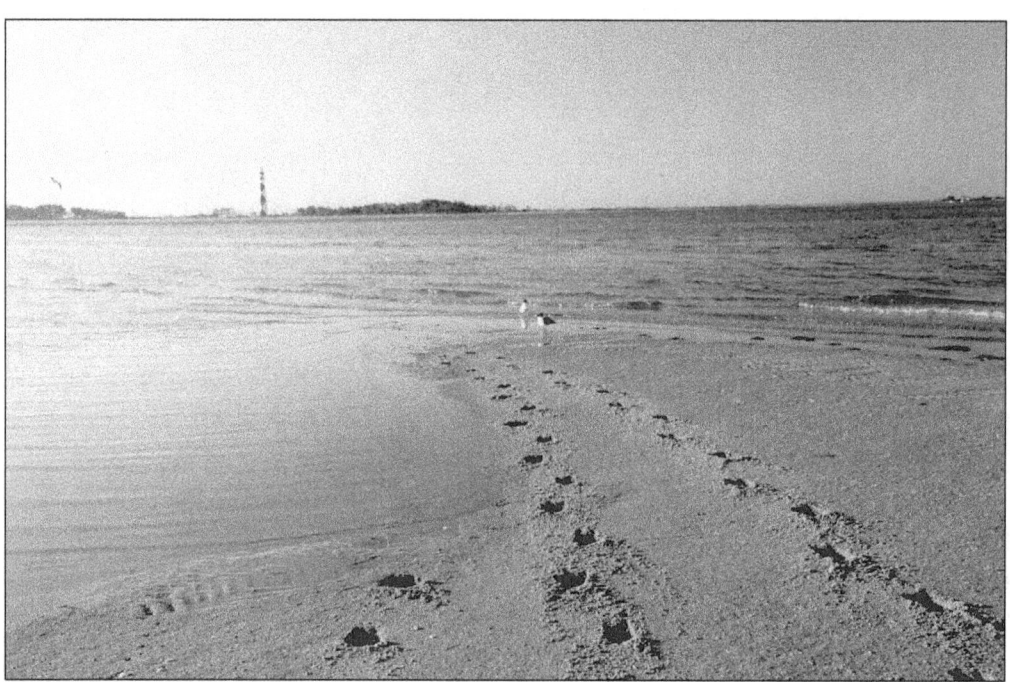

Horse hoof prints are visible in the beach sand across the Bight on Shackleford Banks looking toward Cape Lookout and the Cape Lookout Lighthouse. (Photo by Frances Eubanks.)

The wild banker ponies on Shackleford Banks are related to Spanish mustangs that are thought to have swum ashore from Spanish ships that ran aground and broke up on the shoals. The herd's presence has been documented to precede European colonization. (Photo by Frances Eubanks.)

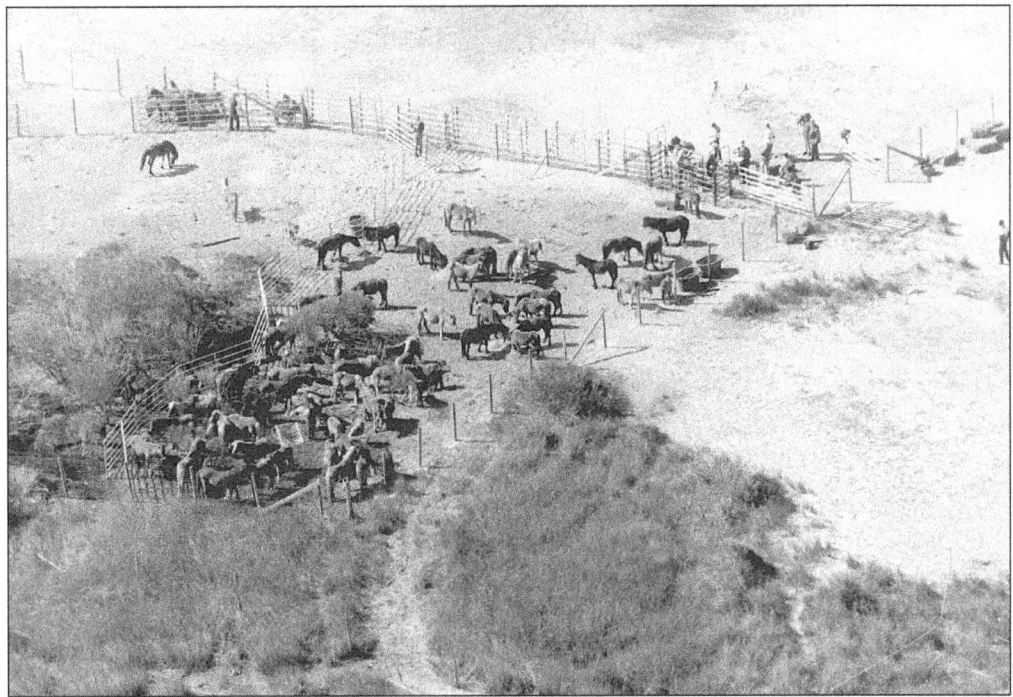

The pony round-up and penning in 1996 was held by the Cape Lookout National Seashore administration to test the herd for equine infectious anemia. The herd was rounded up by herding dogs, horses, and all-terrain vehicles. (Photo by Frances Eubanks.)

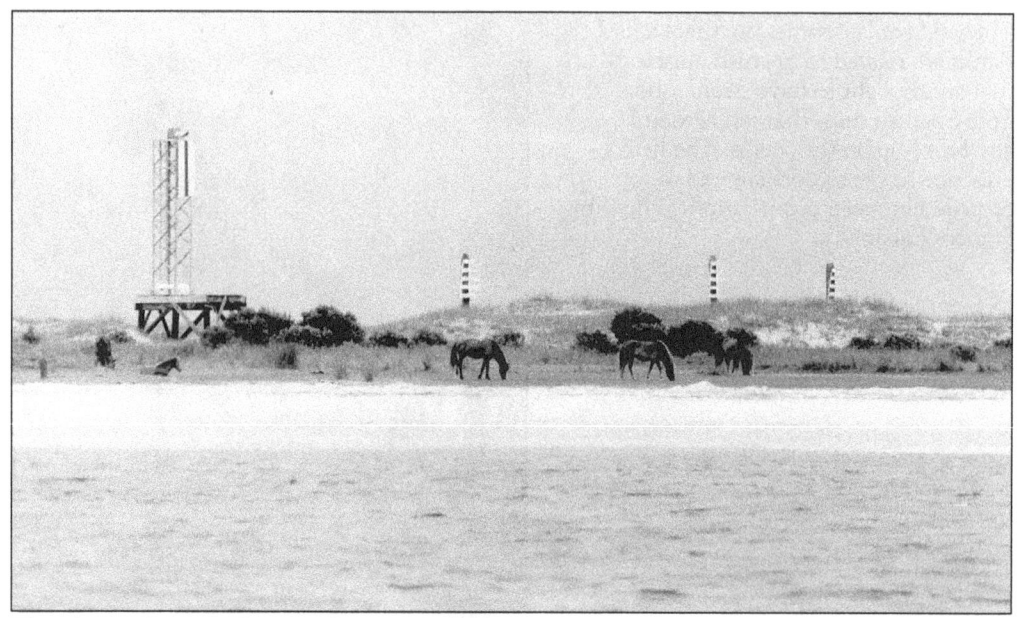

The above photograph was taken inside Beaufort Inlet looking toward the range markers on Shackleford Banks. It was in sight of this inlet that Blackbeard's flagship was sunk in 1718. (Photo by Frances Eubanks.)

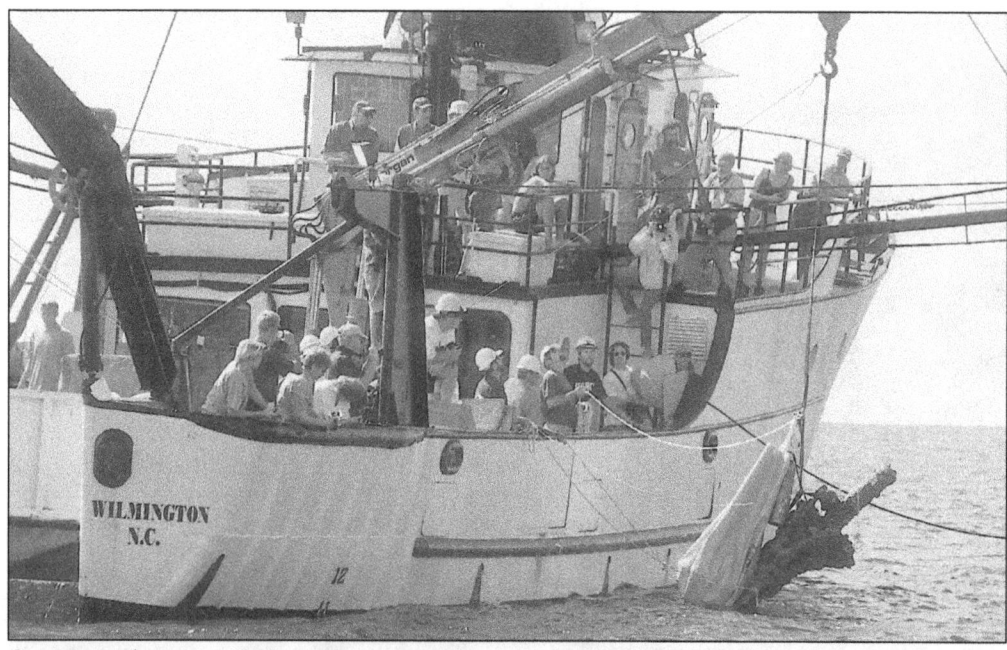

On November 21, 1996, private researchers working for the North Carolina Division of Archives and History found the remains of a sailing vessel believed to be the *Queen Anne's Revenge*, the long lost flagship of the pirate Blackbeard. The vessel was sunk in June of 1718 and originally had 20 cannons. Pictured above is the raising of the third cannon on October 12, 1998. (Photo by Frances Eubanks.)

A 6-inch-long pewter syringe was brought up during the recovery mission. The curved funnel tip is like a modern irrigation syringe. Possible uses of the artifact include administering medicine, wound irrigation, or lubricating delicate mechanical devices. The artifacts shed light on a period of history and provide a look into the lives of pirates. (Photo by Frances Eubanks.)

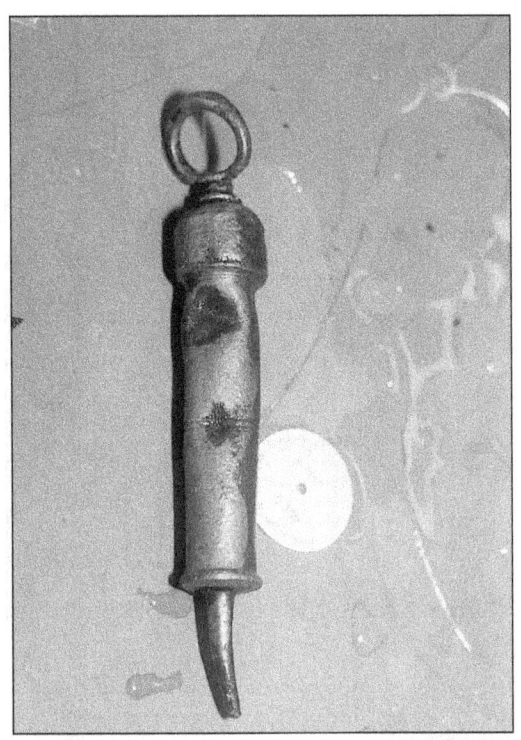

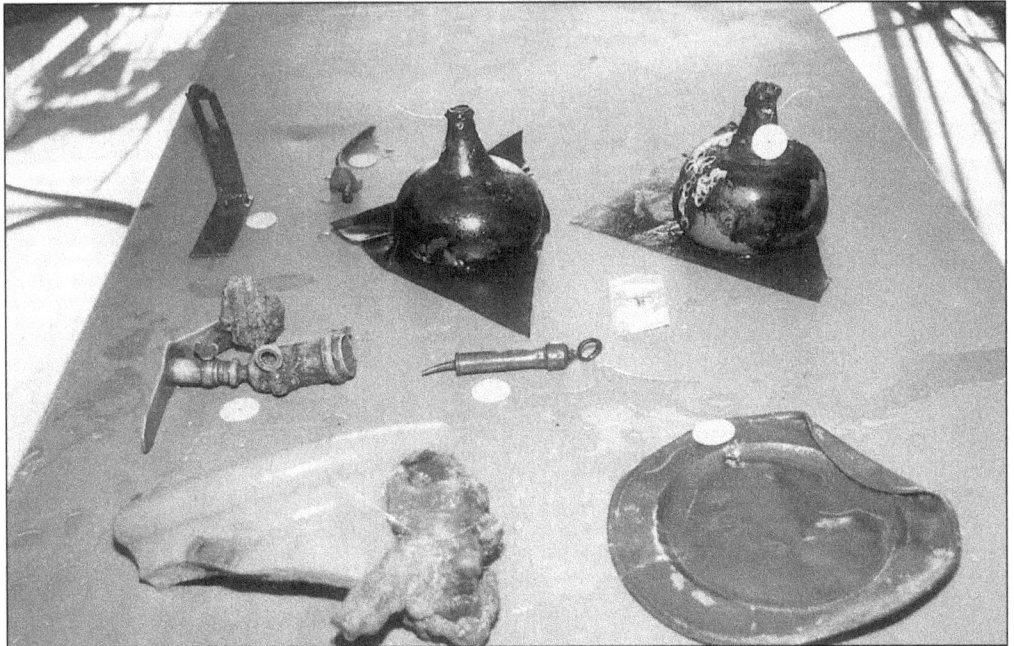

Many artifacts have been recovered. Among those above is a brass swivel mount, complete with a ball and socket component. The pewter plate features a marking of a London manufacturer. Non-intrusive archaeological techniques have been used in the site examinations. The artifacts are on display at the North Carolina Maritime Museum in Beaufort. (Photo by Frances Eubanks.)

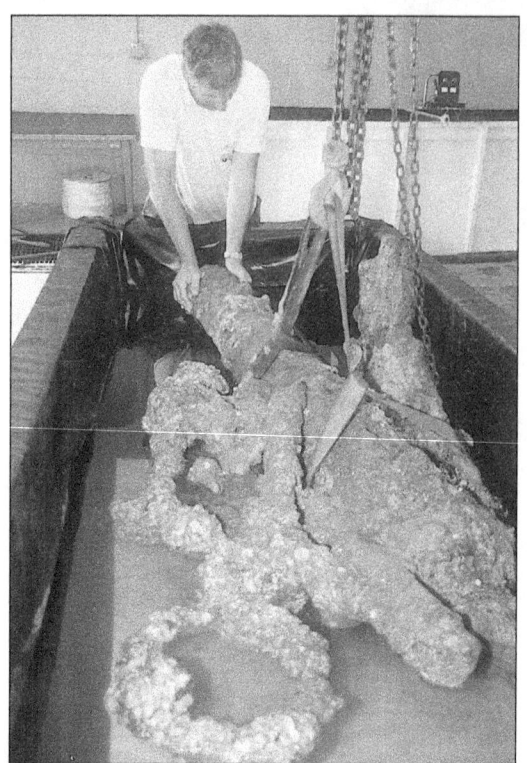

A cannon is placed in the conservation tank at North Carolina Maritime Museum facility on Gallant's Channel. Also raised have been lead shot and pieces of ceramic storage bottles. All artifacts recovered during expeditions are analyzed, stored, and preserved at the museum's conservation facility. (Photo by Frances Eubanks.)

Two 5.5-by-5.5-inch onion bottles were found in good shape; they are glass English wine bottles resembling bottles that date to 1714. (Photo by Frances Eubanks.)

Six

THE STORMS

Residents of Carteret County are aware of wind, storms, gales, and hurricanes. They know the meaning of cloud formations, nor'easters, water spouts, and sou'easters. Storms are an important part of the county's history. The earliest storm records also took note of the extraordinary bravery required of the residents of the barrier islands referred to as the Banks. These residents had no other choice than to tough out the ferocity of nature.

Such tempests caused a large part of the Banks population to move to the mainland and also to Harkers Island. The Hurricane San Ciriaco in 1899 devastated the barrier islands, washing over houses and gardens and uncovering graves.

Today's modern forecasting warns residents in time for them to seek higher ground, yet nothing can stop the storms. No one will ever get used to hurricanes, but interestingly, no one who lives in Carteret County would ever want to leave the sea.

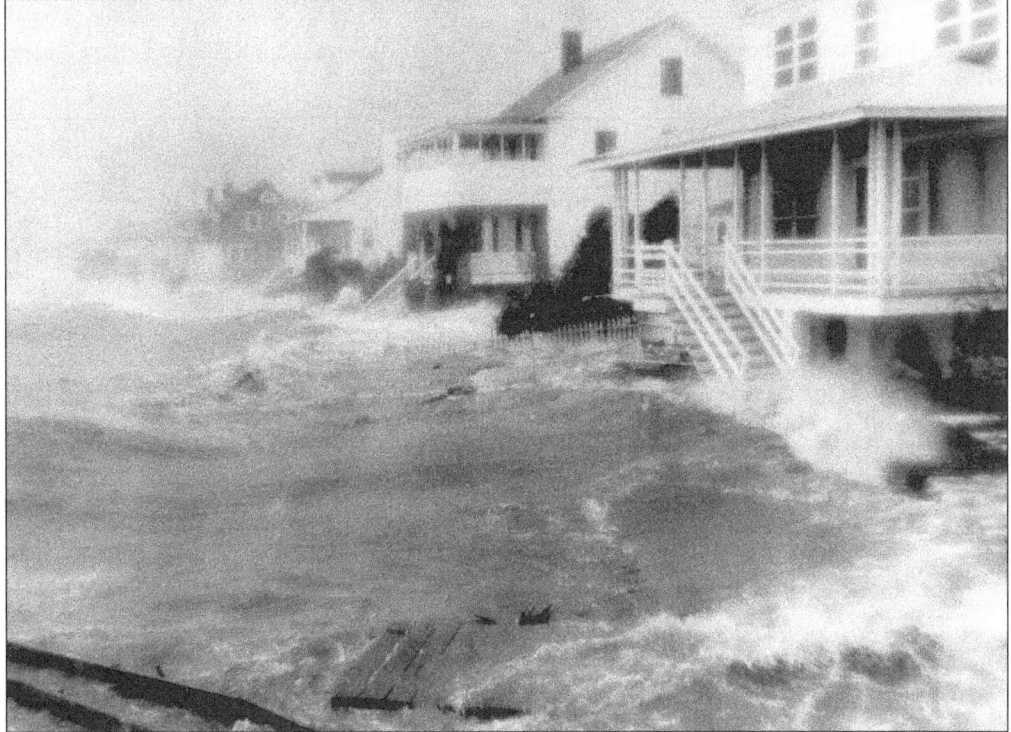

Hurricane Hazel in October 1954 was one of the more infamous storms to hit Carteret County. The eye passed approximately 100 miles west of the county, causing the area to catch the devastating northeast portion. High tides flooded parts of Morehead City. This famous photograph shows the rage of Bogue Sound, looking more like the Atlantic Ocean. (Photo by Clifton Guthrie.)

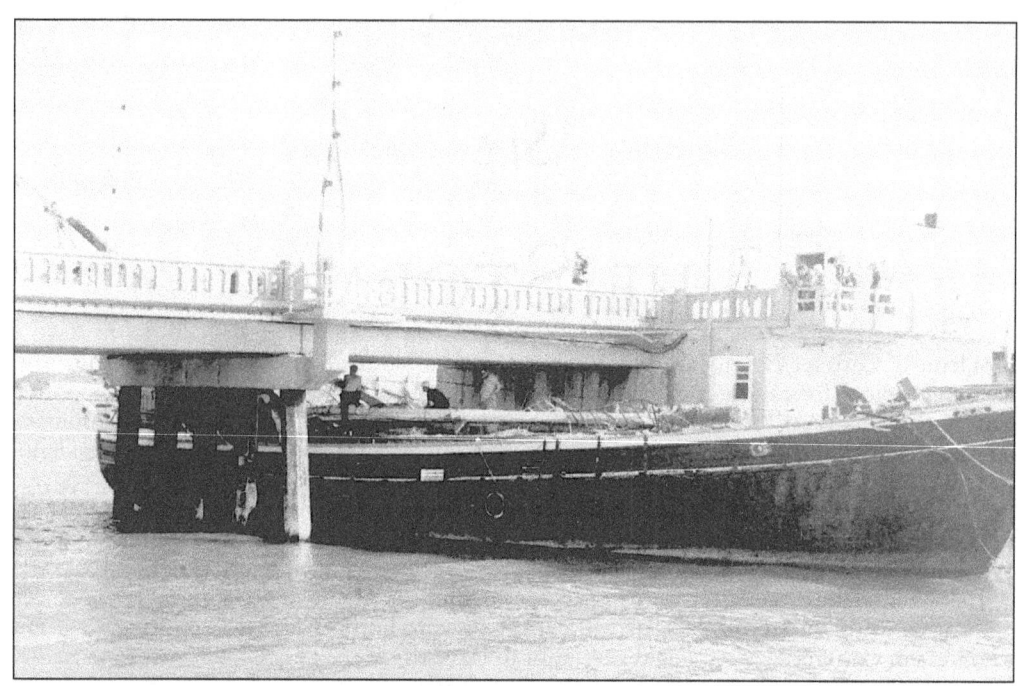
Hurricane Gloria hit in September 1985 and rushed across the barrier islands toppling trees and flooding streets. Many citizens stayed to "ride-out" the storm, which reached a level three intensity. (Photo by Frances Eubanks.)

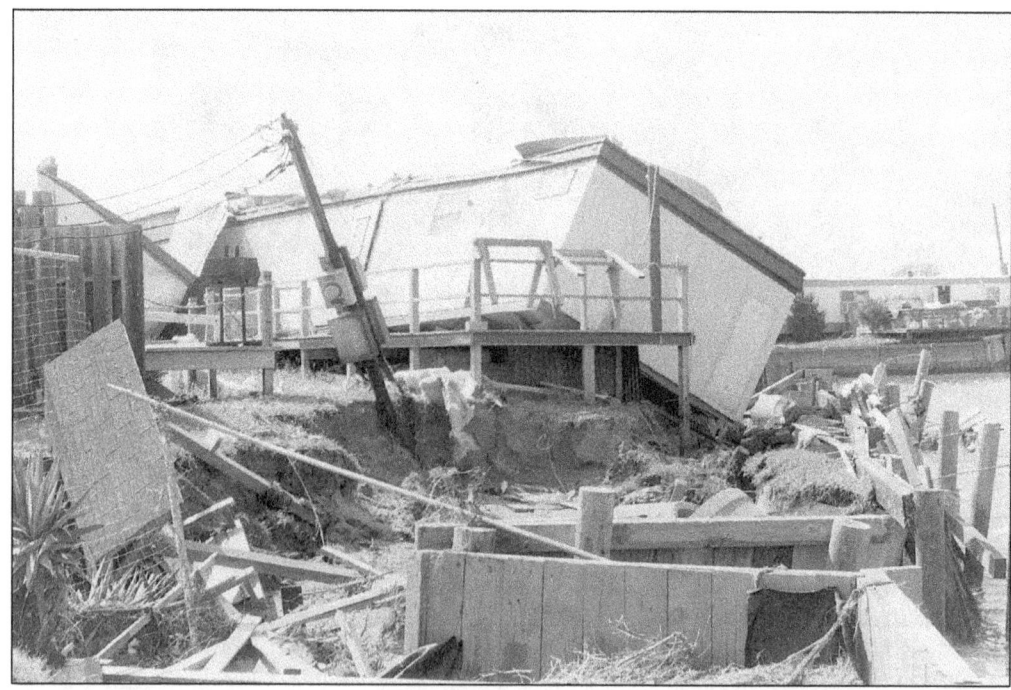
Hurricane Gloria skirted the coast of North Carolina and directed its energy north all the way to Long Island, New York, before it dissipated. On September 22, 1985, it curved through the coast of North Carolina and then passed up the East Coast. (Photo by Frances Eubanks.)

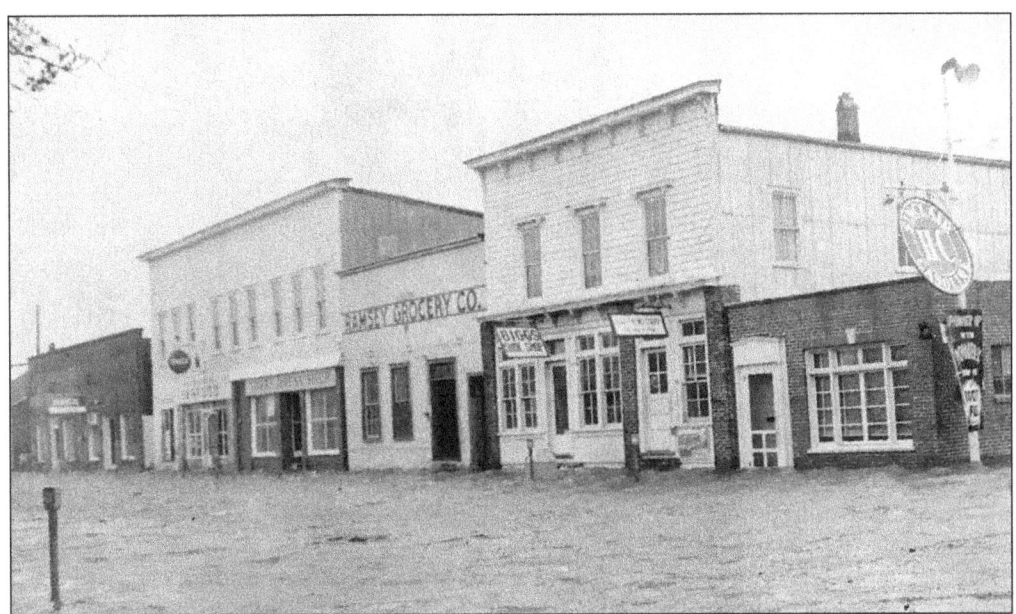

Hurricane Hazel was a category four hurricane and remains as one of the most intense and deadly storms ever to strike the United States. Pictured is Front Street in Beaufort, which went under water. Notice that water is nearly over the parking meters. The surge struck at the exact time of the highest lunar tide of the year—the full moon of October—and was the greatest surge in recorded history. (Courtesy *Carteret County News Times*.)

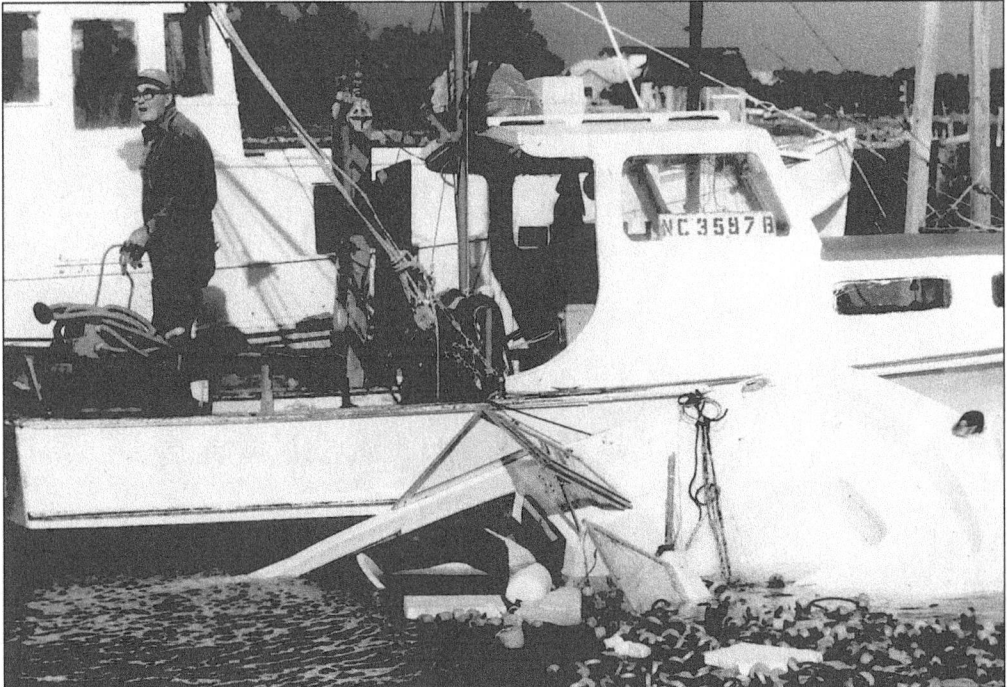

Hurricane Fran slammed into the North Carolina coastline in September 1996. It was referred to as Hurricane Hazel II when the ferocity of the impact was compared. It eroded the beaches and tumbled houses off their foundations and into the ocean. (Photo by Frances Eubanks.)

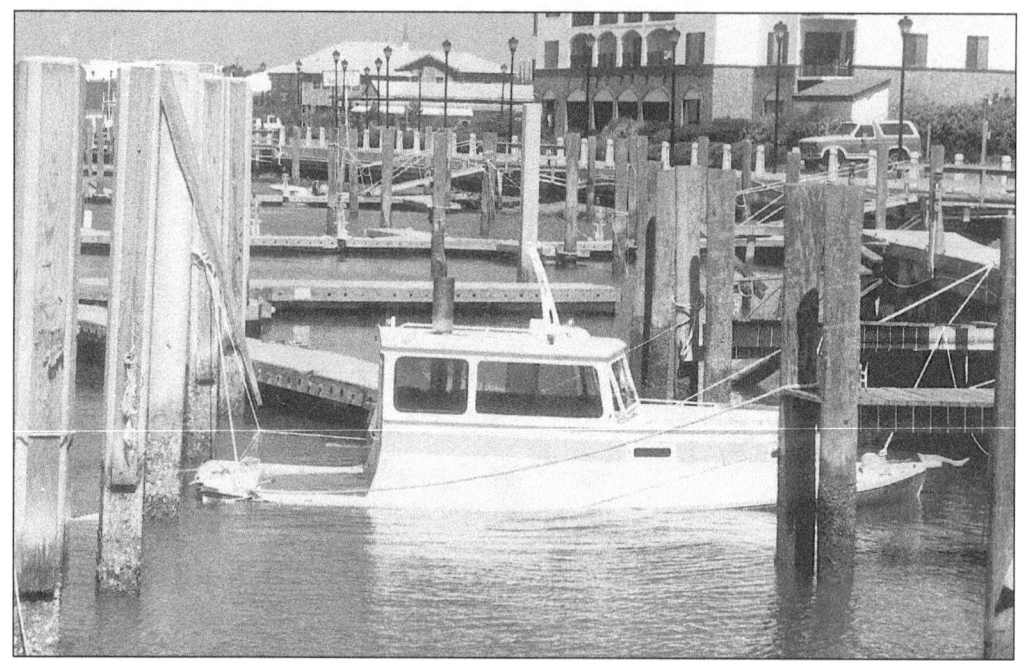

After Hurricane Fran made landfall near Southport, it tore across the coast sustaining winds of 105 miles per hour. Brunswick County to the south took a punch as the storm knocked down a pier before moving north to Carteret. (Photo by Frances Eubanks.)

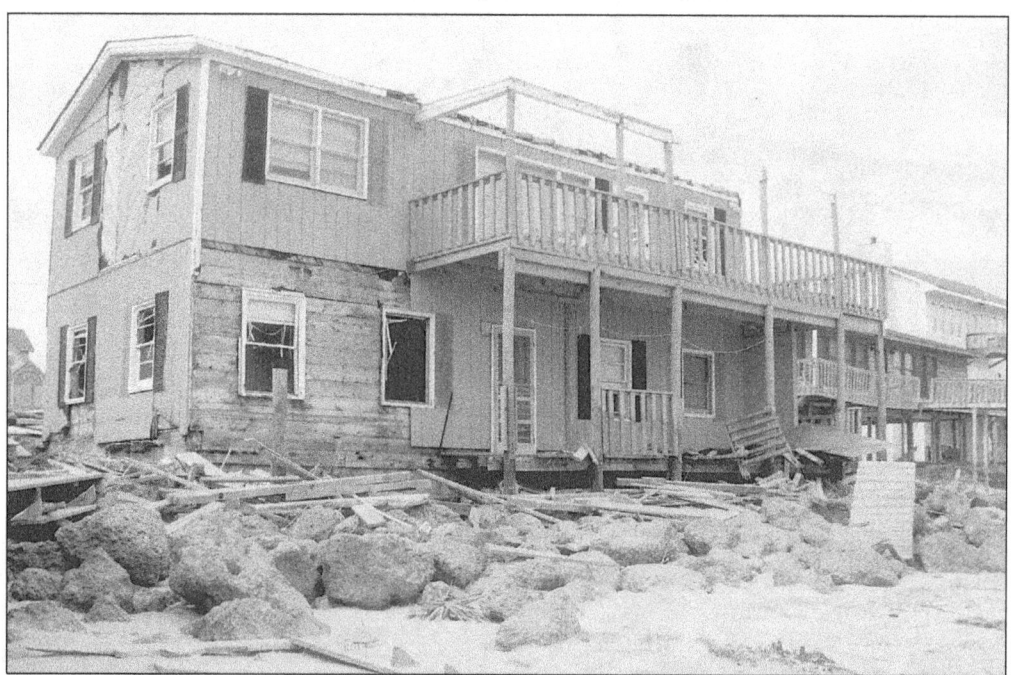

The aftermath of Hurricane Fran is reflected above. As the tide reached 12 feet above normal, flashflood warnings were issued for the entire state. The storm bent pine trees to a 45 degree angle, broke signs in two like match sticks, removed roofs from houses, and lifted mobile homes off their foundations. (Photo by Frances Eubanks.)

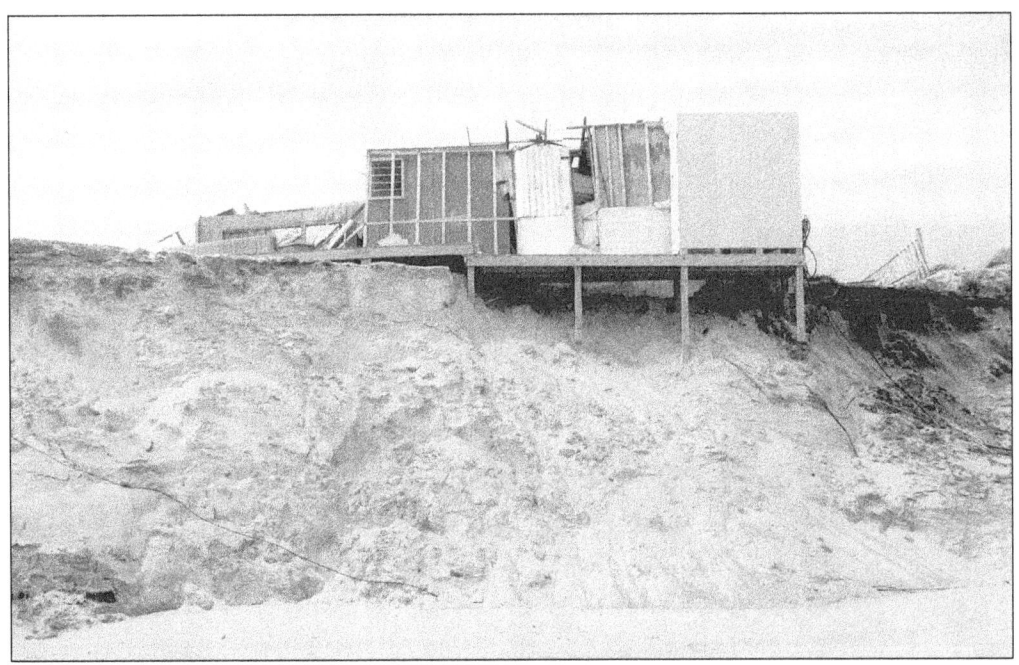

Hurricane Fran forced the residents of the low-lying areas on the Pamlico Sound to flee to higher ground. Coming on the heels of Hurricane Bertha, the damage was magnified if businesses and homeowners had not completed repairs. A second hurricane in one season meant double work for residents. (Photo by Frances Eubanks.)

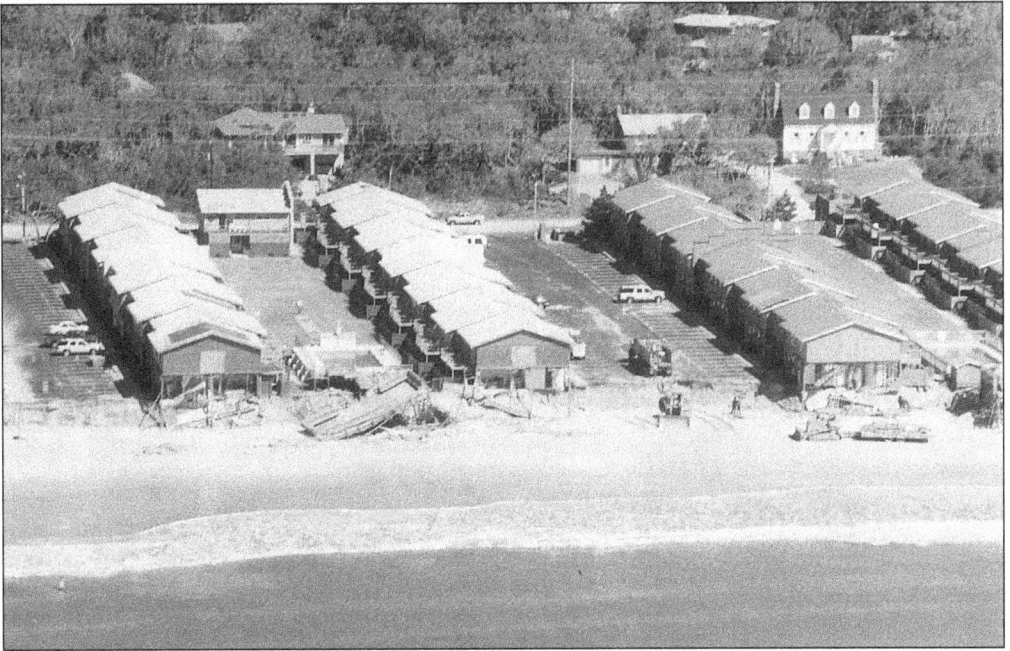

In September 1999, Hurricane Floyd roared up the Southeastern coast as first a strength five and then four storm. Carteret County felt its impact with flooding and erosions. The Pine Knoll Towne condominiums are pictured after the sea swept away sand from its foundation. (Photo by Frances Eubanks.)

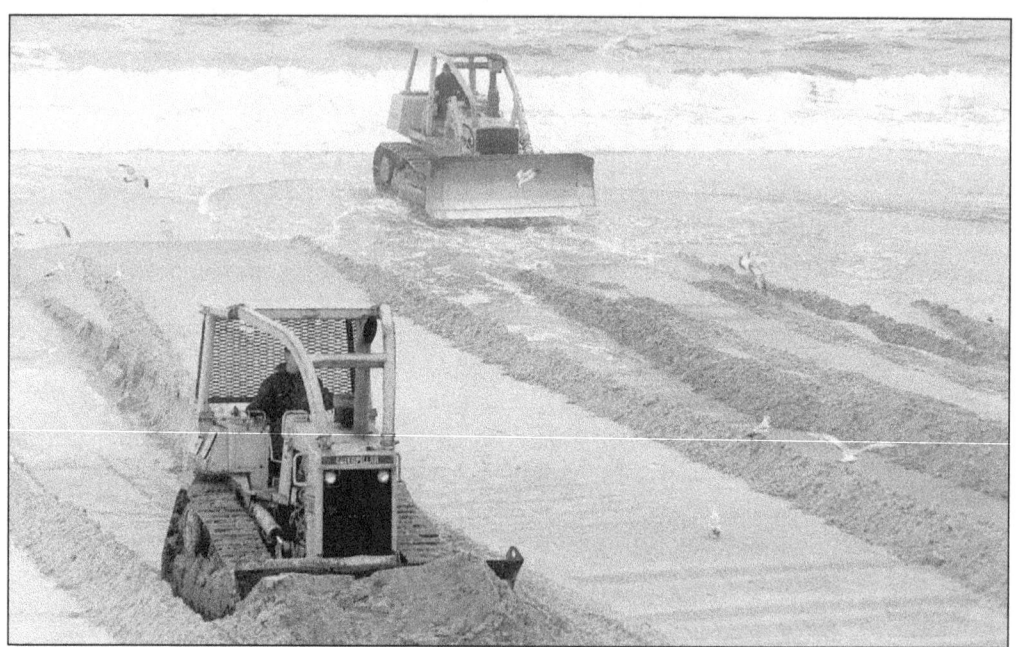

Hurricane Fran hit just two months after Bertha, and many areas had little time to complete the clean up from the first hurricane. Bulldozers are pictured above in an attempt to repair the beach and perhaps "buy" a little time for owners of front-row houses. (Photo by Frances Eubanks.)

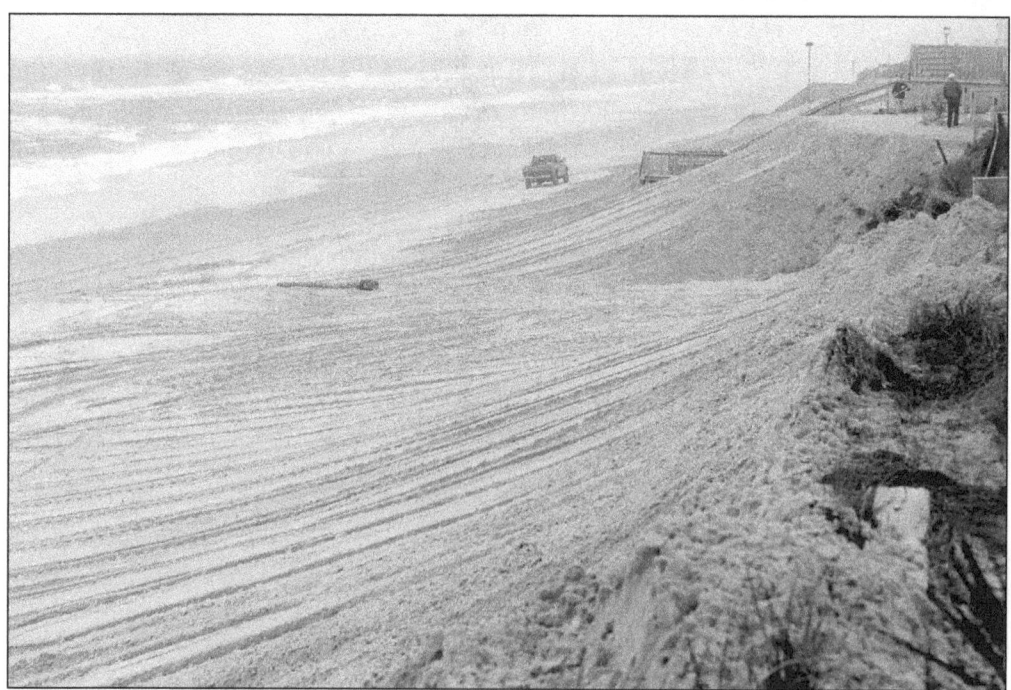

After hurricanes, erosion control is used in a dramatic attempt to rebuild beaches. It is usually a short fix for a problem that is beyond human control. Citizens and homeowners hope for tides to redirect themselves and rebuild certain beach areas. (Photo by Frances Eubanks.)

Seven
SCRATCHING A LIVING

From the very beginning, the settlers of Carteret County scratched a living from the sea and from the land. They were hardy and hardworking. In the earliest years, they were isolated except from the sea. Subsistence farming and fishing took care of all their families' needs. The railroad brought a way out for residents and a way in for tourists, hunters, and entrepreneurs.

The settlers on the banks were boatbuilders by necessity. By the end of the eighteenth century, many had become master boatbuilders and were sought out among their neighbors and kin to build boats for community members. Harkers Island became known as a haven for boatbuilders and their families. Master builders were known for building boats without blueprints. Pictured is the hull of a hand-constructed wooden boat. Most boats were built after fishing season was over. (Courtesy Carteret County Historical Society.)

Beaufort Fisheries is one of the largest employers in Carteret County and is the only remaining menhaden processing plant. Oil is squeezed from the menhaden, and the dry fish is cooked and sold to be used as aqua-culture feed for catfish. It is also used as feed supplements for poultry and swine. The oil is exported to Europe or used in margarine. (Photo by Frances Eubanks.)

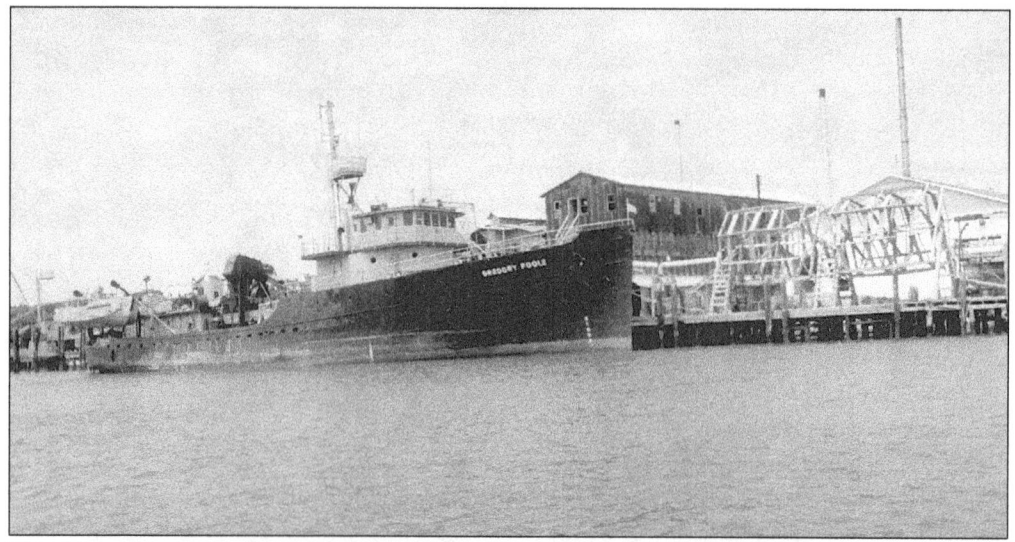

The *Gregory Poole* is one of the menhaden mother ships owned by Beaufort Fisheries. The large steel-hulled vessel was used in World War II as a mine sweeper. Because of her size, she is referred to as a "mother ship," and two purse boats fit right up in her stern. (Photo by Frances Eubanks.)

At the turn of the century, there was no mechanization, and early commercial fishing was a community endeavor. Captain Gib Willis's net spread was in his backyard on the banks of Bogue Sound. His daughter Nettie remembers all of the games the children played as they ducked under the net spread. (Courtesy Nettie Murrill, private collection.)

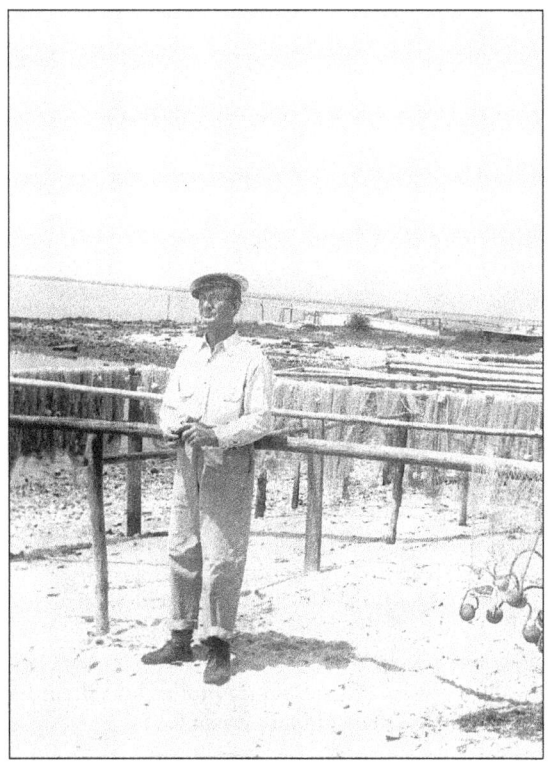

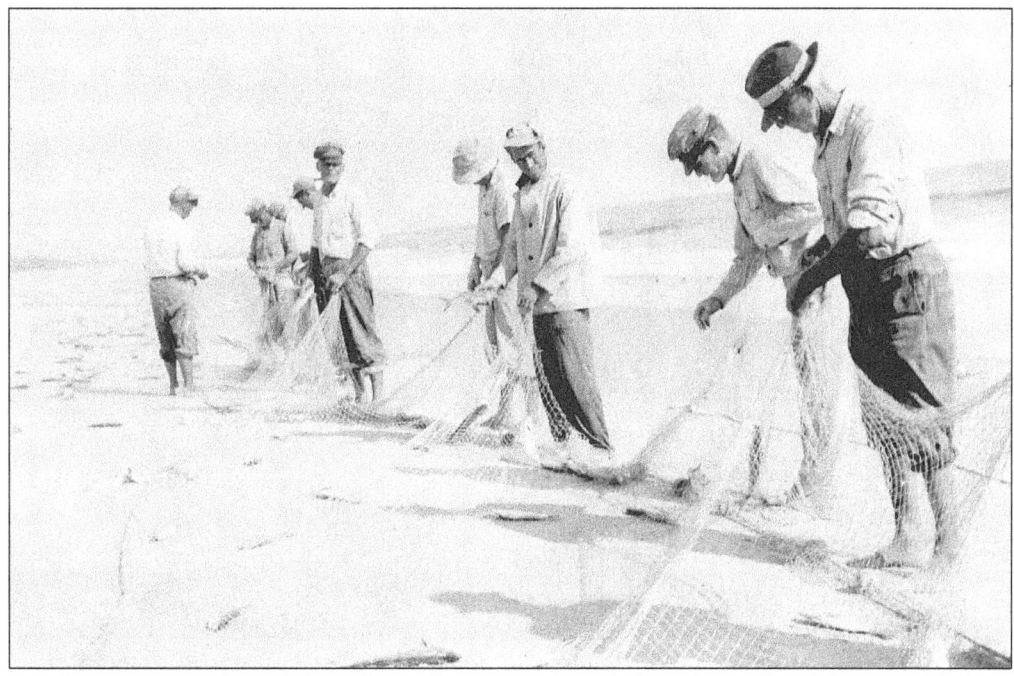

Residents are seen shore fishing for mullet in 1945. Little has changed as fisherman fish from the shore. (Courtesy Carteret County Historical Society.)

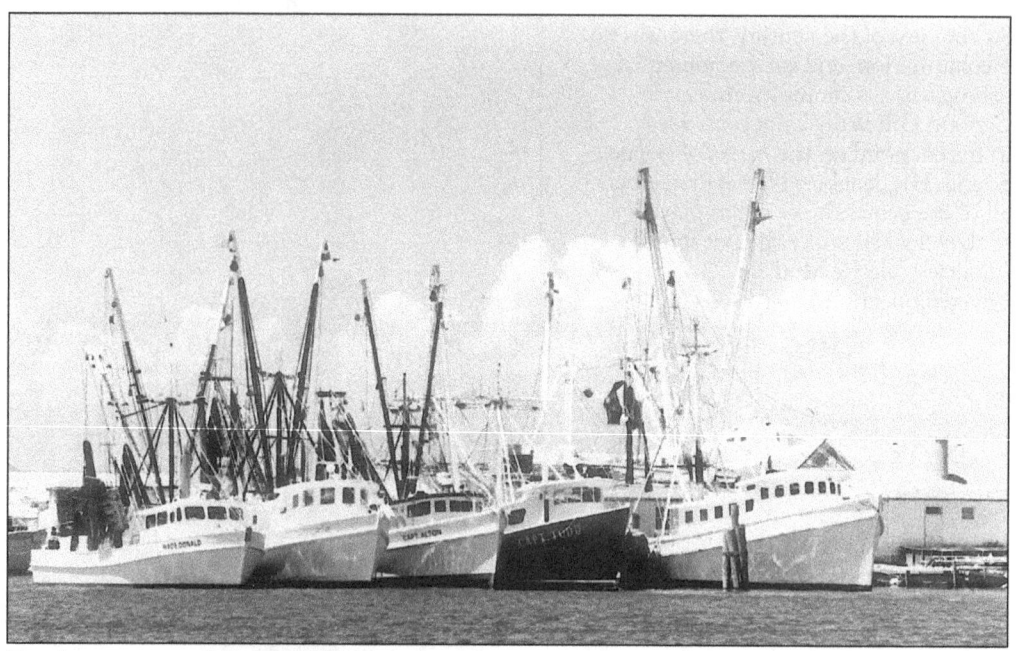

Trawlers, transomed to the docks, await tomorrow's journey. The boats on Gallant's Channel fish for different species including mullet and flounder. They are packed and shipped to Northern markets. (Photo by Frances Eubanks.)

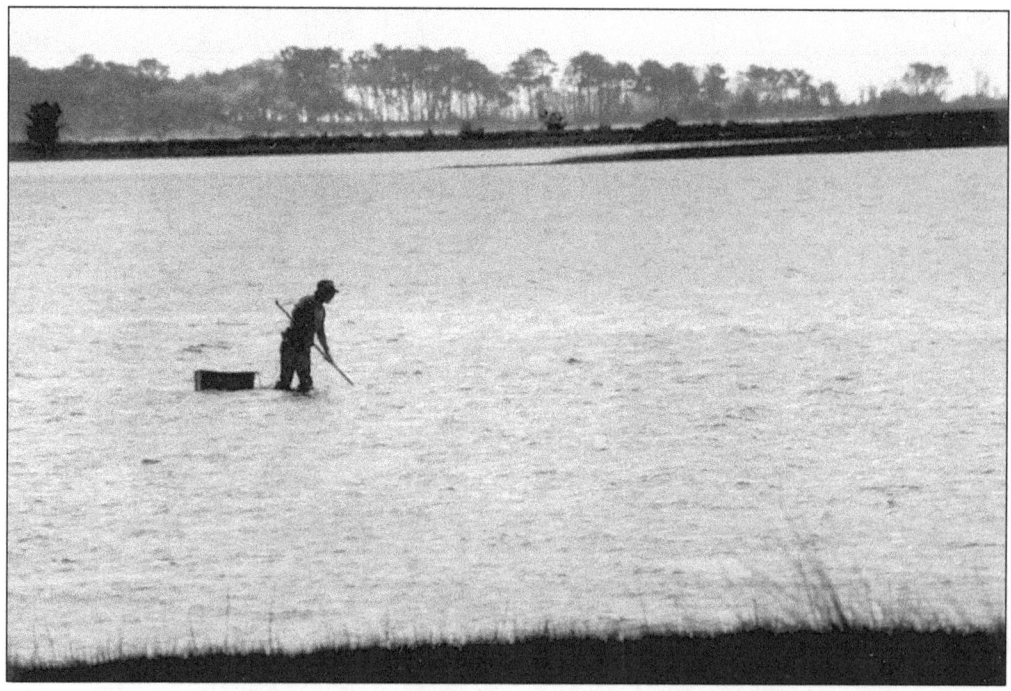

Clamming today is still done as it has been for hundreds of years. The lone clammer looks picturesque as he goes about his job. The photographer didn't know whether the subject was a recreational clammer or would be selling his catch. (Photo by Frances Eubanks.)

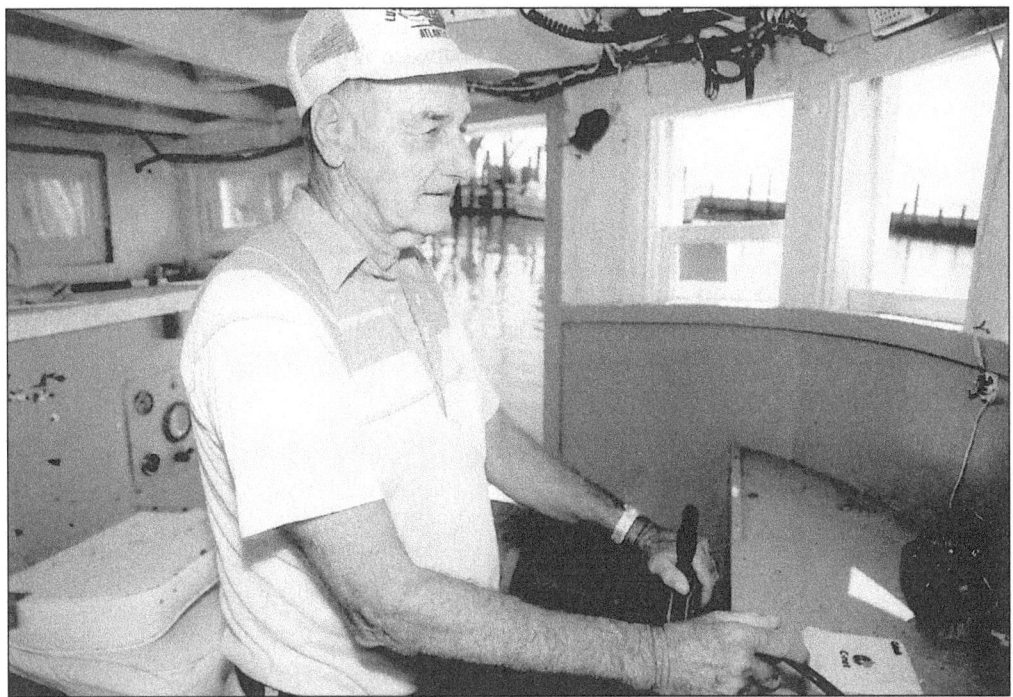

The steady hands of Captain Norman Styron steer the *Kathryn L. Smith* to Royal Shoal off Portsmouth to rendezvous with fishermen manning nets. The run boat transports the catch to the packing plant. (Photo by Frances Eubanks.)

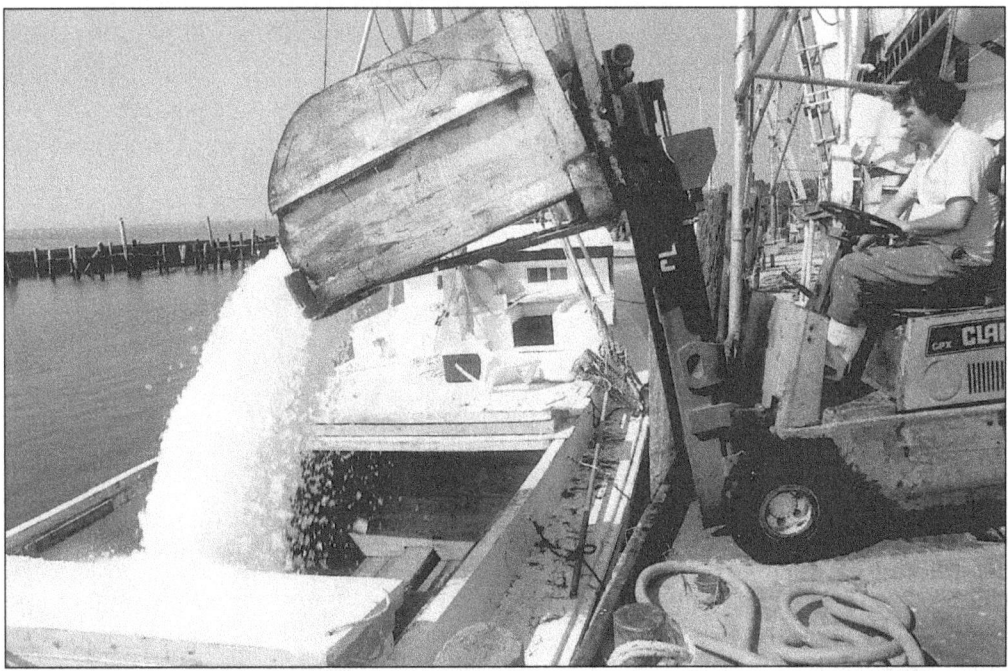

The *Kathryn L. Smith* is loaded with ice so that fish can come straight from the sea into its hull. The boat "runs" the fish from the sea right to the packing house. (Photo by Frances Eubanks.)

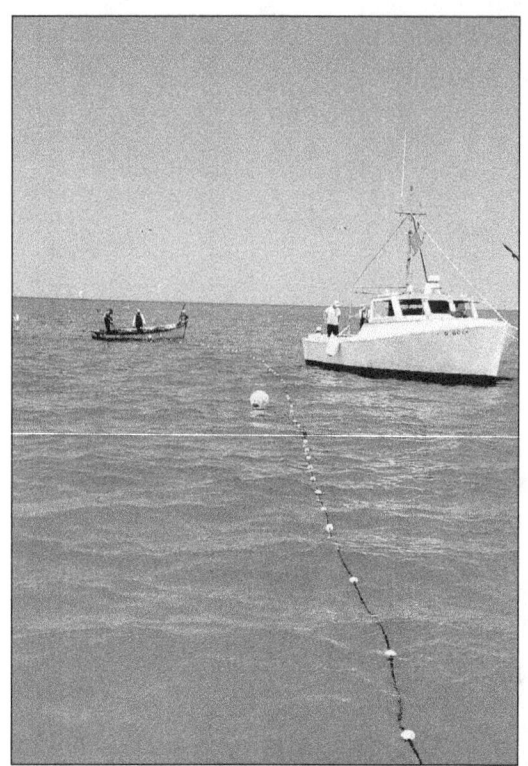

Long hauling requires long nets spread between two boats. The nets are pulled to trap fish. Modern-day catches follow a method known as reduction. The nets have culling panels which allow any juvenile fish to escape as the net is being hauled in. (Photo by Frances Eubanks.)

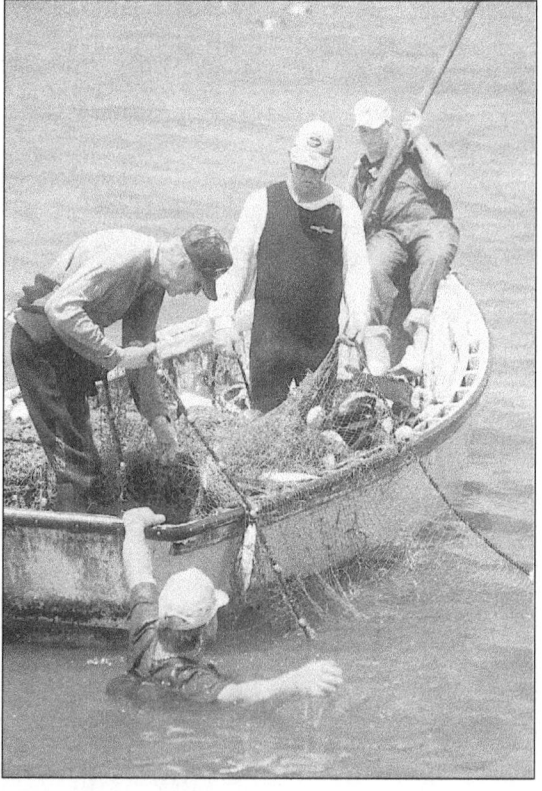

The net was hauled and there were so few fish that the fishermen are shown hand picking the fish from the net. The men seen here are Bill Finn Smith (bending), Larry Nelson (standing), Robert Nelson (in bow), and Johnny Willis (in water). (Photo by Frances Eubanks.)

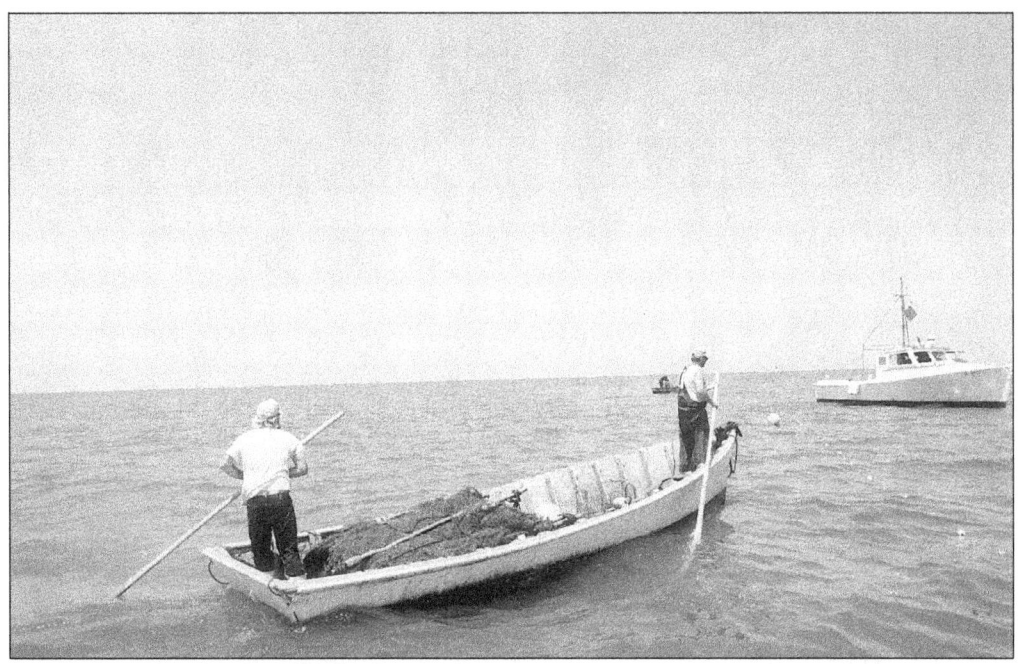

Larry Nelson and Michael Hardgraves are in one of the net boats. Long hauling requires the use of two boats. After the net is set, the boats position on either side and begin the hauling process. Mechanization and technology have changed commercial fishing, yet massive human physical labor is still required. (Photo by Frances Eubanks.)

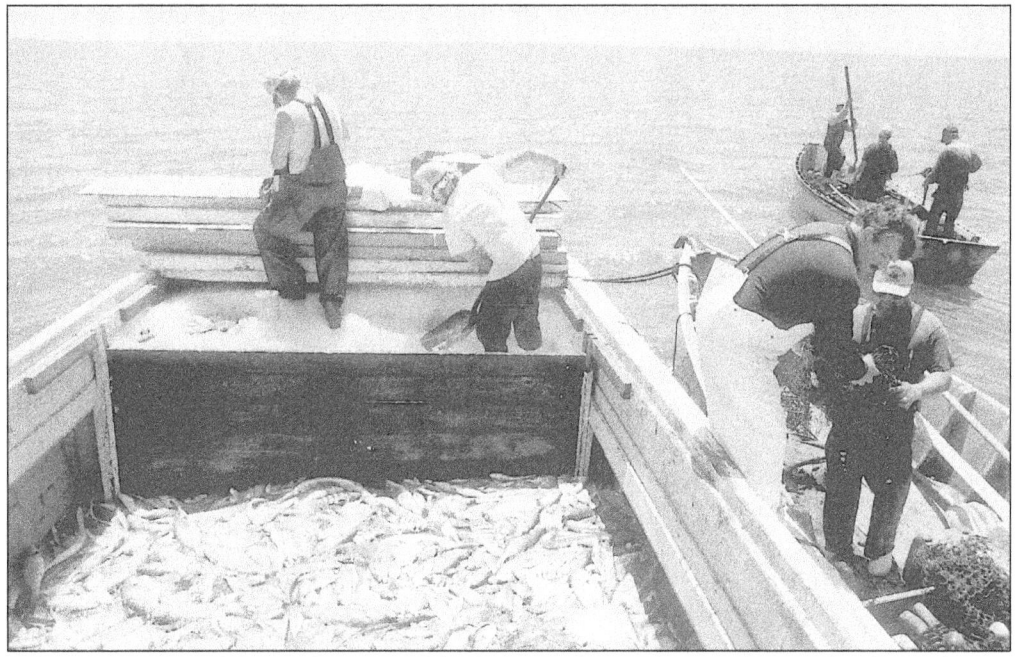

Fish are taken straight from the nets and loaded onto the run boat and dumped right on the ice. Michael Hardgraves is shown shoveling the ice on top of the fish to keep them fresh. (Photo by Frances Eubanks.)

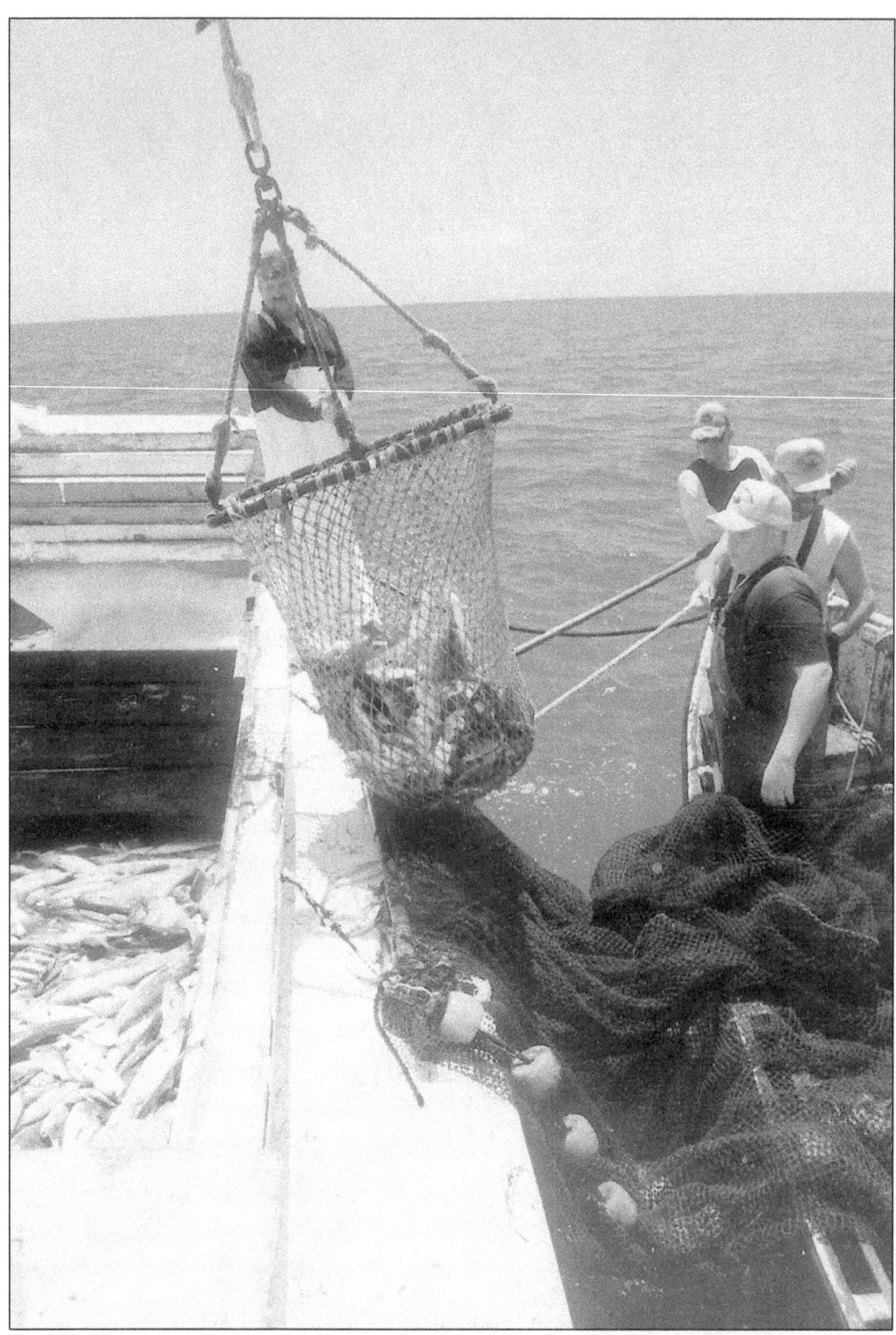
The process of transferring the fish from the net to the run boat is expedited by use of a large dip net. (Photo by Frances Eubanks.)

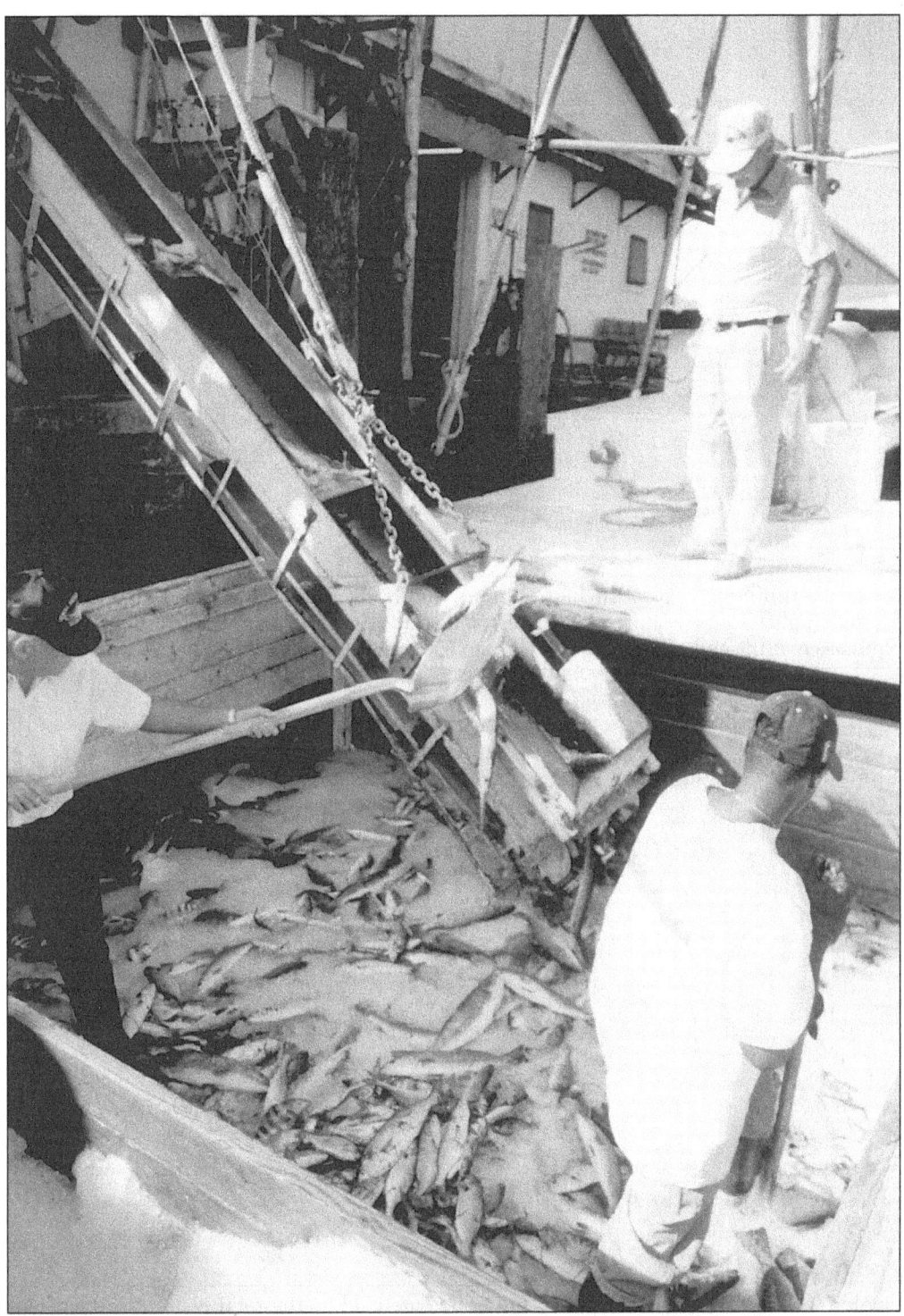

After arriving at the Luther Smith and Sons dock, Captain Styron oversees the unloading of the fish by conveyor belt. Pictured on the left is Jerry Willis with David Murrell (right). (Photo by Frances Eubanks.)

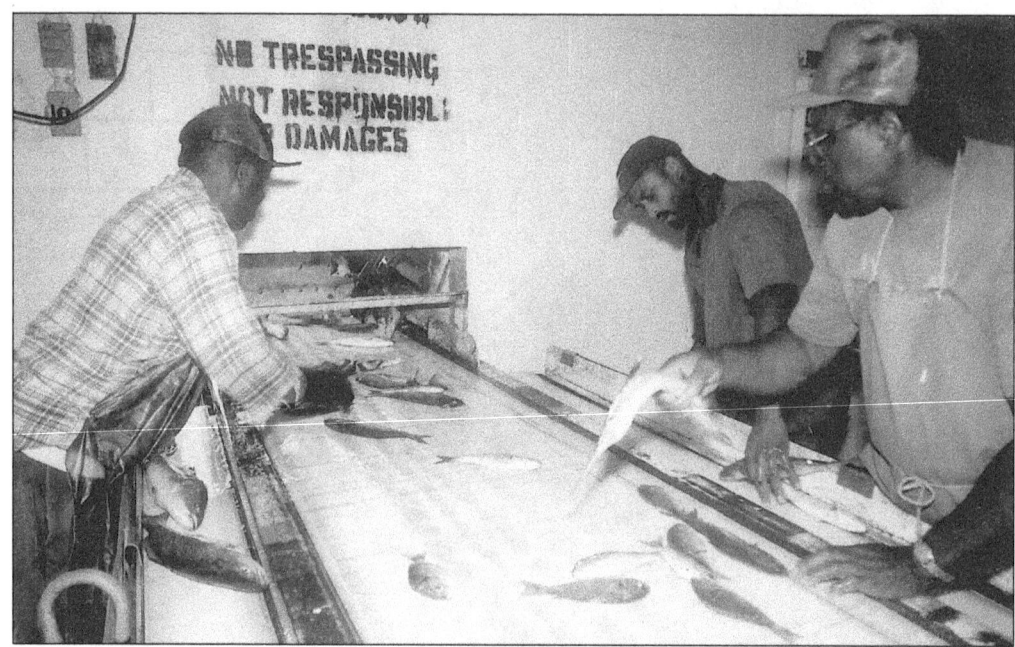

Inside the fish-packing plant at Luther Smith and Sons, Raymond Taylor (left) and Ledell Murrell (right) sort the different species of fish and prepare them for weighing. Michael Simmons is at the end of the conveyor. (Photo by Frances Eubanks.)

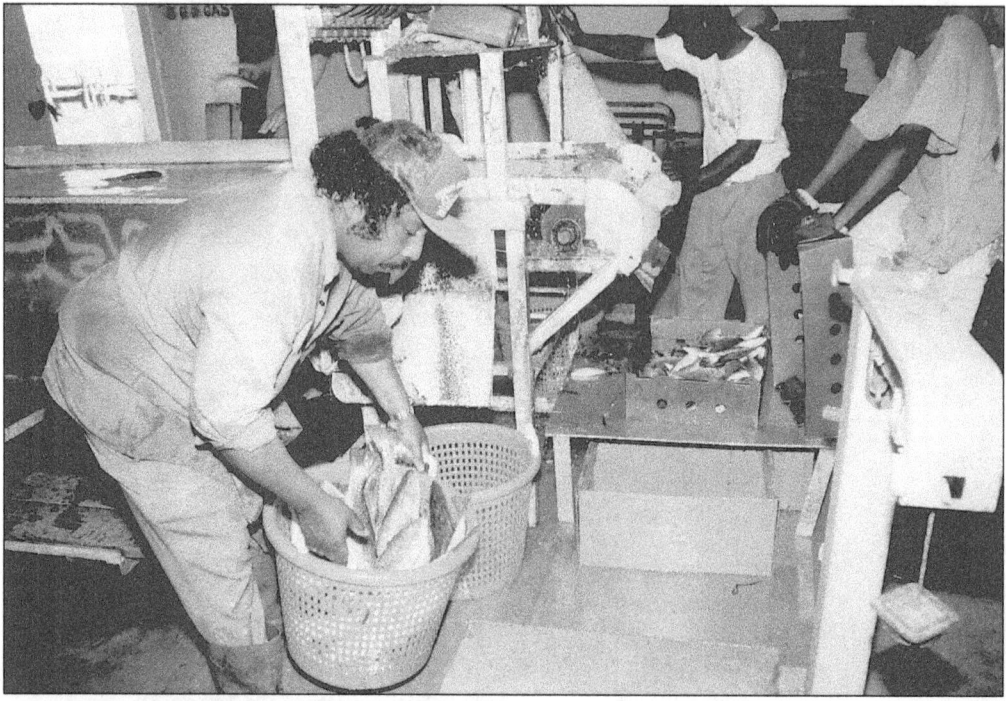

Gordon Taylor weighs speckled trout. Fishermen are paid by the total pounds in the catch. Each species had a different market value. From the packing house, fish are rushed by refrigerated trucks to fish markets in Philadelphia, Baltimore, and New York City. (Photo by Frances Eubanks.)

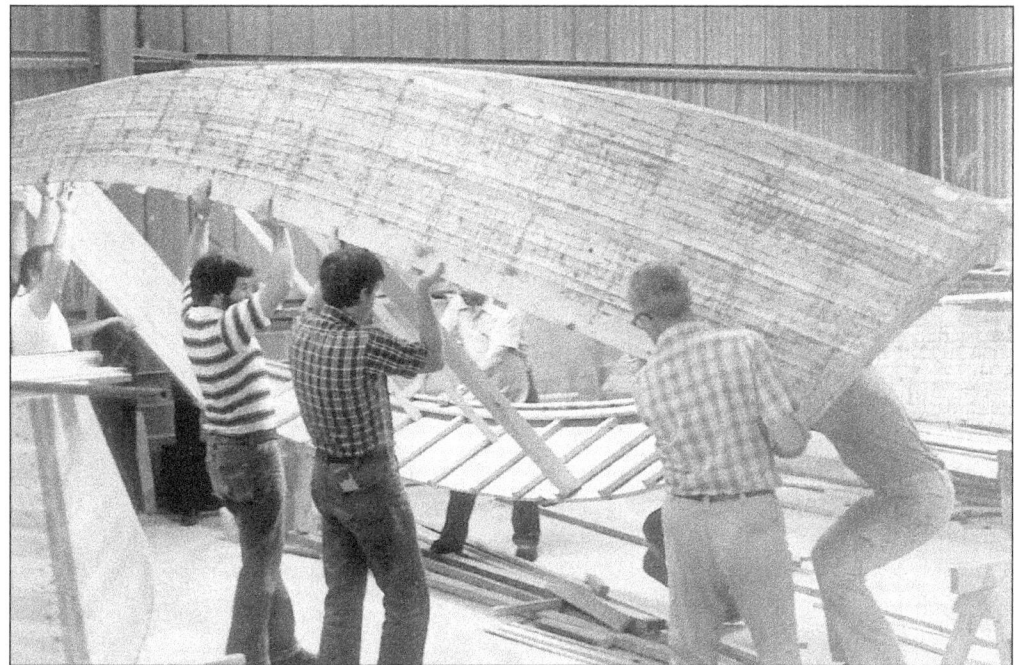

Wooden boatbuilding by hand goes on today in Carteret County. Carteret Community College and the North Carolina Maritime Museum sponsor classes in traditional boatbuilding to keep the art alive. This flam style boat was constructed by individual class members who were willing to purchase their own juniper. (Photo by Frances Eubanks.)

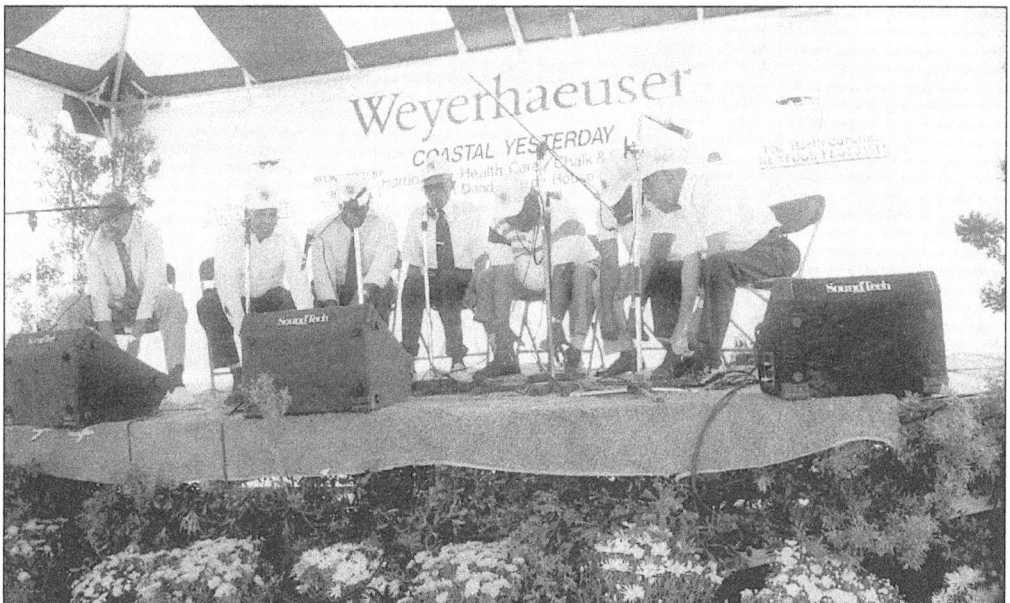

The Menhaden Chanteymen were part of a menhaden fishing crew before the days of mechanization. The lead crew man was usually a tenor who would chant songs as the men hand pulled the net. They would lift with the cadence, all joining in. They would lift or dip on a certain word. After retiring, the men performed extensively and recorded a cassette tape. (Photo by Frances Eubanks.)

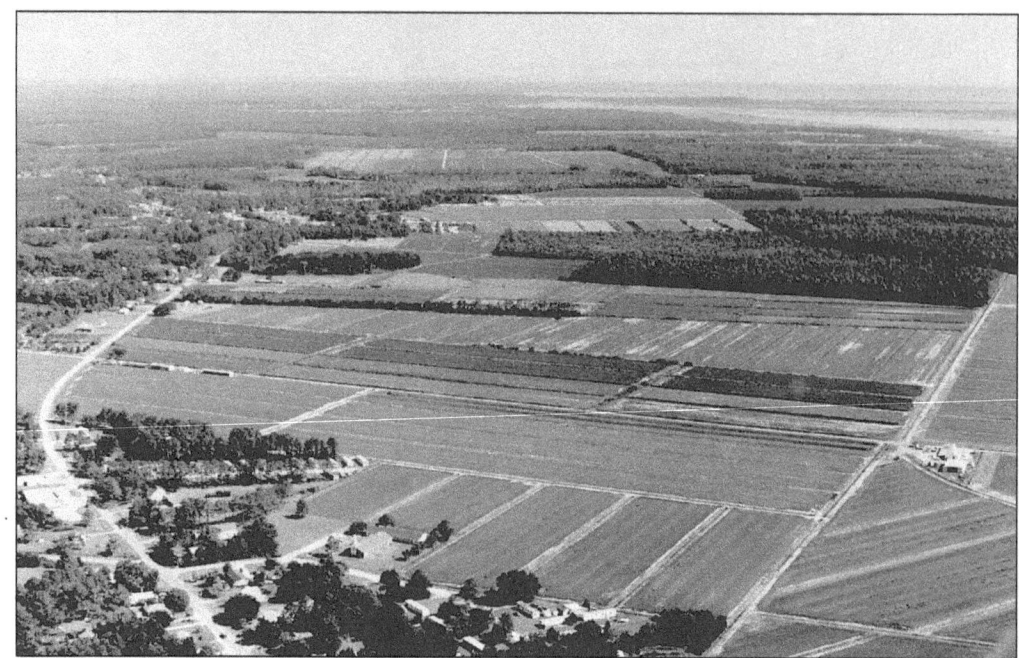

From the air, Carteret County farmland looks like a patchwork quilt. The rich farmland of the county cannot be overlooked. Many of the water families were farmers when they were not fishing. Delicious fruits and vegetables are still grown for family consumption, truck farming, and shipment to grocery stores. (Photo by Frances Eubanks.)

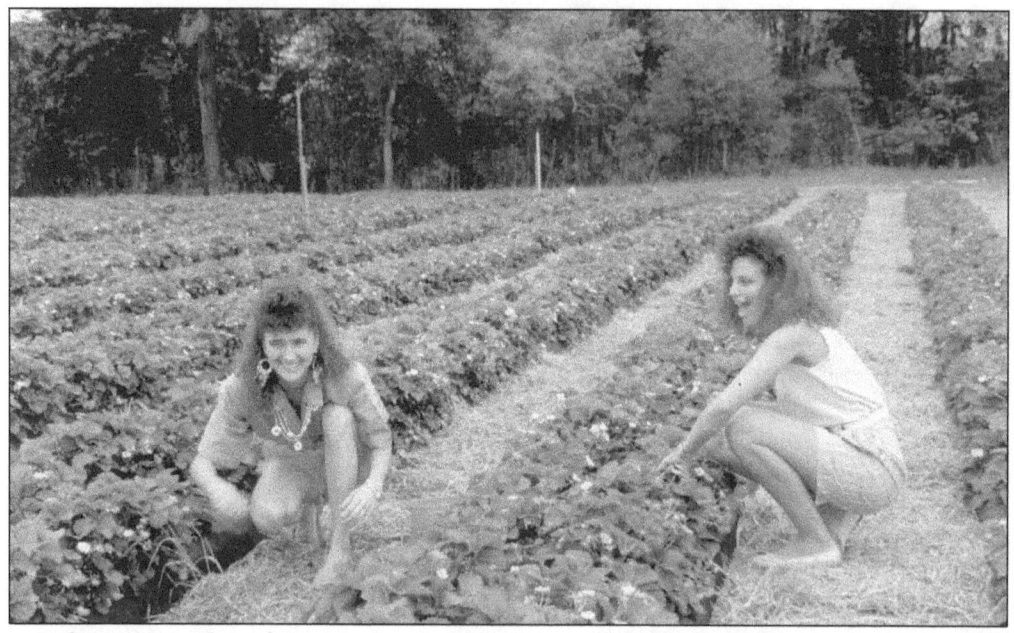

Strawberry farms abound from Newport to Down East. This one in Newport is the Garner's Farm. Carteret County is also known for corn, sweet potatoes, and tomatoes. (Photo by Frances Eubanks.)

Eight
Celebrations and Traditions

Carteret County has seen its share of celebrations over its 300-year history. The modern-day festivals began celebrating the new century and then following World War I and II. The entire town turned out when Morehead City celebrated its centennial. Since the 1950s annual celebrations have become important to the economic growth of the area. History has become the county's biggest selling point, and thousands of participants turn out for fishing tournaments, the Seafood Festival, the Newport Pig Pickin' Festival, the Decoy Festival, and other occasions marked by food, family, and fun.

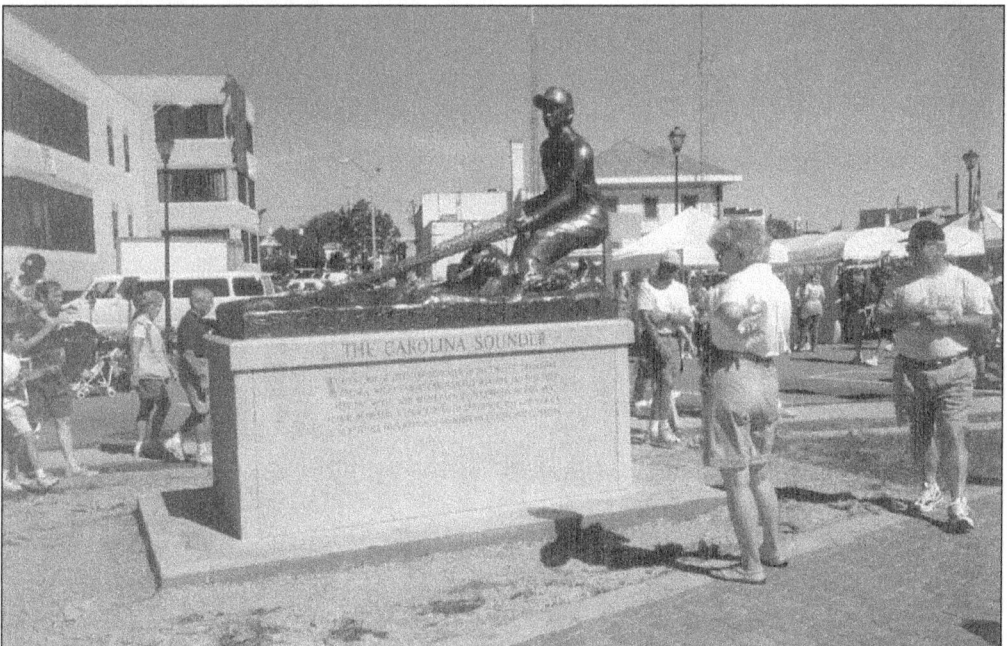

The *Carolina Sounder* was designed by Doug Alvord to honor the fishing industry. Under the sponsorship of the North Carolina Fisheries Association, it was cast and then erected on the Morehead City Waterfront in remembrance of all the North Carolina commercial fishermen. (Photo by Frances Eubanks.)

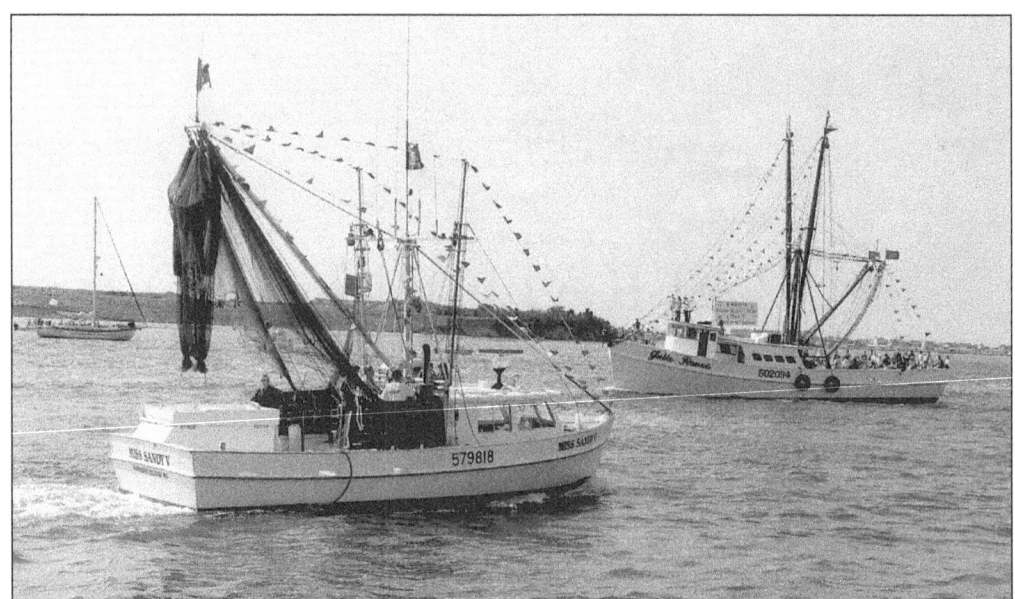

The Blessing of the Fleet was a tradition begun encompassing all faiths. Held at the beginning of the fishing season, prayers are said for the boats and crew, the fishing nets, and for daily work. Pictured above, the parade of boats are blessed and participants pay tribute to those whose lives have been lost at sea by throwing wreaths into the water. The Blessing of the Fleet in Morehead City is held on the first Sunday in October. (Photo by Frances Eubanks.)

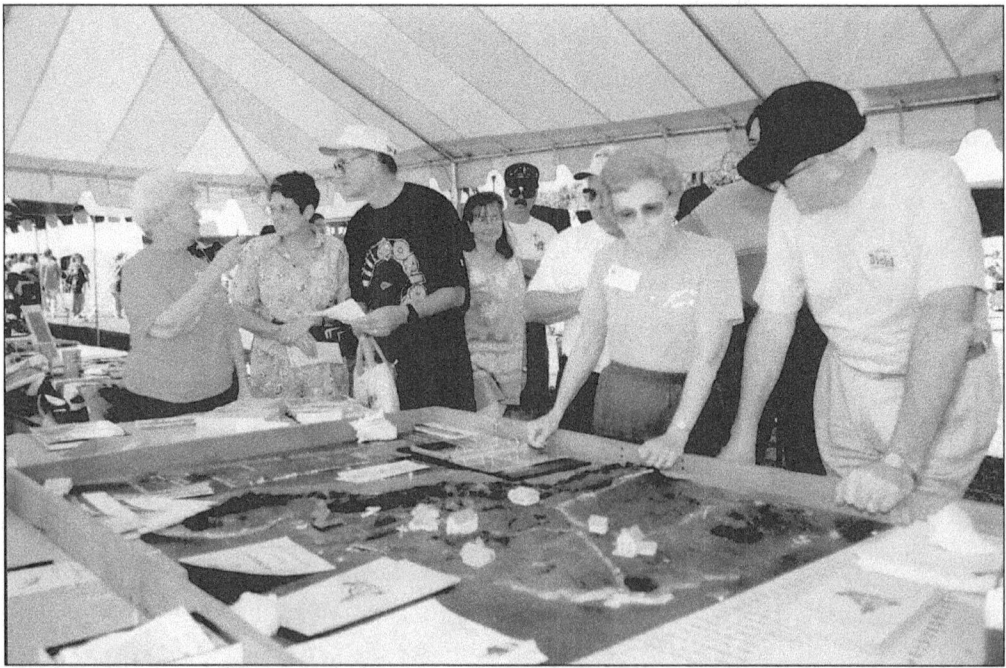

The North Carolina Seafood Festival was created in 1986 to promote the consumption of seafood. It is a year-round project that is the largest civic event in the county, which boosts the area economy by over a million dollars. Pictured above is the Coastal Yesterday display by the Friends of Portsmouth Island organization. (Photo by Frances Eubanks.)

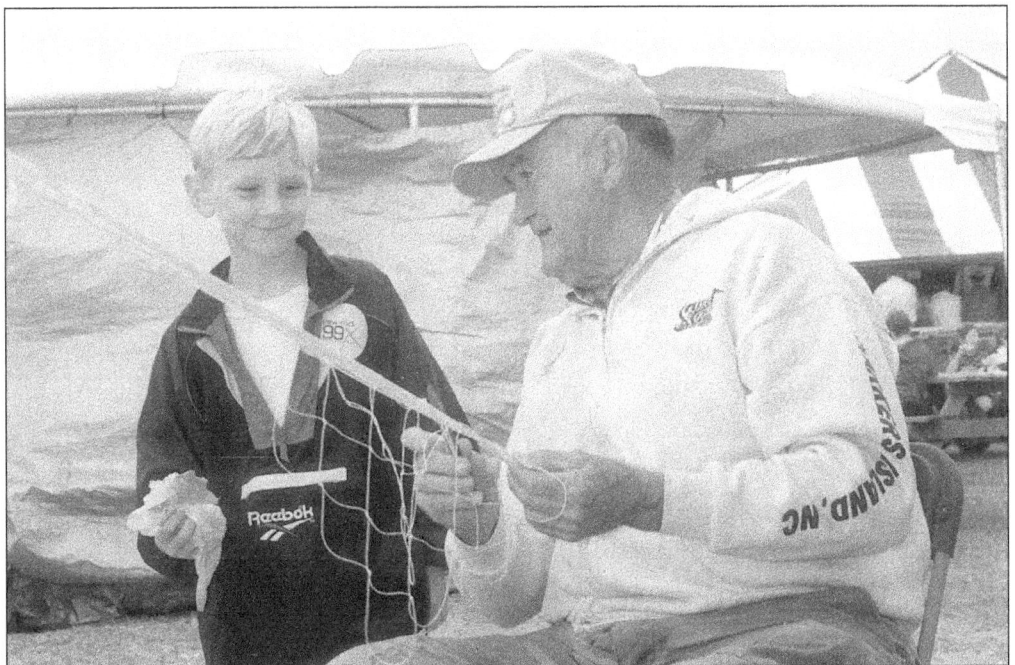

Colon Taylor demonstrates net making to Chad Goodwin as part of the live demonstrations at Coastal Yesterday at the Seafood Festival. Colon is also known as a decoy carver and is a regular volunteer at the Core Sound Waterfowl Museum. (Photo by Frances Eubanks.)

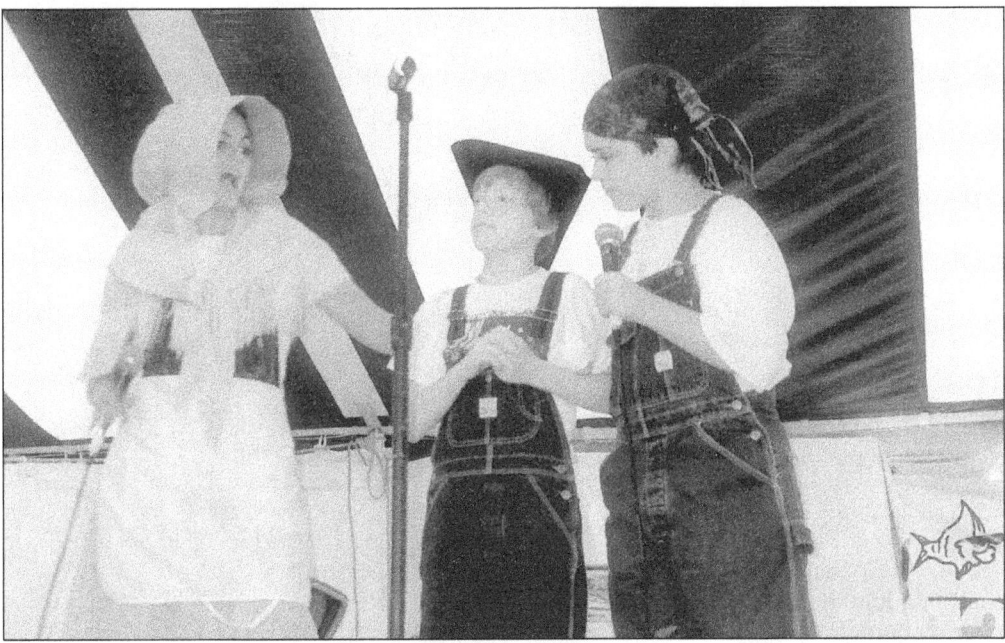

The North Carolina Youth Touring Theatre performs plays and dramatizes stories based on the settling of the coast on the main stage of Coastal Yesterday. Their performances prior to the festival are for school students studying North Carolina history. Jenny Springs, Brian Salsi, and Bo Salsi (from left to right) enact a scene about pirates coming to the mainland. (Photo by Burke Salsi.)

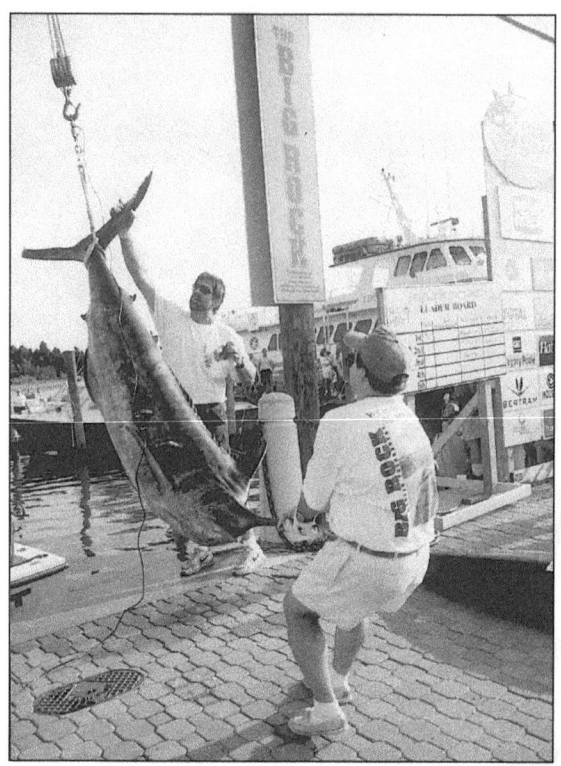

The Big Rock Blue Marlin Tournament was begun in 1957. At the time no one was sure that billfish existed in waters off the North Carolina coast. Most fishermen rarely went out of the sight of land. Therefore there were few stories of game fish. A cash prize was offered and fishermen went out to see if they could catch marlin. (Photo by Frances Eubanks.)

The Big Rock Tournament promotes deep-sea fishing and the charter boat industry. It is now part of the World Billfish Series. On June 15, 2000, the record was broken when angler Ron Wallschlager landed an 831-pound blue marlin. The fish was caught aboard the *Summertime Blues*, captained by Al Johnson. (Photo by Frances Eubanks.)

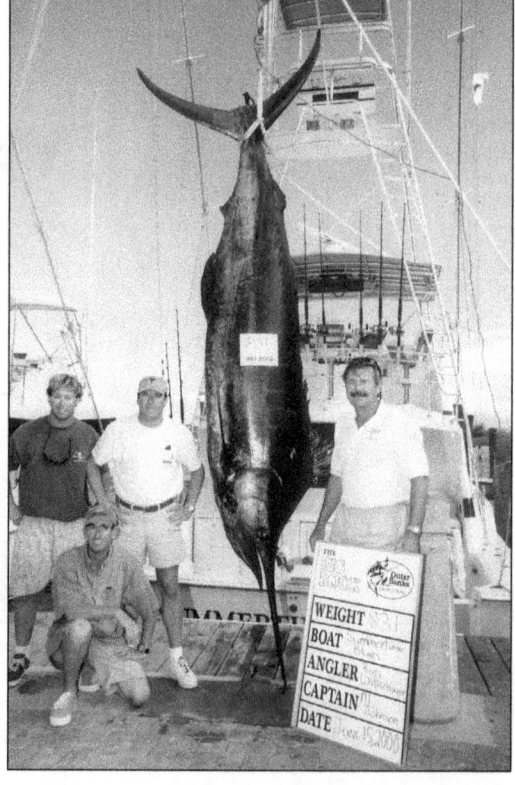

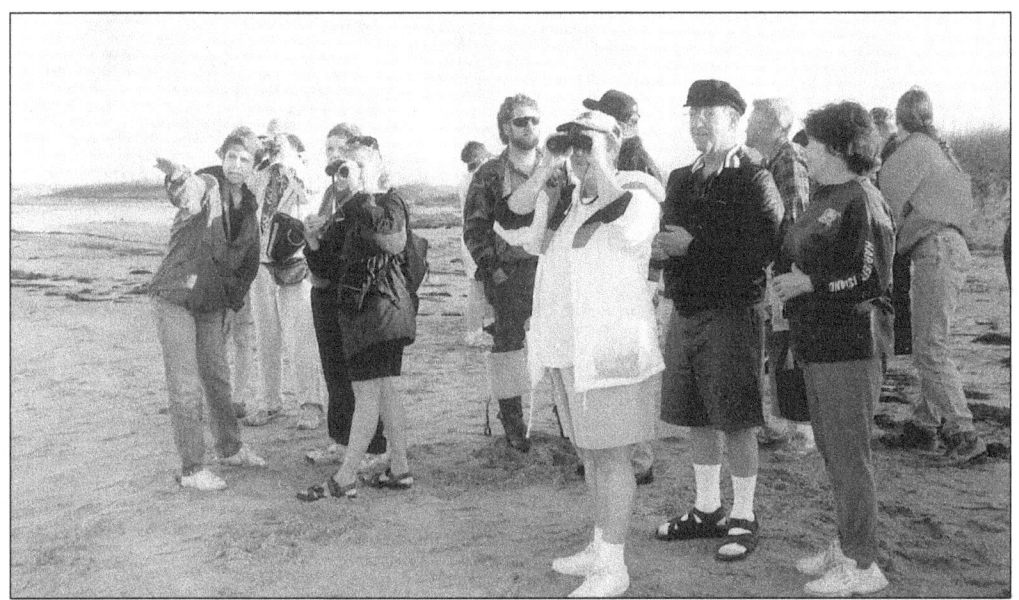

The Core Sound Waterfowl Museum established Loon Day to celebrate the tradition of "the loon." At the turn of the twentieth century, loon hunting was a way of life for residents and provided food for families. By law the only loon hunting allowed today is by bird watching. The first festival, on May 29, 1999, featured an early morning loon hunt with binoculars as pictured above. Other activities included a carving competition, a turkey pickin', and children's events. (Photo by Frances Eubanks.)

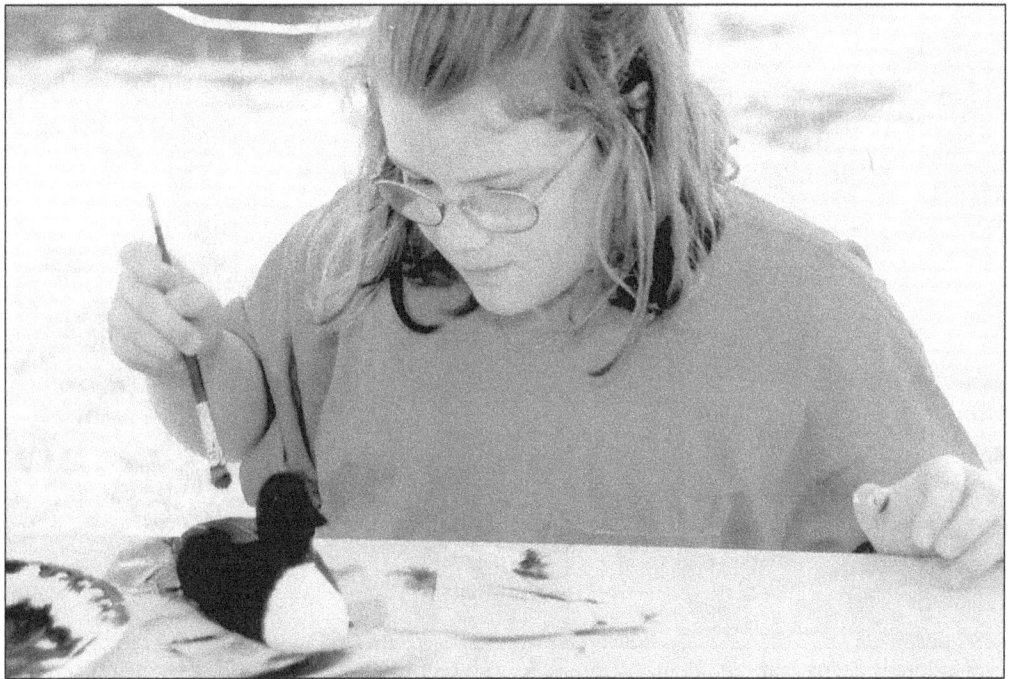

Katie Amspacher participates in loon decoy painting as part of the annual Loon Day celebration, sponsored as an enrichment project by the Core Sound Waterfowl Museum on Harkers Island. (Photo by Frances Eubanks.)

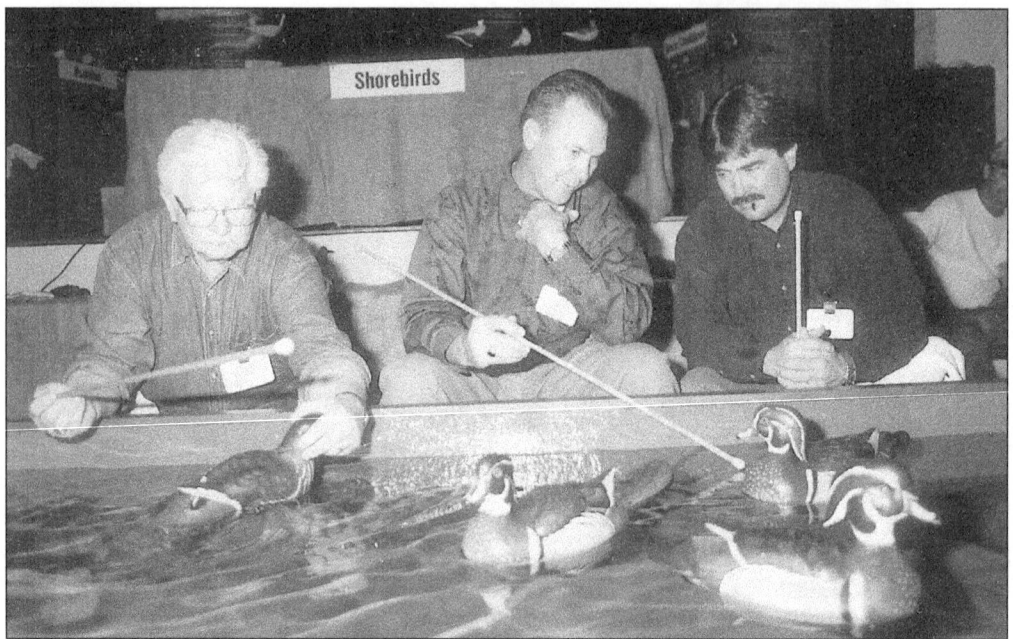

The Core Sound Decoy Carver's Guild sponsors an annual Decoy Festival the first full weekend of December. Thousands gather for food, fun, and fellowship. In this picture, judging is held at the float tank, and working decoys are evaluated on how realistic they appear while floating. (Photo by Frances Eubanks.)

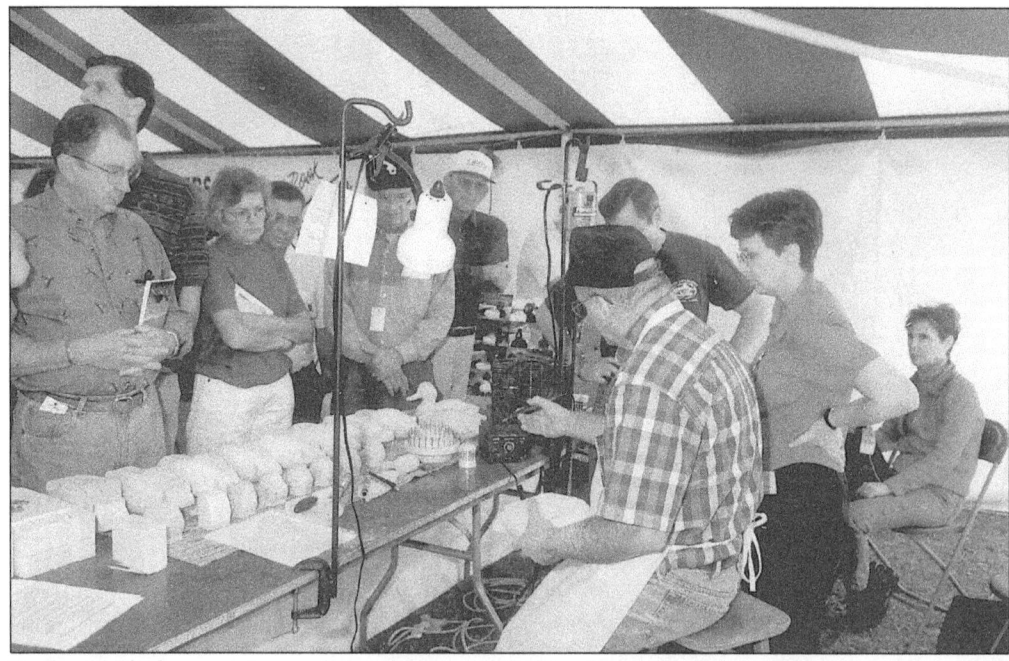

Professional decoy carvers demonstrate carving techniques and share carving tips with would-be carvers. The festival gives decoy carvers the opportunity to gather and present a massive show of an almost lost art form. The Core Sound Waterfowl Museum works year-round to present the art and heritage these carvings represent. (Photo by Frances Eubanks.)

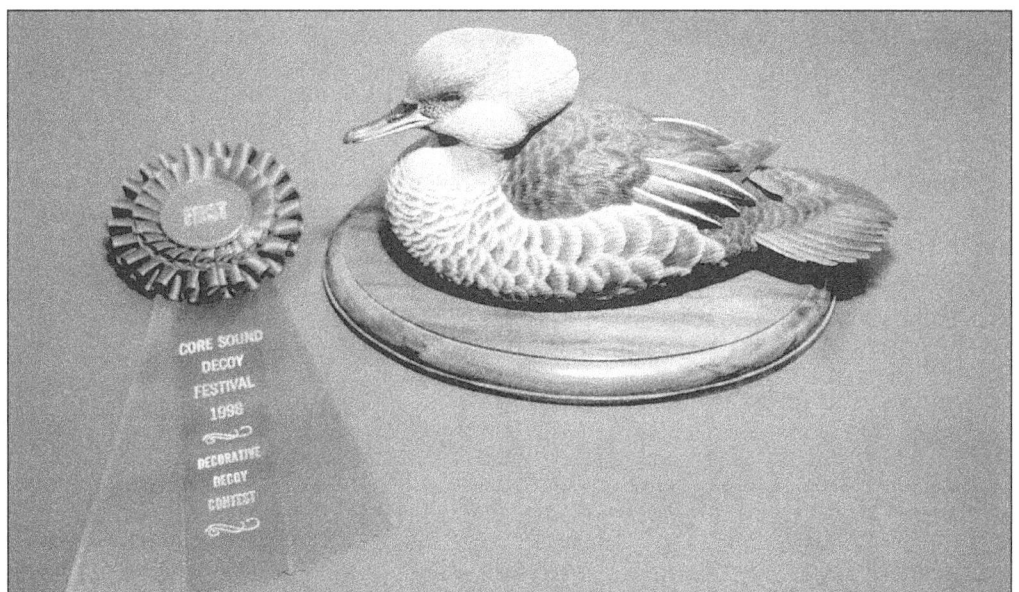

Decoys are judged in categories. There is judging for working decoys and also for decorative decoys. Every aspect of the art is analyzed. The decorative decoy judging is based on realism, size, and proportion as well as technique and painting. Winning decoys are always museum-quality presentations. Pictured above is a winner in the decorative decoy competition. (Photo by Frances Eubanks.)

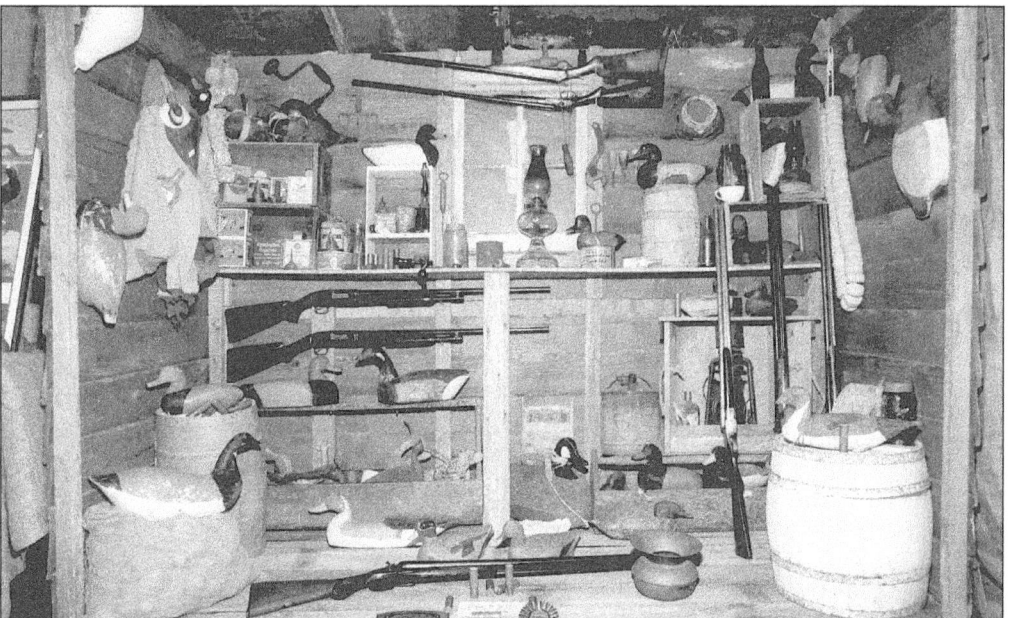

The Core Sound Waterfowl Museum diligently works to collect and preserve artifacts that represent the rich history of the hunters, the hunting lodges, the way of life of guides, and the havens for waterfowl that have gained national attention for Carteret County and especially for Down East communities along Core Sound. The collection continues to grow as the organization plans their move into a new museum. This exhibit is part of the annual Decoy Festival. (Photo by Frances Eubanks.)

The Blackbeard's Bounty Festival is an annual one-day event that raises interest in North Carolina's maritime history. It was prompted by the discovery of what is thought to be Blackbeard's flagship, the *Queen Anne's Revenge*, off Beaufort Inlet in 1996. Pictured is Sinbad's boat, *Meka II*. (Photo by Frances Eubanks.)

Mock battles in the Morehead City harbor add excitement to the Blackbeard's Bounty Festival. It is a family celebration featuring a Blackbeard look-alike contest, a pirate feast, and reenactments. Artifacts found through diving the wreck are on display at the North Carolina Maritime Museum. (Photo by Frances Eubanks.)

Nine
THE DAWNING OF A NEW CENTURY—2000

A hundred years of progress have connected the citizens of once rural and remote Carteret County to every modern convenience and most importantly, to the rest of the world.

Since the end of World War II, vacationers have flocked to the coast causing a building boom and crowded highways. The area is now known as the "Crystal Coast," and the future is bright for continued tourism and economic growth.

Yet, despite technology, the hurricanes keep coming. Call it an omen or a coincidence—the dawning of the twenty-first century was ushered in by Hurricane Floyd in September 1999 as ferociously and violently as the San Ciriaco, which challenged the residents in August of 1899.

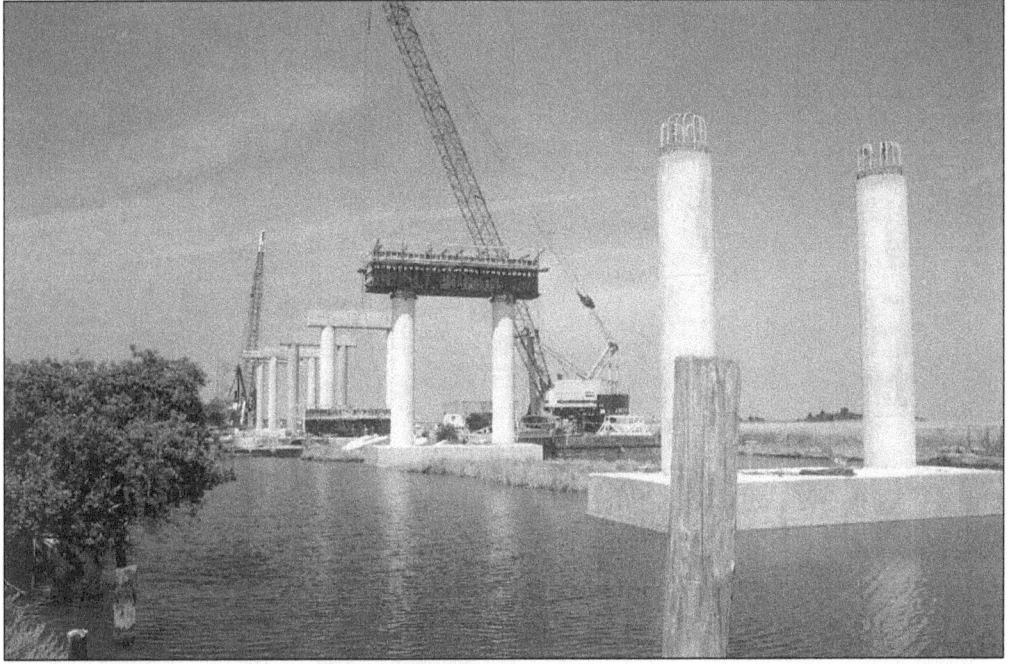

In 1999 the Cedar Island thoroughfare replaced a little bitty rickety old drawbridge and connected the Down East communities to Cedar Island. This new addition has made the trip to the Cedar Island Ferry, which connects Carteret County to Ocracoke Island—an easier and much safer trip. (Photo by Frances Eubanks.)

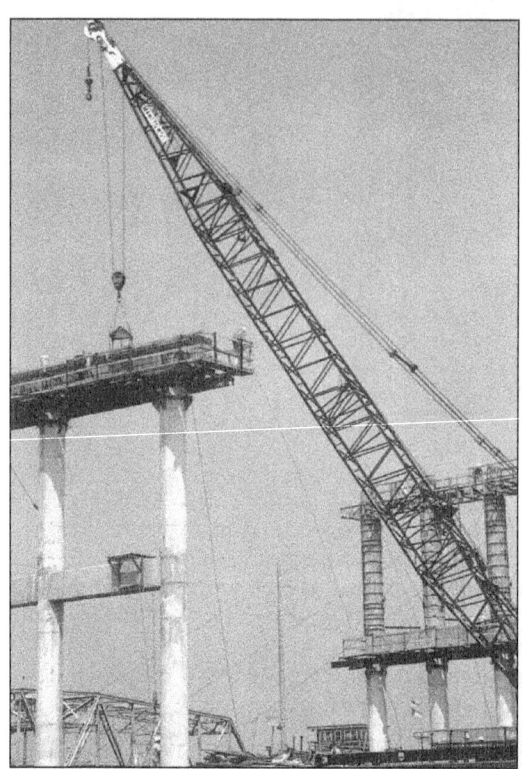

The march to the twenty-first century began in 1985 with the opening of the high-rise bridge connecting Morehead City with Atlantic Beach and the other barrier island beach resorts. This bridge replaced a causeway and drawbridge. The old bridge was a nightmare, especially in summer. The weekend traffic jams were legendary. (Photo by Frances Eubanks.)

The new beach bridge allowed the free flow of traffic. Its high-rise profile accommodated boat traffic, doing away with the traffic jams due to the drawbridge. This modern roadway completely transformed the barrier island that it connected with a high demand for tourist rooms. It has encouraged a population boom and business opportunities. (Photo by Frances Eubanks.)

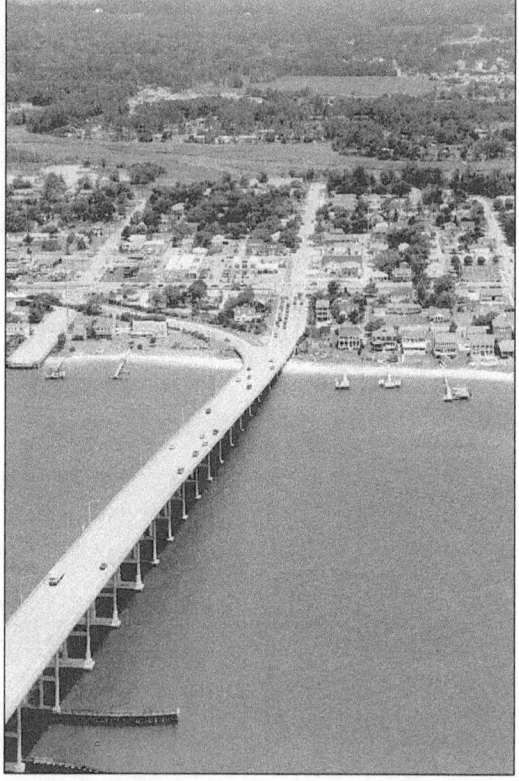

The train tracks still bisect Arendell Street, the main thoroughfare of Morehead City. The train is delivering wood chips to the port. The track dead ends into the port, where it makes loads and transports products to other parts of North Carolina and the United States. The depot is now used by the Carteret Community Theatre. (Photo by Frances Eubanks.)

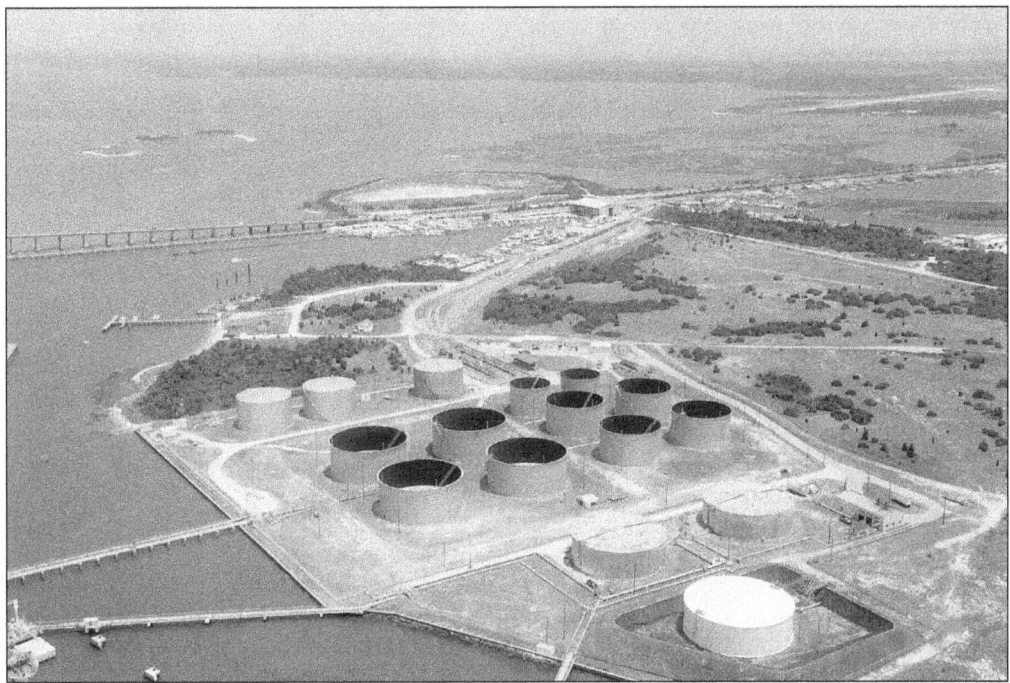

An aviation fuel terminal is now part of the landscape on Radio Island. At the turn of the twentieth century, neither the island nor airplanes existed. Radio Island was created in the 1940s from dredging activities. (Photo by Frances Eubanks.)

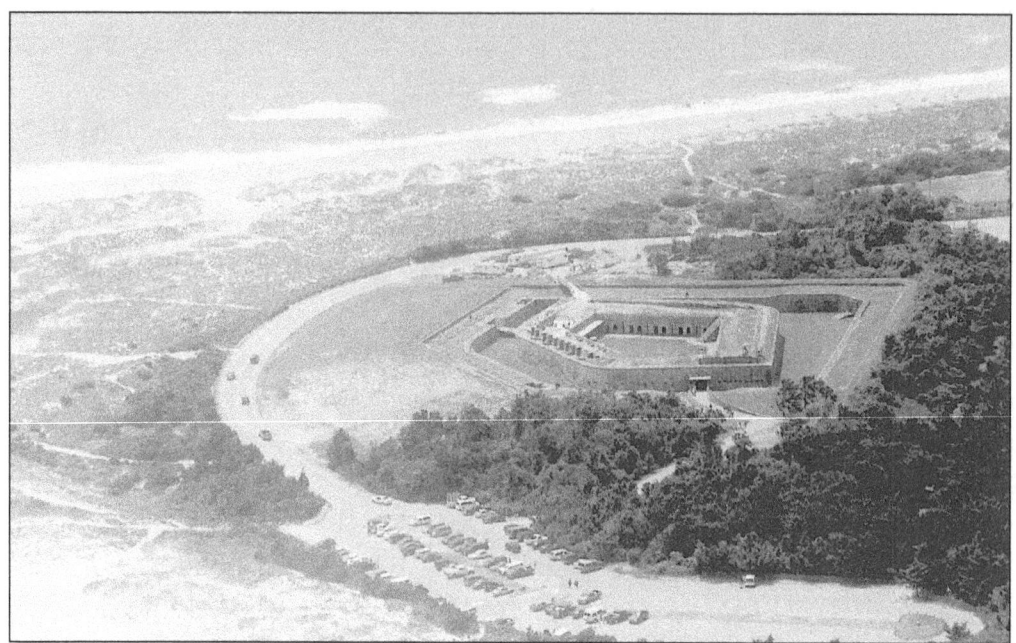

Fort Macon has not been in military service since World War II. The above photograph shows improvements being made in 1999 during a massive renovation project. According to the *Fort Macon Ramparts*, "The project will last for five years, will cost approximately 14 million dollars, and is intended to repair and stabilize the fort for at least 150 years, if not forever." (Photo by Frances Eubanks.)

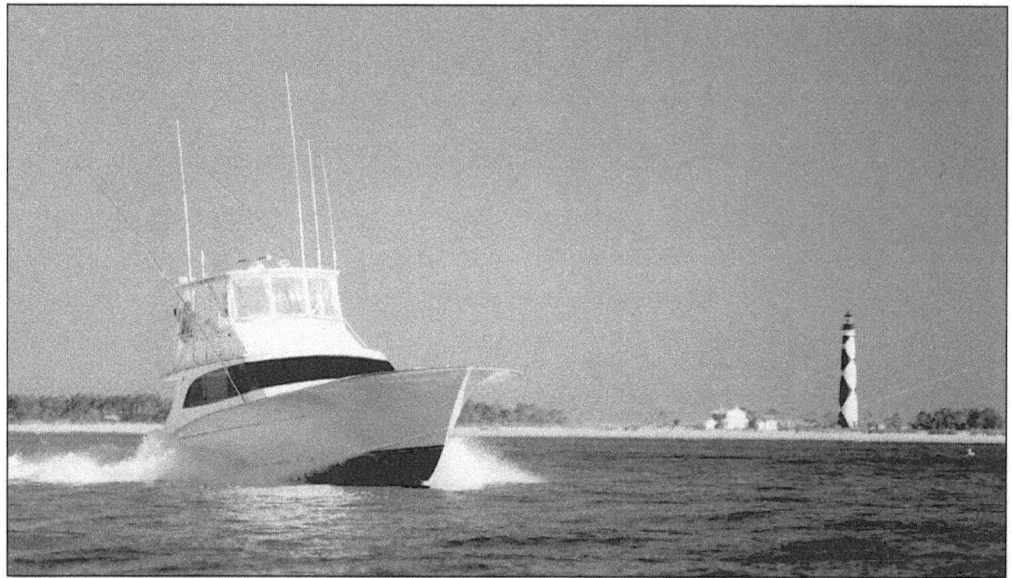

The irony of the modern age is pictured above in the mixing of the past with the present. At the dawning of 1900, the only fishing boats within sight of the Cape Lookout Lighthouse would have been personal sail craft or commercial sailing vessels. Pleasure boating was little known. At the turn of the century sport fishing boats are seen throughout the sounds and offshore of the islands. Fishing is a popular individual sport, as is pleasure cruising on powerboats and sail craft. (Photo by Frances Eubanks.)

As the new century dawns, fathers are still teaching their children the finer points of fishing. This photo illustrates that Carteret County's rich fishing grounds are available for all ages in small boats as well as large boats. Mark Eubanks is shown helping daughter Ashley with her "catch of the day." Ashley caught two large (eating size) hog fish on a Snoopy rod and reel the first time she had ever been fishing. (Photo by Frances Eubanks.)

Watercraft has come a long way in a century. Boats are no longer Carteret County's main mode of transportation, yet the increase in horsepower allows the modern boater to get there faster. Candace Hentschel is shown getting operational tips from her grandfather, Larry Eubanks, while boating in Bogue Sound. The Wave Venture and other types of Wave Runners are a new breed of transportation that is now seen taking to the sound and the ocean. (Photo by Frances Eubanks.)

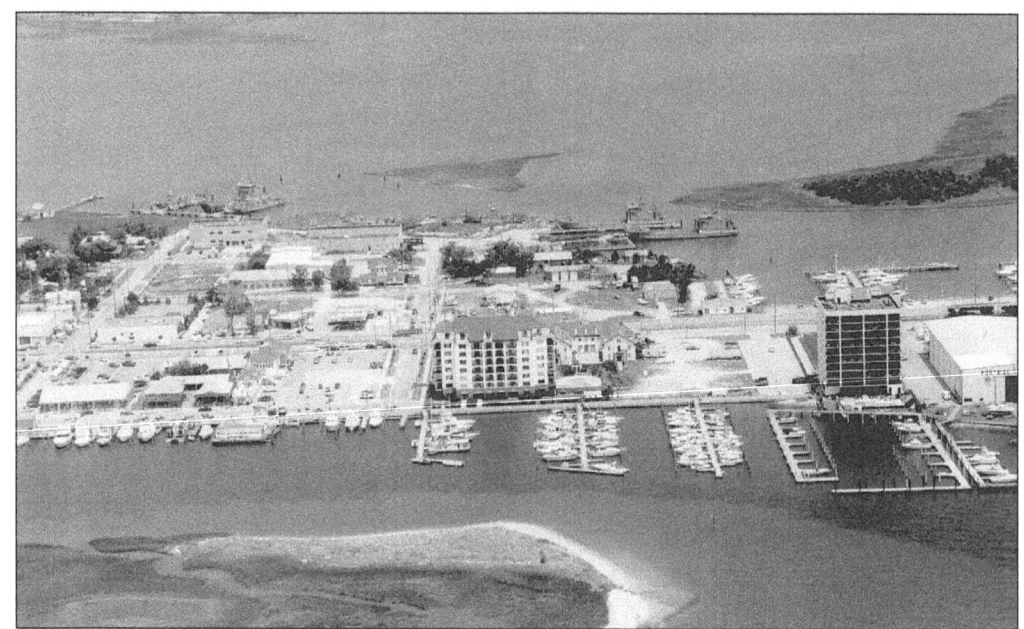

Above is a 1998 aerial photo of modern Morehead City. A new waterfront park, moorings, and high-rise condominiums were part of a 1990s revitalization. (Photo by Frances Eubanks.)

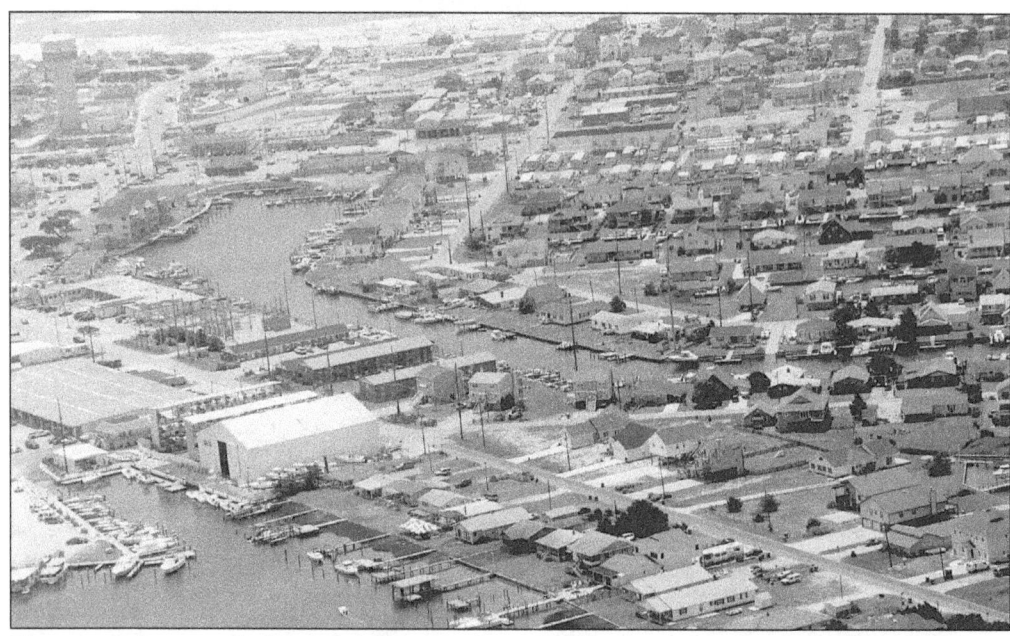

The aerial photograph shows Atlantic Beach at the dawning of the twenty-first century. The beach was a tourist attraction at the dawning of the twentieth century but could only be reached by boat for daytime activities. In 1925 a rustic hotel was built, and daytrippers could square dance in the pavilion for a quarter. The beach came into its own in the 1940s, and now visitors pour into Atlantic Beach, Salter Path, and Emerald Isle as a vacation destination. (Photo by Frances Eubanks.)

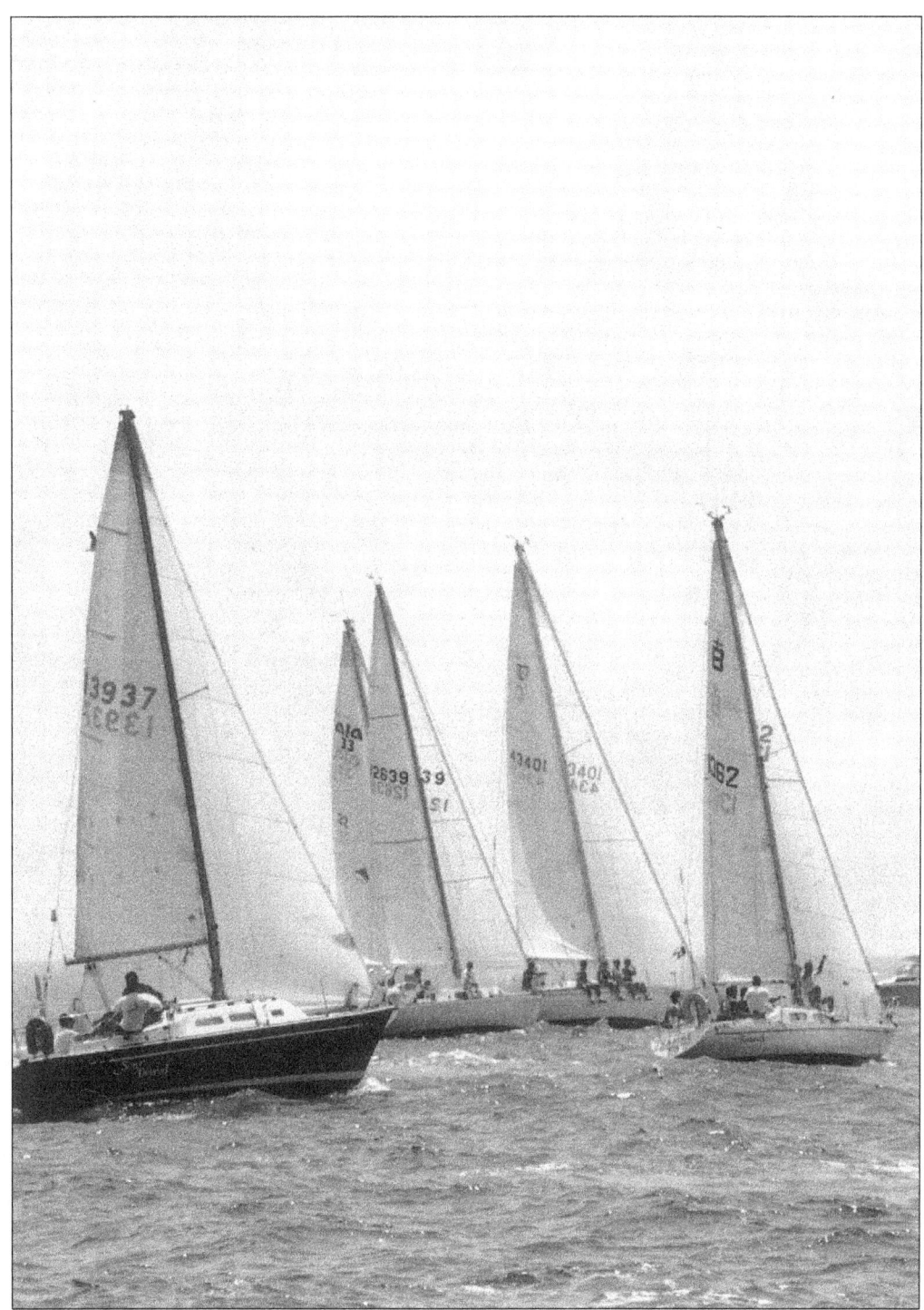

Pleasure sailing has taken the place of commercial boats under sail. In 1985 the North Carolina Yacht Racing Association (NCYRA) sponsored races off Atlantic Beach. (Photo by Frances Eubanks.)

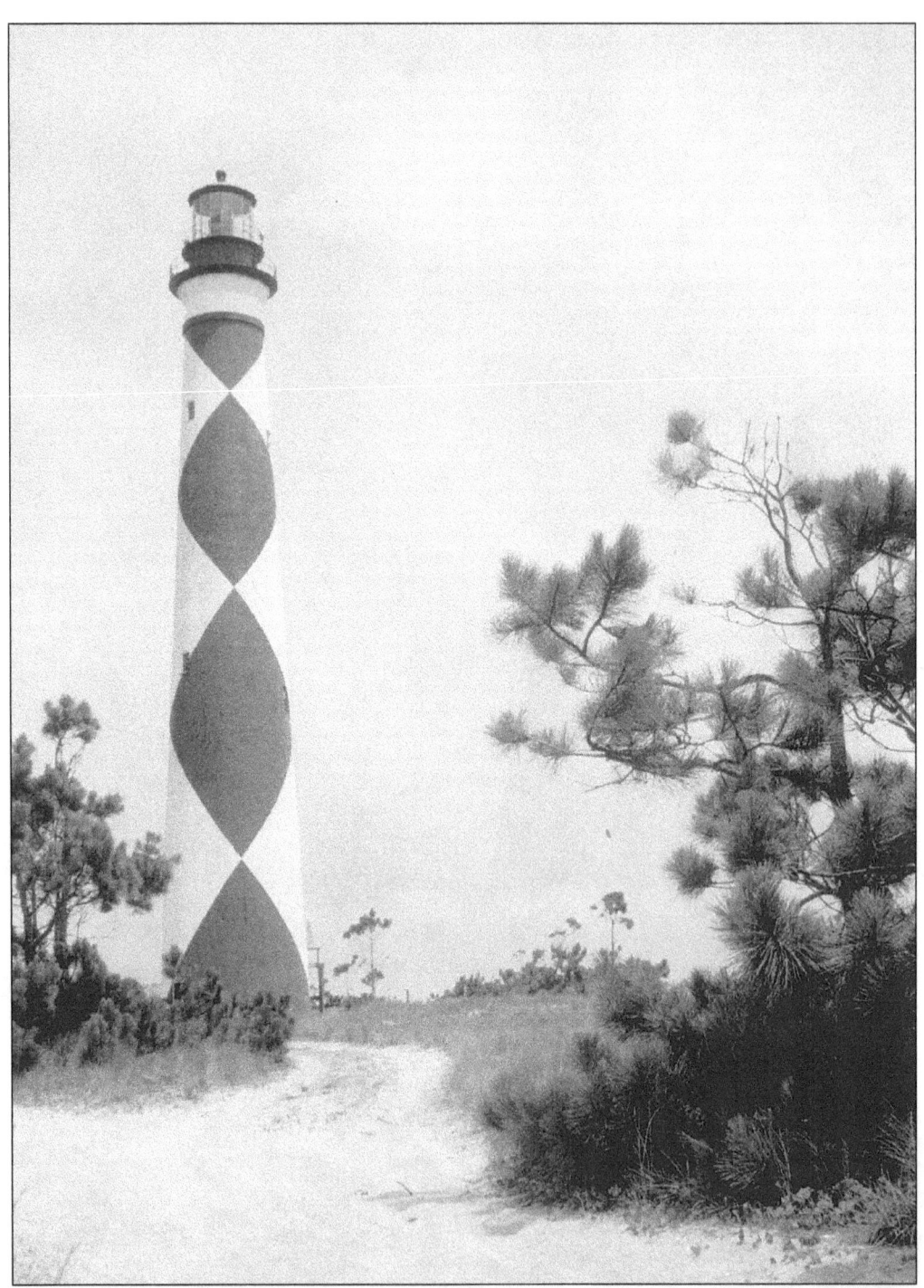

As the dawning of another century begins, the Cape Lookout Lighthouse stands as the sentinel to the shoals and an icon of a century. The lighthouse is no longer thought of as just a navigational aid for mariners. After over a hundred years of service, the lighthouse has been preserved as part of a romantic history. Cape Lookout is now part of the National Seashore. The island is visited as a popular recreational destination. (Photo by Frances Eubanks.)

Visit us at
arcadiapublishing.com

www.ingramcontent.com/pod-product-compliance
Lightning Source LLC
Chambersburg PA
CBHW080852100426
42812CB00007B/2001